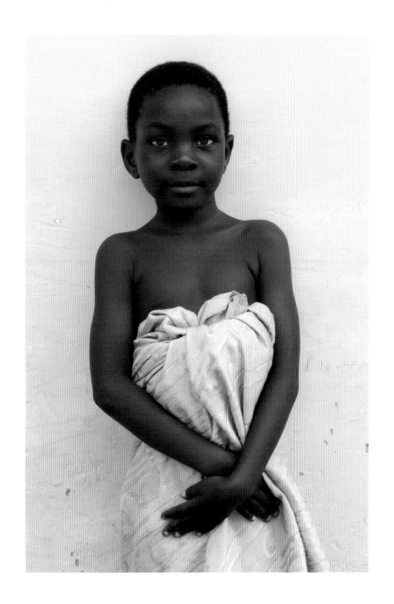

Ghana

AN AFRICAN PORTRAIT REVISITED

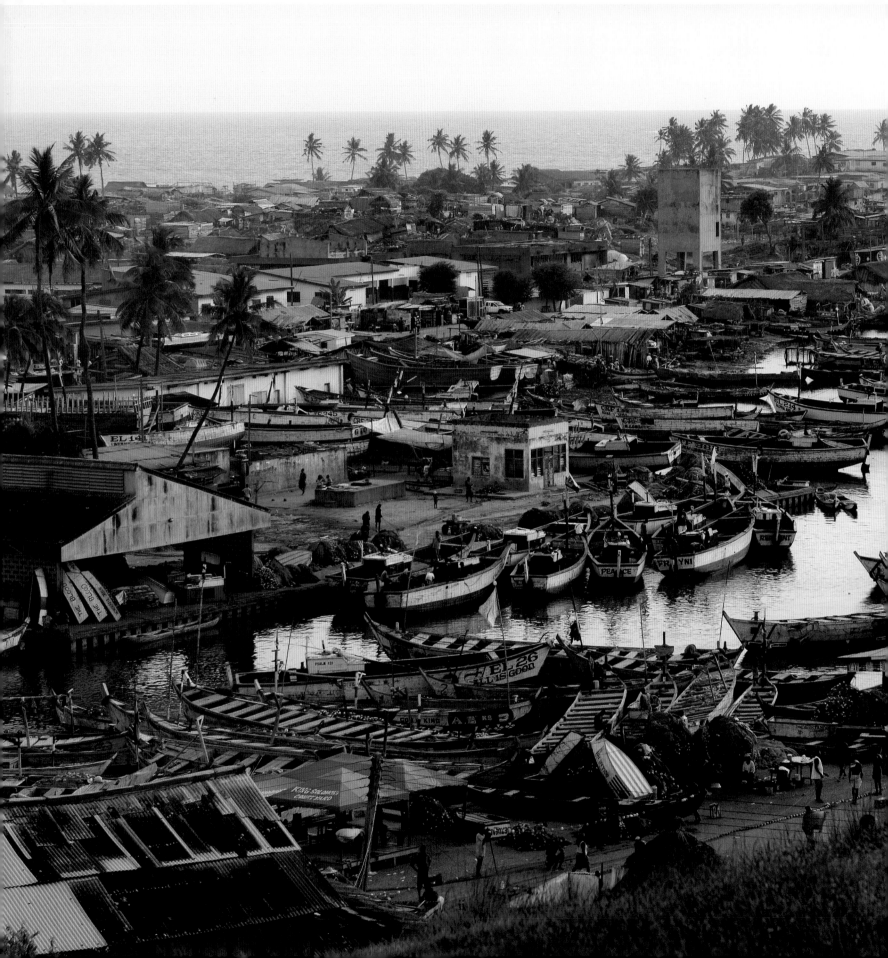

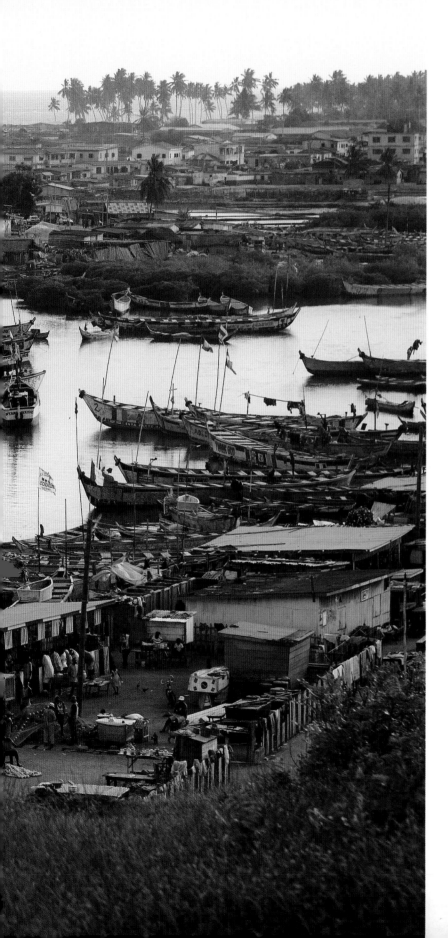

Ghana
An African Portrait Revisited

Peter E. Randall
Editor and Photographer

Barbara Bickford
Tim Gaudreau
Nancy Grace Horton
Gary Samson
Charter Weeks
Photographers

With an essay by
Abena P. A. Busia

Peter E. Randall Publisher LLC
Portsmouth, New Hampshire
2007

Co-published by
Sub-Saharan Publishers
Legon, Accra, Ghana

Dear Reader,

I am delighted to welcome you to Ghana through the magical photographs of a magical country as presented in this book.

 Africa's best-kept tourism secret is being gently exposed with such art that will tempt you to visit and see for yourself.

 Should your introduction to the book be while you are in Ghana then you have a bundle of memories in your hand.

J. O. Obetsebi-Lamptey
Minister, Tourism & Diasporan Relations
Accra, Ghana
November 2006

Dusk, The Brink of Another Day, and *The Drum in Labor*, all by G. Adali-Mortty; *Do Not Tell Me, Friend*, by Joe DeGraf, *Time*, by Kojo Gyinaye Kyei; and *A Passing Thought* by Amu Djoleto, from *Messages, Poems from Ghana*, edited by Kofi Awoonor and G. Adali-Mortty, Heinemann Educational Books, 1971, reprinted with permission of Kofi Awoonor.

I want to go to Keta, and *Gently* by Kobena Eyi Acquah from *Summer Fires: New Poetry from Africa*, Heinemann Educational Books, 1983, reprinted with permission.

Eclipse by Kwadwo Opoku-Agyemang, printed with permission of the author.

Once Upon A Time by Efua Sutherland, printed with permission of the Sutherland family.

Ancestral Milk by Abena P. A. Busia, printed with permission of the author.

© 2007 Peter E. Randall Publisher LLC
Printed in Hong Kong.

Essay © 2007 Abena P. A. Busia.

Design: Peter E. Randall

First published in Ghana in 2007 by
Sub-Saharan Publishers
P. O. Box 358
Legon, Accra, Ghana

ISBN: 9988-647-14-X
ISBN13: 978-9988-647-14-8

in a co-publishing arrangement with

Peter E. Randall Publisher LLC
Box 4726, Portsmouth, NH 03801
www.perpublisher.com
www.ghanavisit.org
www.petererandall.com

ISBN: 1-931807-57-4
ISBN13: 978-1-931807-57-9

Library of Congress control number:

Half title page: Sara Kumi. Aburi, 2006, Gary Samson.

Frontispiece: The inner harbor and fishing pirogues. Elmina, 2005, Peter Randall.

Front end leaf: Cocoa beans. 2006, Barbara Bickford.

Rear end leaf: Peppers. 2006, Barbara Bickford.

Preface

The idea for this book began in 1984 when I was hired as a consultant for the Food and Agriculture Organization of the United Nations to go to Ghana. My assignment was to document an improved method of smoking fish.

With little access to refrigeration, many Third World people resort to smoking as the only viable alternative to preserve their catch. My friends Bill Brownell and Jocelyn Lopez expanded a project to smoke fish using a mud-brick oven for the fire and wooden trays lined with chicken wire to hold the fish. Called Chokkor after the village where the technique was first used, this method allowed fifteen times the amount of fish to be smoked at once using the same amount of wood as the usual method, which used a fifty-five-gallon oil drum. This month-long trip, later extended to Togo and Senegal, allowed time to photograph for myself as well as to gather images for the UN project. Later I produced a booklet, poster, and slide presentation for the 1985 meeting concluding the first International Decade for Women, held in Nairobi.

Traveling around the country in 1984, I met many friendly Ghanaians and resolved to return to this West African country. As part of my research before visiting Ghana in 1984, I discovered that one of the great photographers of the twentieth century, Paul Strand, had been invited to document the country by Kwame Nkrumah, the nation's first president. Long a British colony, Ghana in 1957 was the first sub-Saharan country to become an independent nation. Three years earlier, Nkrumah literally left his jail cell to become prime minister. He had visions of becoming the George Washington of a United States of Africa and apparently thought that Strand's photographs of his country would enhance his image. Nkrumah's vision of Pan-Africanism inspired others and within a few years most Black African colonies became independent nations.

Strand, then seventy-three, and his wife spent six months during 1963-64 traveling throughout Ghana with a car and driver supplied by Nkrumah. Working with a large-format camera, Strand made some five hundred images. In February 1966, while Nkrumah was away on a state visit to Beijing, China, his government was overthrown in a military coup. Nkrumah never returned to Ghana and died in 1972 in Romania where he was being treated for cancer.

Strand's photographs were eventually used in a book, *Ghana, An African Portrait*, published by Aperture in 1976, the year Strand died. He did not see the finished book, which was first published as a hardbound edition and later as a paperback. Both editions are long out of print. Apparently the book was never distributed in Ghana, for I have yet to find a Ghanaian who has seen it.

I have been photographing since my days as a student at the University of New Hampshire (UNH). Over the years I have used my images in a newspaper and a magazine that I edited, and since 1974 in nine books. As I looked at, and contemplated, Strand's

work, I thought someone should go to Ghana and document the country forty years after Strand. Why not I?

I considered various approaches to the project and, after concluding that I had neither the resources nor the time to spend six months in Ghana, decided to make the book a collaboration. I invited several New Hampshire friends to join me on a three-week photography excursion to Ghana in May 2006. Much to my joy, five of whom enthusiastically agreed to accompany me.

Charter Weeks and I were students at UNH, and during a long career his work has included travels to Japan and Niger and filmmaking in London and the United States. He lives in a house he built and operates a communications agency in Barrington.

Gary Samson and I have been friends since 1978, when we met at a UNH Isles of Shoals exhibit at which some of my images were on display. We have photographed together in Guatemala, traveled to conferences, and collaborated on several statewide photography exhibits. Gary worked for twenty-nine years at UNH making documentary movies and managing the university's photographic services department. He left UNH to chair the photography department at the New Hampshire Institute of Art, in Manchester, where he teaches full time and continues to document many aspects of New Hampshire. Gary worked with me to found the New Hampshire Society of Photographic Artists (NHSPA). He lives in Concord.

Nancy Grace Horton, a full-time Portsmouth photographer, does commercial and editorial assignments throughout New England and the East Coast and has traveled extensively.

Tim Gaudreau recently completed his master of

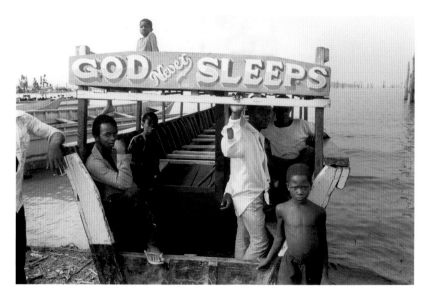

Water taxi. Volta Lake, near Kpando, 1984, Peter Randall.

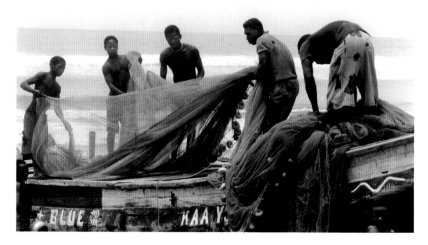

Fisherman, Chokkor, 1984, Peter Randall.

fine arts degree at the Maine College of Art. With his latest work, Tim combines his photography with video, new media, graphics, and sculpture to create public art. He is especially interested in environmental subjects. He does commercial and editorial photography from his Portsmouth studio and has traveled to India and Brazil.

Barbara Bickford's photographic work extends to many Southeast Asian countries including Vietnam and Cambodia. She lives in Portsmouth, and she, along with Nancy and Tim, is a member of NHSPA.

When I went back to Ghana in 2005 with my friend Bob Nilson, the mud ovens I had documented two decades earlier were evident everywhere and I even met a Chokkor woman whom I had photographed at a conference there in 1984. My '05 trip was taken to conduct research for the book project. I wanted to see how Ghana had changed since my first 1984 visit. When I saw Accra, the capital city, I was overwhelmed. The airport was new and modern, no longer a facility with little security and plainclothes "officials" demanding extra entry payment. The '84 Ghana had few new products of any kind for sale, the phone system didn't work, electricity was unreliable, roads were nearly impassable, and medical facilities were poor. The country was ruled by a dictator and armed soldiers were present everywhere.

The 2006 Ghana has new vehicles for sale, supermarkets, cell phones, Internet cafés, and many roads being reconstructed as four-lane highways. Accra boasts high-rise buildings and modern hospitals. Soldiers are now in their barracks. Ghana's democratically elected government supports the most economically stable country in West Africa. This is not to say that Ghana is without its problems, however. Many of

its twenty-two million people are poor; some schools lack even basic supplies, and rural areas need proper sanitation facilities and better water sources. Ghana is beginning to attract more foreign investments, and has few products to export, but does produce gold (the country was formerly known as Gold Coast) timber, and cocoa. Ghana's cocoa production stood at 500,000 metric tons in 1965, tops in the world, but by 1983 its output had dropped to as low as 150,000 tons. In 2005, Ghana was again expected to exceed 500,000 metric tons of cocoa.

There is a major emphasis on tourism, especially so-called Roots tours mostly for African-Americans wanting to know where their ancestors came from. Some of Ghana's slave forts are five hundred years old and it is not without emotion that visitors view the holds where male and female slaves were kept prior to being shipped across the Atlantic to Europe and the Americas. Although Ghana lacks exclusive Caribbean-style resorts, it is safe and friendly, and offers an ideal introduction to Africa for travelers who have never visited the continent.

Born in 1890, Paul Strand, received early photography training from Lewis Hine, was a protégé of Alfred Stieglitz and a friend of Berenice Abbott, Charles Sheeler, and Edward Weston, as well as Georgia O'Keeffe. When Ansel Adams began to photograph at Manzanar, the World War II Japanese relocation camp, his work was inspired by the images of Strand, whose portraits of peasants in *Photographs of Mexico* (1940) were for Adams "documents in the highest sense of the term." After meeting him, so impressed was he with Strand and his work, that Adams decided to become a full-time photographer.

Strand set up a commercial studio in 1909 and

first worked in a pictorialist style, but gradually shifted to a more sharp-focused approach. Stieglitz championed the photographer's modernist, abstracted compositions by devoting the last two issues of *Camera Work* to Strand and giving him his own show at the famous Gallery 291. Influenced by modern trends in other media, Strand made abstracted close-up views of nature as well as sharply defined urban images. Stieglitz declared that "Strand is without doubt the most important photographer developed in this country since Alvin Langdon Coburn."

Strand became political in the 1930s and his socialist, some say Communist, views led him to support and became part of organizations that were concerned with social issues and the working class. From the mid-1930s until 1944, Strand was primarily a film maker, both filming and producing documentary films. His company, Frontier Films, was spawned from the New York Photo League, a collection of like-minded photographers concerned with social issues and the only noncommercial photography school in the country.

Strand was given a retrospective one-man show by the Metropolitan Museum of Art in 1945, but in the late 1940s, when the Photo League and other organizations were investigated by the House Un-American Activities Committee and members were blacklisted, Strand decided to leave the United States and live in France.

Most of his work was published in books, the first being *Time in New England* (1950), a classic documentary of the region. Later he produced *La France de Profil* (1952), *Un Paese* (photographs of Italy's Po River Valley, 1955), *Tir a'Mhurain / Outer Hebrides* (1962), *Living Egypt* (1969), and *Ghana: An African Portrait* (1976). All of these projects reveal Strand's

intention to portray the residents of a place with the place itself. Some of these titles have been reprinted, but others, *Ghana* included, can be found only by searching used book sites on the Internet.

Peter Schjeldahl, art critic for the *Village Voice*, described Strand's work: "He set incredibly lofty standards for himself. A shot of his had to have just about everything in terms of formal rigor and inherent fascination to be worth printing, and his printing itself, commonly on platinum paper, crackles with sensitivity to nuances. The result almost always is something definitive—as if each picture were the first and last in the world—that happens to take as its subject a contingency of light and time."

At his death in 1976, Strand had been photographing for nearly three-quarters of a century, but his work was not finished. He was working on projects in Morocco and Romania. In 1971, he remarked to friends Milton Brown and Walter Rosenblum, "It's an inexhaustible world. And I would say that very little of it so far has been photographed. People have made photographs here and almost everywhere in the world. But they certainly have not photographed with any degree of finality and completion."* That's the challenge Strand gave to himself and few others have been able to accomplish it as he did.

Clearly, photographing after Strand was to be a challenge. While we had as a goal "photographing in the manner of Strand," we brought our own vision to the project. Six photographers have six points of view, six different styles, and six different ways of working. Strand photographed slowly over half a year with a large-format camera in black and

*From *Paul Strand: essays on his life and work*, Aperture, 1991.

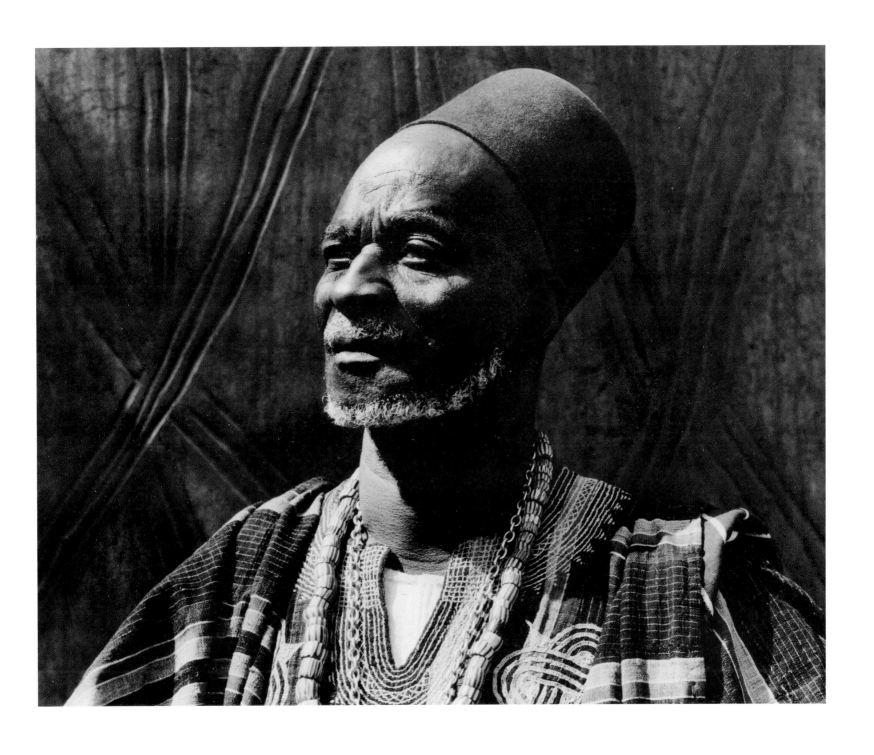

Paul Strand: Awoleba Adda, Navropio of Navrongo, Ghana, 1963, © 1976, Aperture Foundation, Inc., Paul Strand Archive.

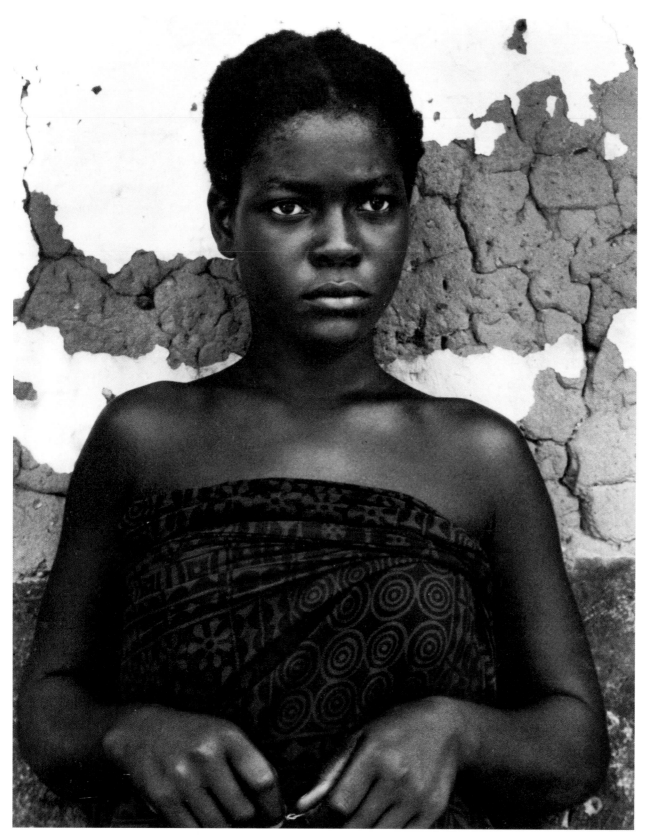

Paul Strand: Afe Negble, Asenema, Ghana, 1964 © 1976, Aperture Foundation, Inc., Paul Strand Archive.

white. Most of us used digital cameras and we decided to work in color during our three-week trip.

Strand was and remains our inspiration. He showed the world Africa's first sub-Saharan independent country. His book is filled with portraits of proud Ghanaians, people who looked to the future with hope and dignity. In some ways, Ghana has not changed. Traditional people wear the same style of dress, eat the same food, and work the same crafts. When Strand was there, the people were newly liberated from a colonial power. After the demise of Nkrumah until the mid-1990s, Ghana endured numerous coups and a lengthy dictatorship, finally to emerge with a democratically elected government. Now is a time not dissimilar to the days when Strand was there. Once again the people have hope for the future. One day in Accra I was talking with a man about Ghana's apparent economic improvement, but he had other thoughts. "I am happy," he said, "that now I can say what I want without fear of arrest."

There is no way of knowing whether Strand would have approved of our photographs, but it is certain that the old socialist, the man who appreciated, had empathy for, and saluted the common man and woman, would be pleased for the new Ghana as it makes its way forward in the family of nations. That we were able to photograph the country on the eve of its fiftieth anniversary of independence has made our effort that much more meaningful.

ACKNOWLEDGMENTS

First I must thank Barbara, Charter, Gary, Nancy, and Tim who embraced my vision for a book about contemporary Ghana. Only I had been to Ghana before, yet they all jumped at the chance to join me, and they worked hard and with much cooperation. We began as friends and finished the same way, something that does not always happen when groups travel.

Other people helped make our work successful. Vita Awuku Galeota, a native Ghanaian who lives near Boston with her husband, Joe, shared contacts with her friends in the country and answered many questions for us. Vita's longtime friend Reeta Auguste was our guide around Accra. Nancy Keteku, who has family in Portsmouth and has lived in Ghana for twenty-five years with her husband, Willy, enthusiastically shared her knowledge of people and places. Theresa Kwakye, of Cross Cultural Studies and Tours, provided advice and our vehicles and drivers: Stephen Nortey, Ellis Sackey, Godfred Omaboe, and Maxwell Ninsiful. These men were indispensable when it came to navigating Accra's winding, often clogged thoroughfares, translating when needed, and keeping an eye on us as we sought to photograph people and places in diverse parts of the country.

Jake Obetsebi-Lamptey, Minister of Tourism, helped with contacts and provided his own vehicle and driver, Nana Takyi-Akonor.

In 2005, Portsmouth formed a sister-city relationship with the neighboring Ghanaian towns of Aburi/Agyimanti and Kitase. In September, we were visited by Nana Kwame Takyi I of Aburi and Nana Adu Ampoma II of Kitase, both men considered kings by their communities. They greeted us in their own villages in 2006 and assisted Gary Samson during his week in Aburi.

Several years ago, Charter's son, Bill, who teaches West African drumming, visited the small religious

community of Jordan Nu, located near Kpando. Bill's friend George Alorwu and members of the Jordan Nu White Cross Mission welcomed Charter, Gary, and me for a memorable weekend in rural Ghana.

Charter and Barbara spent several days in Kumasi with Kwame Adzenyo from J & K Engineering, truck mechanic extraordinaire and knowledgeable guide to all things and places Ghanaian. Charter also photographed in Pokuase, where another New Hampshire friend, Dana Dakin, has formed a women's development trust organization. Here Charter was assisted by Gertrude Ankrah and Eric Ankrah.

Nancy and Tim worked mostly in central and northern Ghana with their driver Ellis. Nancy said, "The list is long. Many people I have names of, many I do not. I do thank every face I met. The kindness and openness of the Ghanaians was welcoming and happy. Along the many miles traveled, there were countless people who helped. Rita August's friend Prince took us around Kumasi to the markets, palaces, and craft centers. E. A. Hammond, Ghana Tourism Board, northern regional manager, provided introductions to the crafts of Tamale; and Raymond A. Silverman, director, Museum Studies, University of Michigan, connected us to Nana Baffour and the fetish priests. And thanks to Nana Yaw Mensah, Nana Akua Anane, Gambarana Yahaya Wuni, Awal Yussif, Hello Furniture Works, Jacob Abudu, Benjamin Sakyi, and Coconut Grove."

It is said that a photograph is worth a thousand words, but add ten words and it may be worth ten thousand words. Although our photographs can stand alone, words place the images in context. From the beginning of this book project I wanted a woman essayist. During previous visits to Ghana I was constantly aware of the hardworking women and knew that they rarely received credit for their efforts. I was very pleased when Abena P. A. Busia, associate professor of English at Rutgers, agreed to add words to our photographs.

Codirector of the groundbreaking Women Writing Africa Project, a multi-volume anthology published by the Feminist Press at City University of New York, Abena also serves on the advisory board of the Ghana Education Project, as well as the board of the African Women's Development Fund, the first and only Pan-African funding source for women-centered programs and organizations. Her father, Kofi Abrefa Busia, was prime minister (1969-1972) during Ghana's second republic and in the country there is hardly a person of note whom she does not know.

We also appreciate the support of the Paul Strand Archive at the Aperture Foundation, Millerton, New York, for granting permission to reproduce two of Strand's images in this publication

And kudos to Grace Peirce for assistance with design and Deidre Randall for her marketing skills.

It is not often that one can dream about a project for two decades, and then see it come to fruition. To have made this book happen, I was blessed with the hard work and energy of five comrades. I was blessed to have made the acquaintance of a marvelous woman author. I am blessed to have the support of a loving family, especially my wife, Judith, who puts up with my dreams and travels and always has a cozy home ready when I return.

Peter E. Randall
Portsmouth, New Hampshire
November 2006

Sources

Briggs, Philip. *Ghana*, 3rd edition. Bucks, UK: The Bradt Travel Guide, 2004. The only travel guide to Ghana, but comprehensive.

There are few recent books about Ghana, so web sites are the best source of material. The government tourist site is www.ghanatourism.gov.gh

For more information about Paul Strand:
Maren Stange, *Paul Strand: Essays on His Life and Work*, New York: Aperture Foundation, 1991.

Paul Strand. Aperture Masters of Photography. New York: Aperture Foundation, 1987.

Strand, Paul, Catherine Duncan, and Basil Davidson. *Tir a'Mhurain: Outer Hebrides of Scotland*. New York: Aperture Foundation, 1962.

Strand's other books, *Time in New England*, *La France de Profil*, *Un Paese*, *Living Egypt*, and *Ghana: An African Portrait* are out of print, but can sometimes be found by searching internet book sites.

Collections of Strand's photographs:
Tomkins, Calvin. *Paul Strand: Sixty Years of Photographs*. Aperture, 1976 (reprinted).

Busselle, Rebecca and Trudy Wilner Stack. *Paul Strand Southwest*. Aperture, 2004.

Lyden, Anne M. *In Focus: Paul Strand, Photographs from the J. Paul Getty Museum*. Oxford University Press, 2005.

Walker, John. *Strand: Under Dark Cloth*. DVD. New York: King Video, *1990*.

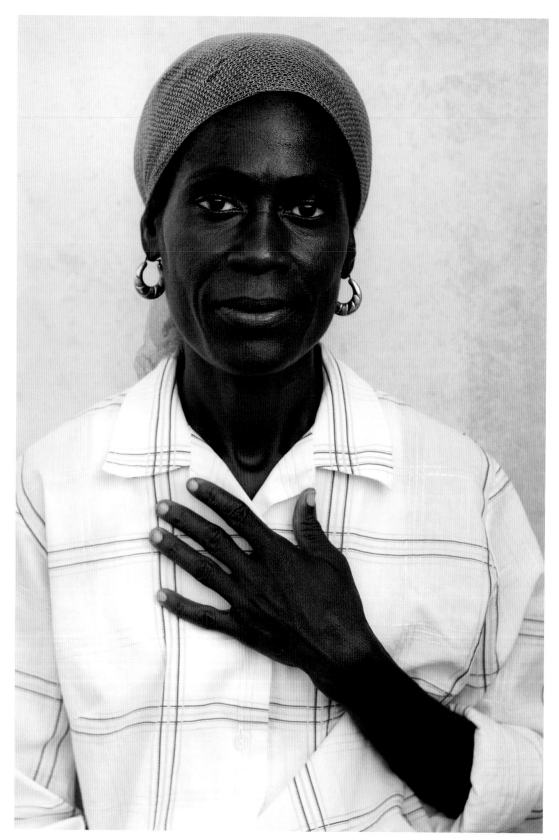

Woman. Accra, 2006, Gary Samson.

Of Records and Memory:
An African Portrait Revisited

BY Abena P. A. Busia

I've always wanted to be aware of what's going on around me, and I've wanted to use photography as an instrument of research into and reporting on the life of my own time.
— Paul Strand

Look at the things around you, the immediate world around you. If you are alive, it will mean something to you, and if you care enough about photography, and if you know how to use it, you will want to photograph that meaningness. — Paul Strand, "The Art Motive in Photography," in 1923, *British Journal of Photography*, 613

Those words by Paul Strand informed his own work *Ghana: An African Portrait,* published thirty years ago, and have inspired this present collection. The photographers in this volume have journeyed to Ghana to paint a portrait, not to record the first years of Independence, but this time in celebration of her Golden Jubilee, to mark the traces of the years in between. The existence of Strand's work thus sets up a sense of double vision. These photographers have their own eyes and see the world with their own particular artistry. Yet at the same time the memory of that other work haunts the volume, which becomes at one and the same time a document of its own time, and a record of change.

Photographs record images of all kinds, and it is up to us to read them. But what makes up their "meaningness"? These artists have asked that we see their work through this particular double vision, through their own immediate lenses, as well as through our lenses of time, which is the work of memory. At this moment of anniversary, what portraits can make up the memories of a nation? What is the process of progress? How can we read that progress recorded in the faces of the people or in the landscapes and landmarks of their land? Strand believed his record of a place, this place, could be read as a portrait of the continent itself. If the place has changed, what scars on its surface record the process of transformation? What expressions on the faces of people track transformations? How can we mark the process of decades of transformation in records of discontinuous images?

This project is an interesting and curious one, part contemporary documentary, part memory; inspired by Paul Strand's collection with its accompanying essay by Basil Davidson, the photographers have traveled the roads of the same country decades later, raising many questions. What difference does it make that the relationships that inform the works are so very different? First, Basil Davidson and Paul Strand were friends, and they had spent decades contemplating their project. Strand's journey through Ghana took place in 1963-64, at the time when Nkrumah inspired the continent by spearheading the Organization of African Unity, but before he declared Ghana a one-party state and himself president for life. So large was Nkrumah on the landscape of the continent that Davidson could say of Strand's photographs:

They are first and foremost a portrait of Ghana, above all, of the Ghana that Nkrumah led to Independence. But in many ways that may be intimate and profound they are also a portrait of the Africa within which Ghana has taken shape.

So strong was the identification between Africa and Ghana and between Ghana and Nkrumah that in the same way the book was called *Ghana: An African Portrait,* Nkrumah could entitle his autobiography *Ghana: The Autobiography of Kwame Nkrumah.* In fact, so strong was that identification that a decade ago, when photographers Cécile Laronce and Philippe Schlienger, inspired by the same Strand book to return to Ghana to repeat his journey, they called their venture "In Search of Kwame Nkrumah." Their mission then was to see what traces his monumental rule had left on the landscape. This present mission is taking place under far different circumstances, with a host of other memories informed by other histories to contend with, the most significant of them being that in the intervening years Ghana has had another ruler whose presence in power outlasted that of Nkrumah. One other factor of the relationships governing the original publication remains important: Davidson was a friend and great admirer of Kwame Nkrumah and this, above all, shaped the nature of his accompanying essay, published after Nkrumah's overthrow in 1966 and his death in 1972, in 1976, the year Paul Strand himself died.

The relationships governing this project are very different. Artistically most significant, they are not the work of one single photographer, but rather of a group, working together collaboratively, it is true, but of different sensibilities. Different artists, both male and female, they are bound to Paul Strand by several factors, the most defining that they clearly share his

artistic vision of the power and role of photography. In addition, they are all white and all Americans. They are also bound by the fact that though their trip was shorter and more intense than that of Paul Strand, and they did not all travel throughout the land but instead divided it among them, they were all in the country at the same time, during the same three weeks in the summer of 2006.

Their relationship to me is also different, connected by chance; we also had not decided that it would be I who actually wrote the essay until after our first meeting. By that time the trip had already been planned, and the photographers were already in the country. Furthermore, that first encounter was the only one until after the photographs were taken and developed and the essay written. Of all of us, past and present, Davidson, Strand, and the artists in this collection, though I spent nearly half my life in exile, I am the only one who is, and was born, a Ghanaian.

We decided during that first meeting however, that my essay would be fundamentally different. Of his own essay Davidson had written:

> My aim here has been to deepen this portrait without, as it were, repeating it. I wrote this essay independently of the photographs, but keeping them very much in mind. Our idea was to offer the kind of information, reaching back into the past, looking at the present, having the future not entirely out of mind that would illuminate the photographs: just as the photographs, in their turn, would illuminate the text.

My intention is far different. It would be too grand an undertaking to attempt an answer to Davidson's perspective on Ghana's history, or to create a similar document to cover the years since his historical account ended. Also, we wanted a less monumental

and definitive kind of narrative, one that would respond to the photographs and sound a counterpoint: to offer a meditation through the mnemonic frame of the photographs, rather than to offer information through a contextualizing narrative. And my starting point was my relationship to Strand's photographs and Davidson's history.

In looking at Strand's photographs, what I see immediately is the Ghana in which I was a child. The world of the original photographs is only a little younger than that into which I was born. Those images show me again the world I saw through the eyes of a child. Born in 1953 and four years old at the time of independence, I was six when I first left home. The world Paul Strand photographed is the years of the middle of our first exile, and from the hindsight of memory, it is very much a mixture of the worlds I remember, the one I left in 1959, and the one I returned to in 1966. The images were taken in 1963-64. Thus, what moves before me in those photographs, is the world of my childhood, and the world I came back to after seven years away. Under Nkrumah, my father, Kofi Abrefa Busia, had been leader of the opposition at independence, and leader of the opposition in exile, until the coup d' état that overthrew Nkrumah and the government of the First Republic in 1966.

What is far more muted in the Davidson's essay is the gap between the world in which the photographs were taken, that of 1963-64, and the world in which his essay was written and the book published, 1976. In that year I was graduating from college in the middle of a second exile. Having returned home a decade earlier in 1966 after the overthrow of Nkrumah, we were exiled again six years later, in 1972, after the military coup that overthrew the government of the Second Republic, which was headed by my father. Thus the time of hope Davidson cele-

brated in the 1960s was less unambiguously so for many of us, myself included. Davidson saw the decade between 1966 and 1976 as an ignominious coda. For him, the year 1966 was the moment when dreams faltered; for us it was 1972. Other people locate the moments of hopes and dreams at other times, and most Ghanaians agree that for us as a nation, worse was yet to come after the failure of the Third Republic before they got better again.

Time has passed for all of us. Forty years later, the world of these photographs is a very different one. I am home again, in an adult world that has also become a time of research and scholarship. The history of my country has been tumultuous, and, as a consequence, so has mine. The history of Ghana since the breakup of the United Gold Coast Convention (the original pro-independence movement) has been dominated first by the two political groupings into which that United Convention split: the Nkrumahist CPP tradition (very strong and united at independence, much weaker and fragmented today), and the Danquah-Busia tradition, (at independence an alliance of small groups united against Nkrumah, today a grouping of much stronger coherence), each of them under various party names, at different times. These two traditions were joined in the mid-1980s by the NDC of Jerry John Rawlings, which numerically at least, had eclipsed the CPP as the other strong force in the country.

Looking at the two sets of photographs, asking myself what the difference is between their two worlds, I am asking myself what the difference is between my two worlds. These photographs have been taken at a moment when—for Ghanaians of whatever political persuasion—the single most important factor of our political life as a nation is that the Fourth Republic has held. Whatever shortcomings

attended its conception, whatever controversies surrounded its birth, and whatever missteps since its promulgation, civil society has had its way. The rule of law has been restored, becoming more tenacious by the day. We are on the brink of the fifth elections under our fourth republican constitution of 1992. In some respects little has changed, and yet much has changed, too, and those changes in the present re-inform our sense of the past. And the present shows its impacts in many ways, subtle and profound, in these photographs.

A Guide Through Memory

These pages contain the portraits of many people who have been witness to the events that have taken place between the two sets of photographs. A group of World War II veterans who served in Burma, and thus of the generation of soldiers whose protest actions led directly to the first steps toward independence, were young men then; they are elderly now. Mrs. Theodosia Okoh, who designed our national flag is still waving it, unchanged after all these years. Kwame Nkrumah is no longer living, but Nana Kwame Takyi I, Chief of Aburi, is with us still. A retired assistant superintendent of police and a sitting traditional chief since 1988, Nana Takyi's life in a sense dramatizes that continuity in change these photographs represent. As a policeman his detail was to serve Nkrumah, which is what Nana Takyi was doing when he was exiled with the president in 1966. He returned to the country after Nkrumah's death in 1972, and stayed. Nana Takyi was born in 1924, the same year as my mother, whose exits and entrances have been the reverse of his; it was the coup of 1966 that allowed her to return to the home she had escaped in 1959, and that of 1972 which determined her second exile until after the death of her husband, my father. I looked through the first

photographs sent to me while sitting beside her, and through her eyes, her eye for detail and her eye of memory, begin to comprehend those many differences, visible and invisible.

Some of the visible differences are ones that all would notice, from density of Accra to the styles in fashion. Yet some things even in the fashion world have not changed; there Mother sees a photograph of a cloth with a bunch of bananas, which could have been photographed by Strand. The print was popular then, and it is still being worn, an old design holding its own against a plethora of contemporary ones. The decoration on women's clothes sewn by industrial sewing machines recalls for her a subtle shift only a seamstress would remark: that the embroidery on the clothes of the women has changed.

That change has come about not only because there are now more factory-made clothes than there were four decades ago, but also, and more poignantly, because even home-tailored clothes are no longer embroidered predominantly by hand, as Mother did with our childhood outfits. These days embroidery is done with the kind of domestic machines designed to create decorative stitching whose coming into vogue in Ghana in the mid-1950s my mother remembers well. Mother could name the homes of the women who acquired them first and developed a clientele of friends to do such work for. In the intervening years we have learned to articulate far more cogently the ways in which "the personal is political," and I discover how very true this is through my mother's reminiscences about embroidery machines, which jog memories of my own.

In 1955, my father and R. R. Amponsah, a member of the United Party, of which father was leader, had been victims of a suspicious car accident on the road from Cape Coast in the general mayhem that was the run-up to the independence elections.

They were both seriously injured and Father broke his nose as a result. Mother had been saving up to buy herself an embroidery machine, which, after this accident, she never did, because some of the money was spent on Father's medical bills.

As she told this story, it suddenly shed light on a childhood memory of Father showing almost boyish excitement about a gift he had ordered for Mother. He was very anxious that it be perfect, and that it arrive on time. It was a Bernina sewing machine, the top of the line. Only now, more than forty-five years later, do I understand the significance of the gift. Father had lived for five years with the knowledge of the many things his political activities cost Mother, many of which could never be compensated for. This one thing could, and he bought for her the sewing machine she had wanted so much and had sacrificed in order to bring him back to health. I remember to this day his excitement when the machine arrived at our home in Holland, special delivery on a Sunday, in time for the first birthday she spent in the first home of what was to be only the first of her exiles.

It is such conversations with my mother that encourage me to read the photographs as a witness to history, to see what is both there and not there; what has disappeared and what materialized, to consider what those differences might mean. We are always the history makers, and the eyes to the camera prods us into seeing differently, and remembering.

Continuing Witness to History

There are many ways of being a witness to memory and history, some of them carried out in solitude, others public and monumental, and the camera's eye is a witness to both. As the Davidson essay outlined, Ghana has had a long and checkered history and, as with so many communities along the West African coast, one of the most checkered aspects of that history is slavery, a legacy that scars the landscape, both natural and monumental. Davidson's journey began appropriately in the north, and that is where I too will turn, with the reflections on the images taken in that part of the country.

The one that strikes me first, and that takes me by surprise, is the portrait of a familiar face. It is the face of a woman, a traditional priestess, that has been haunting me since I first encountered her some fifteen months ago, in the summer of 2005, on a study tour of the internal slave routes of Ghana and Benin with a group of colleagues from Rutgers University and the University of Ghana at Legon along with a comprehensive group of New Jersey educators. We traveled the length and breadth of Ghana, and one of our first stops on the route north was the historic slave market town of Salaga. There we saw, as in many other places in that part of the country, the way in which the history of slavery is still eched in the landscapes of place and memory. The once secret locations of places where slaves were bathed before sale are now revealed; naturally beautiful places where wells were kept secure as places to water slaves are now well signed in a landscape turned eerie through knowledge. Such places were certainly not on the tourist path fifty years ago.

Some monuments are living, however, and one of them is a baobab tree, whose history we learned through the witness of the traditional priestess whose duty it is to keep alive the story of the place. Her testimony was so moving it inspired my poem "Ancestral Milk." That the tree marks a memorial to captives who could not survive the journey south is a story told completely sotto voce, unacknowledged by any of the kinds of monumental markers found on the coast at the end of the trail. Some remembrances are done through monuments, others only through living witnesses, and this living witness beneath this baobab tree was certainly also not spoken of, or

recorded fifty years ago.

As Strand *did* record, the north of Ghana leaves a legacy of our history in its architecture as well. The tragedy of the transport of humans that ties the routes between north and south is marked also in the structures of the buildings. Whether traveling north across the Sahel toward the Sahara, or south through rain forests toward the Atlantic, the architecture of the palace of the Paga Pio, the traditional ruler of one of the northernmost towns of present-day Ghana, and that of the Sahelian style mosques such as the one found at Larabanga in Brong-Ahafo are as resonant of that the history of slavery and domination as the more infamous slave forts of Elmina and Cape Coast along the southern coast. They too are still there, more restored to ironic grandeur than they were half a century ago. These photographs reflect the tense embrace between time frozen and time passing. There have been changes. In 1998 the government of Ghana instituted Emancipation Day as an annual public propitiation of the sins of the past. On the first of these, the local chiefs placed a plaque that reads:

> *In everlasting memory of the anguish of our*
> *ancestors.*
> *May those who died rest in peace.*
> *May those who return find their roots.*
> *May humanity never again perpetrate*
> *Such injustice against humanity.*
> *We the living vow to uphold this.*

That apology, prominently displayed at the entrance to the male dungeon marks, more than anything else, a change in sensibilities. That departure was echoed a few years later by then archbishop Charles Palmer-Buckle, of Koforidua, in the Eastern Region, when he made a public apology on behalf of African ancestors for the role they played in the slave trade. Awareness of history comes hand in hand with memorializing that past, and there are now many signs of remorse in those same ancient places.

The slave forts and castles are still there and continue to dominate the seascape. In Cape Coast and Elmina we have always had, as in Accra, fishing villages whose people live their structured lives in the shadow of those forts with a rhythm still controlled by a knowledge of the needs and temper of the ocean and ocean creatures. A life dominated by fishing—collecting, sorting, smoking, selling, mending nets to start the cycle again—marks the landscape from border to border.

Every age brings its monuments. Unlike those to the past, we have erected post-independence ones to mark our history: some, like the magnificent Kwame Nkrumah Mausoleum, were erected by a grateful nation. There you can see grand memorial architecture—a commemorative statue surrounded by sculptures of a chief's ceremonial guard and, when the city has electricity and water to spare, a waterfall. When Nkrumah died, in Bucharest, his body was returned first to Guinea, where he was accorded the burial of a head of state. His body was later returned to his hometown, where he was buried with his ancestors following custom. He was eventually interred, by the state, in the mausoleum, opposite the old parliament house, and now a national monument. When Strand walked that road Nkrumah was still alive, so the monument would not have been there. Nor would the one now standing on that same road, on the opposite side of the street in front of the High Court; in 1962, it would still have been Parliament House. Today parliament has moved to State House, built by Nkrumah as lodging for the delegates to the first OAU conference in 1963. The old colonial Parliament House is now the seat of the Accra Metropolitan Council. But the court is still the court and today its forecourt is dominated by the

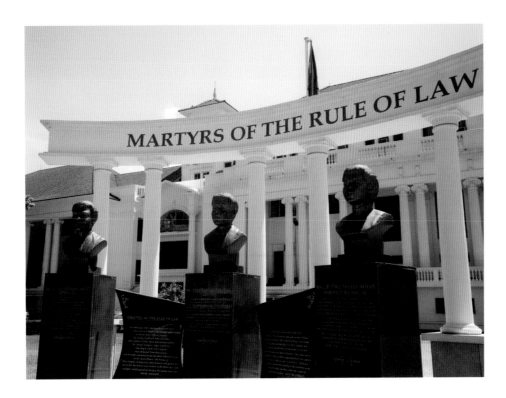

Martyrs of the Rule of Law, 2006, Peter Randall.

memorial to the Martyrs of the Rule of Law.

On the night of June 30, 1982, three High Court judges, Justice Mrs. Cecilia Korateng-Addow, a nursing mother of three; Justice Kwadwo Adjei-Agyepong; and Justice Fred Poku Sarkodee (along with retired army officer Major Sam Acquah, personnel director of the Ghana Industrial Holdings Company), were abducted from their residences by a group of soldiers, and disappeared. Through chance, occasioned by heavy rains that doused the fire set to destroy the evidence, their bodies were discovered a few days later, hastily buried in shallow graves on the Accra Plain. They had been shot and their bodies set on fire, the apparent victims of the "rule by firing squad" that beset Ghana in the 1980s, and for no offense that anyone has yet been able to determine.

The regime proceeded to further undermine the rule of law by setting up lawless "people's tribunals," but unbowed, the members of the Ghana Bar Association courageously unleashed a storm of protest, attracting the attention of those outside the country to the growing violations of human rights and the rule of law under Rawlings. For two decades they did not let the country forget, instituting annual services of remembrance in their honor. Erected by the justices of the Supreme Court under the present administration in 2004, the monument to the murdered judges stands today outside the High Court to serve as a reminder of both great sacrifice to uphold the rule of law and triumph of the will of the people that it prevail.

Those things that are witness to incidents past may also be a testament to continuities. The statue in front of the national theater, frozen in the act of pouring libation, reminds us of the central lesson of Efua Sutherland's play *Foriwa*, that we celebrate who we are by carrying what is sacred about our past transformed into our future. Though apparently recorded nowhere but in a poem by Ama Ata Aidoo, the theatre stands on the site of Efua Sutherland's

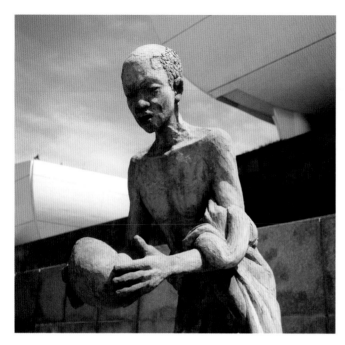

Sculpture by Alex Sefah Twerefour, National Theater. Accra, 2006, Barbara Bickford.

original drama studio and thus both marks and hides the traces of the origins of our contemporary national theater movement. There is much in these photographs that records that continuity in change and change in continuity. And there is much that is simply new, innovative, and a sign only of its times.

EVIDENCE OF CULTURAL CHANGE

These photographs are more than anything else portraits of people, people in the course of everyday life that tell about those lives in simple ways. Beneath the manifest political stability, there is still much poverty evident in the continuing paucity of infrastructure in both urban and rural areas, the latter the biggest consequence of the coup d'état against the Second Republic whose platform was a rural development program that has not really been dusted over until recently. Hand-washed clothes on a

clothesline beside small laterite houses speak volumes.

Nevertheless, that clothing once off the line and worn on bodies is equally telling. Vibrant color is still a signature of the nature of our lives. In the whole range of dress, from the ceremonial regalia of chiefs and officers to everyday wear, adornment is culturally significant. Ghana is celebrated for its kente, which, though still a prestige cloth, it is far more accessible than it once was. That too, though, has undergone both subtle and dramatic change. The "dramatic" is that it is now imitated in print: What made it familiar around the world was when it became visible on the streets through its classic designs printed on inexpensive cotton in the 1980s. But that, for most Ghanaians, is not *kente,* which still means the hand-woven narrow strips of rich cloth carefully assembled, vibrantly on display everywhere from ceremonial occasions to piled high at the stalls of specialty sellers. The finished product is the result of years of apprenticeship and cultivated skill. Yet the vibrancy is also indicative of change; the colors have changed. Once kente was a cloth of a relatively sub-dued palette of natural silk dyes; today some of the designs show off the range of artificial color produced by chemical dyes on man-made fabrics.

Body art and adornment is a prized everyday art form. Elaborate sleeves and collars ornament the "kaba shirts" of women, and inventive use of color and design mark the embroidery and appliqué on the clothes of men and women alike. Though we were once known as the Gold Coast, it is not only gold that reveals our artistry. For instance, where in Strand's pictures for the most part beads are to be found principally on elders and ceremonial people, today beads are everywhere in evidence, even among the urban elite who in the 1950s considered them infra dig. Mother remembers the eyebrows raised against her when she insisted on wearing kente at her

Weaving kente cloth,
Centre for National
Culture, Kumasi, 2006,
Nancy Grace Horton.

wedding in Oxford in 1950 and that remained up when she continued to design and wear jewelry with Aggrey or trade beads on official occasions on our return in the late 1960s. Seeing so many people wearing beads everywhere marks a real and welcome change to those who, like her, for decades fought a quiet campaign in their favor.

The traders were always there; it was the customers who were not so abundant. But ancient Aggrey or trade beads are increasingly popular these days, and, alas, increasingly expensive. In response, however, there is also a flourishing trade in beads made from recycled glass by contemporary artists and sold all over the country. Some of the occasions for wearing them maintain touching ancient customs, like the thin string of small white beads around the hips, wrists, and ankles of a baby in celebration of a safe delivery. Others are equally ceremonial, as in the still continuing ritual dances that Strand photographed, but today we wear them as everyday adornment, for going to church and singing ourselves to the collection plate.

Perhaps the most notable art is the way some people dress and do their hair, though again, this marks continuity in change. The grooming of hair is an activity that is at once extremely personal and highly communal, and in Ghana you see it done everywhere from private parlors to out on the streets. Hair braiding forty years ago was an intimate communal activity, done in homes by family members, friends, and neighbors. Now it has become professionalized: small independent trades owned by women employing hundreds of mostly young women in small groups it is true, but professionalized nonetheless.

While on the subject of hair, striking also are the displays of one of the fastest-growing and intriguing forms of popular or folk-art, the wonderful hand-painted displays on shop fronts advertising the nature of the establishment and the wares or services provided. Some are merely functional, but others are truly feasts of creativity and adventure. The field

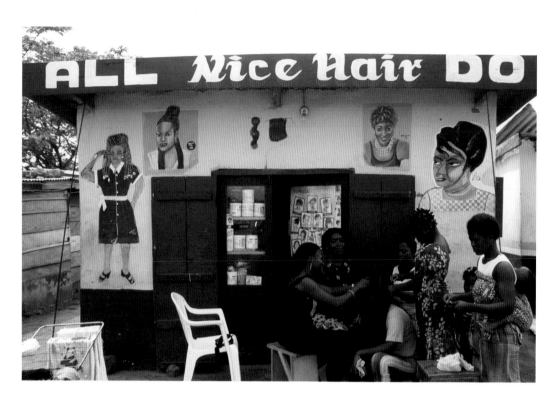

All Nice Hair Do.
Kpando, 2006,
Charter Weeks.

seems to have been captured by the barbers, with those in herbal medicines giving them a close run for second. The barbershop signs seem very inspired by Black American popular culture, with lookalikes of a range of U.S. cultural icons from boxers, musicians, and rap singers donning elaborate "natural" haircuts and the near-shaved, macho street look to the sleekly groomed chemically "relaxed" styles of leading men and sophisticated lounge lizards. It doesn't seem to matter that all this has the air of inspiring a sense of ideal, rather than anything actually wearable.

The proliferation of advertising today is not only of this home-grown variety. Also evident everywhere are the signs of Ghana becoming an integral part of the global marketplace. Advertisements for a whole range of goods appear everywhere, and Africa-directed versions of commercials are seen the world over. To advertisements traditional to Ghana, such as anything manufactured by Lever Brothers, who have

been in Ghana since the 1830s, and Cadburys, who have been in Ghana since 1908, have been added more recent billboards for such products as Coca-Cola, Guinness, and the wholesome Vita Malt, all of them appealing to desires cultivated by a consumer culture in pursuit of its vision of the ideal life.

Another sense of the ideal, in death as well as well as in life, is on display along these streets. Ghanaians often joke that funerals seem to be our only growth industry. As a culture, people of all ethnic groups have elaborate funerary rituals and one of the out-growths of this is an art form that has captured the imagination of the international art market, that of the specialty coffin. This art form has grown up around the ancient fishing villages of Teshie-Nungua and absorbed into the coastal capital city, Accra, in the same way as you find old traditions of funerary art clustered around Elmina, farther west along the coast. Imagine, for example, a wooden sculpture

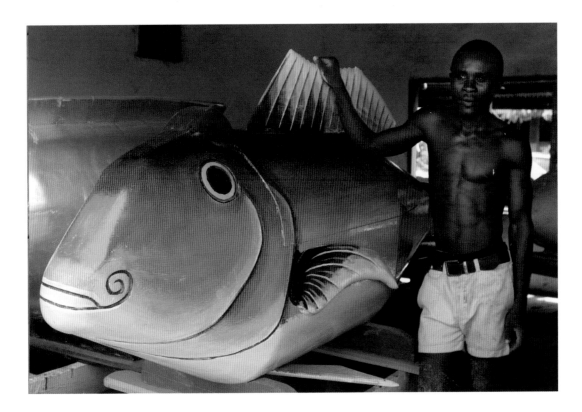

Casket maker with fish casket. Teshie, 2005, Peter Randall.

resembling an idealized, larger-than-life lion, complete with elaborately painted mane and sculptured tufts of hair, that can open up to receive a corpse. A handful of artisans have created a whole new art to satisfy different dreams, like the machine-shaped coffin that triggered Mother's meditation on embroidery. For example, if you are a warrior chief, you can come and claim that lion. Market women who have made their wealth in peppers can be laid to rest in a bright red chili. Or you can, indeed, let your final resting place reflect your dreams, whether or not they ever materialized. A car enthusiast who in life could afford only old bangers can be laid to rest in a Mercedes-Benz coffin. We have gone from fishermen being buried in their canoes to being buried in coffins made in the shape of canoes or, better yet, of a fish.

Ghanaians express artistry in all manner of ways and display their talents anywhere they can. There are functional objects, such as cane chairs, but also elabo-

rate wrought iron gates, some of spectacular and intricate design, others stark in their simplicity, lining the roadway, opening doors to dream homes that have not yet been built. And there is the abundance of art created for tourists to carry away with them, some of it truly excellent, some of it crude, all of it growing in volume by the day. From the regional variety of basketwork to the precision carving of drums, the craftspeople wait in hopeful attention for that right buyer to carry them away to transform their homes elsewhere. And there is also a growing appreciation of contemporary fine art, attested to by the portrait of one of Ghana's most distinguished painters, Ablade Glover, who decades ago created the Artists Alliance as a collective and established a gallery to display and sell the finest work of the fifteen or so Ghanaian artists comprising the group. It is one of the distinguishing features of this gallery, and of Glover's, that many of these artists are not simply his

friends, but also former students, many of them now not only practicing artists, but also teachers training a new generation of artists out of the University of Science and Technology in Kumasi, where Glover himself taught for nearly thirty years.

CONTINUITIES AND TRANSFORMATIONS

Other professions have developed along with that of fine artist. Ghana has had a cadre of lawyers for a long time, the roll of names beginning in 1877 with a class of ten. That list itself makes interesting reading, resonating as it does with names that have shaped the history of contemporary Ghana, such as John Mensah Sarbah, 1887, the inspiration for Achimota College, and J. E. Casely Hayford, the early Pan-Africanist lawyer and politician, 1897. Family names repeat themselves frequently, and in addition to a member of the Bannerman family in every decade since 1877, we can find father-and-son teams such as Edward Akufo-Addo, class of 1941, who was to become chief justice in 1966, and ceremonial president in 1970, and his son Addo Dankwa Akufo-Addo, class of 1975, former attorney general and present minister for foreign affairs. Similarly, the first woman called to the bar in Ghana, Essi Matilda Forster, class of 1947, followed in the footsteps of her distinguished father, George James Christian, class of 1902, a member of the pre-independence national assembly between 1922 and 1940. Mrs. Annie Jiagge (née Baeta), class of 1950, became the first woman to sit on the Supreme Court bench, in 1970, predating Sandra Day O'Connor of the United States by a decade. The list goes on, and includes names of party secretaries; B. J. da Rocha, part of the twenty-five-member-strong independence class of 1957, who in 1969 was general secretary of the ruling Progress Party; presidents: J. A. Kuffuor, class of 1962, elected president of the republic in

2000; and chiefs: Jacob Matthew Poku, also of the class of 1962, enstooled as Asantehene Nana Opoku Ware II in 1970. Thus, the present Chief Justice George Kingsley Acquah, class of 1972, has a long professional pedigree behind him in Ghana.

Other professions have much shorter pedigrees. Though by the 1970s the number of lawyers entering each year had reached more than sixty, there were no Ghanaian dentists and only a handful of Ghanaian doctors in the 1950s, despite a highly literate population. Ghanaian doctors have been active since the early years of the twentieth century, forming their first union to address the discriminatory practices against African medical officers in government service in 1933. They inaugurated a Ghana branch of the British Medical Association in 1953, which merged with the union in 1958, after independence, to form the Ghana Medical Association. Despite a roll call of names as distinguished as those of the lawyers, entry into the scientific professions has been more difficult. Medical schools in Ghana have been graduating approximately fifty doctors a year since 1993, for a little over two thousand doctors; however, today the medical profession faces a severe challenge as trained doctors and nurses leave the country, at an estimated 40 percent annually, per year, to find places to work where they can hone their hard-won skills under more sympathetic working conditions.

Technology has proved far more accessible than the hard sciences. For example, the Ghana Institute of Management and Public Administration (GIMPA) is at the forefront of information technology transfer to a new generation. What goes on in those classrooms is exemplified on the streets in the plethora of stores catering to a technologically-driven generation who need everything from hardwiring to colored covers for their sophisticated cell phones, and this in a place where two short decades ago the telephone

directory for the entire country was smaller than the directory of faculty and staff at a large university in the United States. Private universities have also come to play their part alongside the various branches of Universities of Ghana to continue to deliver education in a world where supplies for a quality education have become increasingly scarce—at all levels from primary to tertiary. The signs of both the difficulty and change abound and clarify themselves in these pages, which give us photographs of schools so scantily supplied they could have been taken in those same conditions fifty years ago, juxtaposed with the sleek and well maintained computer laboratories accessible to others, especially in urban areas.

Hard-pressed though they are, many doctors and health workers stay, and the changes in the practices of medicine, and the desperate need for those changes, are most visibly striking. There was no AIDS in 1957; today youths have never known a world without it and the streets of every city across the globe abound with signs to educate a population on how to fight it. Public references to such intimate practices would not have been countenanced a generation ago. Less catastrophic on a global scale are childhood diseases, but they are still with us, and dedicated health care workers in villages all over the country still hold clinics in community centers, schools, or wherever else they can serve their population. Midwives, who still practice here, weigh babies in old fashioned slings and doctors dispense new drugs that reflect the changing direction of their profession.

There has been much change all over the country, in both rural and urban communities and the roads that link them. Another observation made by my mother was of the size of the tires on sale for use by long-distance lorries. In the early 1960s, there was no vehicular traffic that took such large gauge tires because there were no motorways to service

them. The Accra-Tema motorway was one of the first projects of the post-independence era; as a consequence the roads are bigger, brasher, wider now, supporting eighteen-wheel lorries with huge-gauge tires. Today, with an eye to the tourist trade, we celebrate Tema, situated on Greenwich Mean and as close to the equator as you can be and still remain on land, as the city at the center of the earth. The enlarged harbor is also there, with all the verve and industry and tonnage of commercial goods that it represents in our modernizing industrial and consumer-driven world.

In the rural areas, where once cocoa dominated, the challenge mounted by other crops for both export and domestic consumption is clear. Palm nuts are still seen everywhere, and though corn has always been prevalent, today so is sorghum, whose increased production since the 1980s is now as marked as the deforestation of the places in which it grows. The timber industry has always been of importance to Ghana, and the exploitation of her woods—especially her luxury hardwoods—is having a dramatic effect, positive and negative, on the economy, interior design, and landscape.

Landscapes change. Though the anthills may grow impervious to human interference, the spectacular and varied geography of the different parts of Ghana have clearly been affected by earthly time and human circumstances. In 1964, Strand photographed the scars in the earth that signaled the beginning of the construction of the Akosombo Dam. Today it has been in use for over forty years, and we now see the beauty of the lake and forget the drowned villages beneath it. The worry human beings cause the environment has become even more acute than the issues raised when the dam was yet to be built, especially up the coast, as the encroaching waters of the Keta Lagoon threaten whole communities not only with

disease, but with total destruction as well. An increasingly active and mobilized environmental movement has seen to the creation of Kakum Forest Reserve and the Mole National Park. These beg the question of how quickly and decisively we may be able or prepared to act to preserve an environment when it has nothing to offer tourism and its only appeal is the preservation of the ecosystem for its own sake and for the survival of the planet. We have made a start, but if we do not face this question fully, few places will retain the serenity of the waters of Lake Bosomtwi.

Surprisingly, what these photographs also record is a subtle demarcation of gender roles in labor; roles that are changing slowly, but steadily. When we see women working, they are still performing service labor, for their families or their firms, and they still predominate in certain crafts; women still fetch firewood, wash clothes, make pots, sell cloth, and collect water. Although we also see women in egg factories, working with plywood, and operating printing presses, what these pictures reflect most dramatically is the impact of industrializations since the 1960s on the lives of men; we see them in camaraderie in factories, or on the docks of the harbor; they butcher but do not cook the meat; they tan hides and apprentice their sons in trades; they sell tires, drive taxis, and buy their dreams through lottery tickets. For those who have lost their dreams, with or without boots they break stone. And buildings, from the high-rises of central Accra to the shells of incomplete houses that litter the landscape, speak to the need to at least reach for, if not always find, a home.

The search for physical homes is reflected in the acute quest for spiritual homes that these portraits reveal; in Ghana as all over the world there has been an increase in faith-based movements from the fundamentalist to the charismatic, of all persuasions and faiths. Whether they are established churches under-going revivals or less structured sects under a charismatic leader, churches and mosques proliferate, with growing congregations who give generously, often tithing regardless of income. But in the end, in Ghana as elsewhere, the hopes of the nation are vested in her children, and portraits of them abound.

These portraits are unsentimental in that they capture the range from poverty to comfort, from still and solitary contemplation to action in concert. We see children in schoolrooms, or out helping adults with their work, we see children playing with and around wheels, boys playing in the dirt dreaming of kicking a football in the Africa Cup stadium and little girls hiding behind their mothers' skirts. These children are doing what children do everywhere, going about the business of living, confident about tomorrow.

Abena P. A. Busia is Associate Professor, Department of Literatures in English, and Women's and Gender Studies, at Rutgers, The State University of New Jersey, where she has taught since 1981. Born in Accra, she spent the first years of her childhood at home, as well as in Holland and Mexico, before her family finally settled in Oxford, England, where she read for a B.A. in English Language and Literature at St. Anne's College, and a D.Phil in Social Anthropology at St. Antony's College.

She is co-editor, with Stanlie James, of *Theorizing Black Feminisms: The Visionary Pragmatism of Black Women,* and of *Beyond Survival: African Literature & the Search for New Life.* She is also coordinating, with Tuzyline Jita Allan, and Florence Howe of the Feminist Press, *Women Writing Africa,* a multi-volume continent wide publishing project of cultural reconstruction. Her volume of poems, *Testimonies of Exile,* was published in 1990.

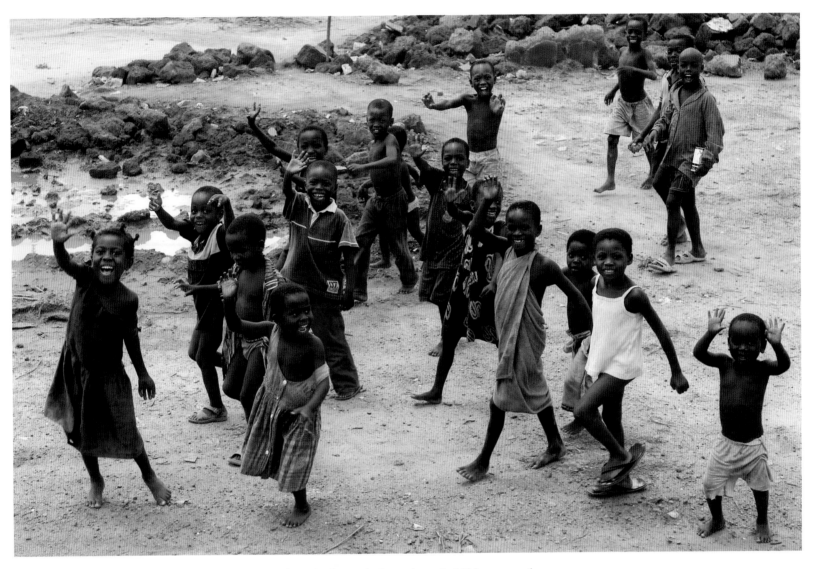

The winds and the voice of children at play
Will join the songs of birds

from DUSK
Adali-Mortty

Saying goodbye in Essueshyai, Ghana, 2006, Tim Gaudreau.

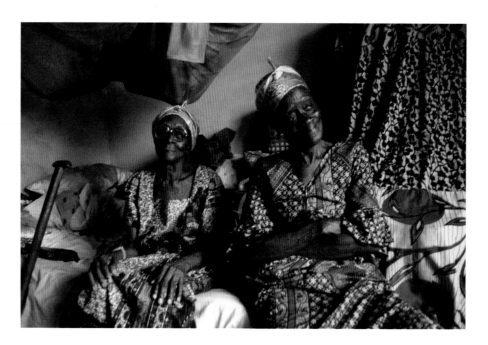

Pokuase, 2006, Charter Weeks.

THE BRINK OF ANOTHER DAY

Now, we are old!
We too once climbed the rising slope
With eager youthful feet.
Now, stand we upon the hill's crest.
Here, we take our place
At the brink of another day.

We sowed the grain; we reaped.
The grain, ungathered, which grain-eating birds
Have spared, together with roots we left
Unhoed, will sprout their good and bad to bless
And curse the later tillers of the land.

Those youthful feet, so light,
Take up our place below in the bowl;
And up, and up they come,
So light of feet,
To take our place at the brink!

Old suns set;
New suns rise
On the mountain top,
As always suns have done,
And always suns will do,
Till fizzle time
When all is spent
And all disintegrate
Like glass on impact
Into crystal bits;
Or else erupt—
Volcanic lava flowing without a bed!

Tell them who climb the slope,
We saw the first suns rise,
The first suns set!

Our voices flow with the waters
Down in the bowl below
Where young feet take our place.

Adali-Mortty

Notes for a Diary of the Republic: A Time-Line

by Abena P. A. Busia

1957-1960: Fledgling Nation

6 March 1957 Ghana is the first of the British colonies in sub-Saharan Africa to gain independence with Dr. Kwame Nkrumah of the Convention People's Party (CPP 72) as Prime Minister and Prof. Kofi Abrefa Busia as leader of the United Party (UP 37) opposition. The Independence celebrations are attended by delegates of seventy-two countries, including HRH The Duchess of Kent and the Right Honorable R.A. Butler, Lord Privy Seal, representing Her majesty the Queen and her government, and Vice President Richard M. Nixon Representing the United States of America, and such dignitaries as Dr. Ralph Bunche representing the United Nations. Ghana has a population of approximately five million, with about 250,000 in Accra. A predominantly rural country, Ghana is the leading cocoa exporter in the world and produces one tenth of the world's gold.

1958 Ghana Airways and Black Star Shipping Line established.

April 1958 Nkrumah convenes a conference of the existing independent African states: Ghana, Egypt, Sudan, Libya, Tunisia, Ethiopia, Morocco, and Liberia.

July 1958 The Preventive Detention Act makes it possible to arrest anyone suspected of working against the state and imprison them up to five years without trial or sentence. Over the next few years most of the opposition fall victim to its use. The protection clauses of the constitution are repealed and regional assemblies abolished.

December 1958 An All-African Peoples Conference is held in Accra, the first Pan-African conference to be held on African soil.

December 1958 Presidents Sekou Toure of Guinea and Nkrumah of Ghana form the Ghana-Guinea Union.

July 1959 Prof. K.A. Busia, leader of the opposition goes into exile. Most of the other leading members of his party are by now in prison, in exile, or dead.

27 April 1960 Nkrumah defeats United Party candidate in presidential elections. Dr. J.B. Danquah, a doyen of Ghana's pre-Independence politics and one of the "Big Six," arrested in 1948 by the British alongside Nkrumah in the struggle for Independence.

1960-1966: The First Republic

1 July 1960: Nkrumah declares Ghana a Republic by plebiscite with himself as its first president. Nkrumah's early years are marked by an industrial push. The Accra-Tema Motorway and the development of Tema harbor have a marked impact on the increase of trade. Large-scale development projects such as the building of the Akosombo Dam to supply the energy needs of the country and the region draw the attention of the world. The contrast between the magnificence of the dam, and the detrimental terms Nkrumah accepted in order to build it, makes it the signature symbol of the very best and the worst of Nkrumah's economic vision.

1961 University of Ghana and Kwame Nkrumah University of Science and technology become autonomous degree awarding universities.

1961 Ghana-Guinea union extended to include Mali under President Modibo Keita.

1961 Danquah is arrested under the Preventive Detention Act

March 1961 President Nkrumah welcomed at the White House by President John F. Kennedy of the United States.

July 1961 The austerity budget to pay for the large industrialization projects begins to cause unrest amongst various groups in the country.

November 1961 HRH Queen Elizabeth II visits Ghana.

6 March 1962 At the fifth anniversary of independence, Ghana is a republic with Dr. Kwame Nkrumah as president.

1962 University College of Cape Coast established.

August 1962 The increasing unrest in the country is signaled by assassination attempt when a bomb is planted at a secondary school in Kulungugu in the Northern Region of Ghana. Nkrumah, returning from the Upper Volta (now Burkina Faso) where he had been negotiating terms to do with the construction of the Akosombo dam, is unharmed, but a child is killed and many injured. The accused are all prominent CPP members and include Ako Adjei, then Minister for Foreign Affairs and one of Nkrumah's 1948 "Big Six" comrades.

25 May 1963 The Organization of African Unity (OAU) is formed at a conference of the independent African states, now numbering 32, organized by Nkrumah in Addis Ababa.

1963 American photographer Paul Strand arrives to take photographs for a portrait of Ghana.

31 January 1964 Nkrumah suspends the constitution, declaring Ghana a one-party state with himself as life president.

1964 Dr. J.B. Danquah is arrested under the Preventive Detention Act for a second time.

1964 Work begins on the Akosombo Dam.

1964: Supreme Court judges including Chief Justice Sir Arku-Korsah and Justice Edward Akufo-Addo, another of "The Big Six," dismissed by Nkrumah for acquitting Ako Adjei and some of the others accused in the Kulungugu bomb trials. Those vindicated were subsequently

convicted at a second trial presided over by a re-constituted court under Justice Julius Sarkodie-Addo with jury hand-picked by Nkrumah.

1965 Nkrumah and the members of his CPP government re-elected unopposed in single party elections.

February 1965 J.B. Danquah dies in Ussher Fort, a maximum security prison, where he had been held without charge or trial since the previous year.

23 January 1966 Nkrumah inaugurates the Akosombo Dam.

1966-1969: Interregnum- The NLC

24 February 1966: Nkrumah and his CPP government are overthrown in a bloodless military coup while on a peace mission to Hanoi. The coup is led by young officers Colonel Emmanuel K. Kotoka and Major Akwasi A. Afrifa who hand over power to the National Liberation Council under the chairmanship of General Ankrah.

2 March 1966: Nkrumah is welcomed by Sekou Toure of Guinea who grants him an honorable asylum and makes him co-president.

1966 Prof. K.A. Busia, leader of the opposition in exile for seven years returns home to a hero's welcome.

1966: Mr. Justice Edward Akufo Addo is restored to the bench and appointed chief justice and chairman of the new Constituent Assembly.

1966: Busia is appointed chair of the Center for Civic Education and a member of the Constituent Assembly.

6 March 1967: At the tenth anniversary of Independence, Ghana is under military rule, with General Ankrah as Chairman of the National Liberation Council

April 1967 Lieutenant General Kotoka, one of the leaders of the coup against Nkrumah is killed in an attempted counter coup led by Lieutenants S.B. Arthur and Yeboah, both of whom are court martialed and executed.

2 March 1969: General Ankrah is replaced by Brigadier Akwasi Afrifa as Chair of the NLC and the constitution of the Second Republic is introduced.

May 1969: The ban on political parties is lifted and the date set for elections.

29 August 1969 Multi-party elections are held and, after a landslide victory (105 out of 140 seats), a new civilian government is formed by Dr. Busia as leader of the victorious Progress Party, and K.A. Gbedemah of the National Alliance of Liberals, a former Cabinet Minister in the First Republic as Leader of the Opposition (29)

1969-1972: The Second Republic

1 October 1969 Busia is sworn in as prime minister by the Three-Man Presidential Commission headed by Brigadier A.A. Afrifa. The Progress Party government inherits a huge national debt exacerbated by the precipitous fall in the price of cocoa. Despite this the government embarks on an ambitious development program anchored on its "Rural Development" plans. These programs to revolutionize agriculture and raise the income and standards of living of farming communities to equal those of city dwellers, involve providing a range of services from feeder roads and good drinking water to improved education and health programs and services. In addition the government implements a series of programs meant to support the establishment and growth of Ghanaian owned businesses in the private sector, all programs that demanded tough economic planning.

January 1970 Edward Akufo-Addo is elected Ceremonial President by National Assembly.

1971 The Mole Game Reserve becomes a National Park as part of a comprehensive plan to study the ecological systems of the country and to reserve and preserve its wildlife, flora, and fauna.

1972-1979: Interregnum- The NRC/SMC

13 January, 1972 Busia's Progress Party government is ousted in a military coup, whilst he is abroad following the Commonwealth Prime Ministers' meeting. Col. I.K. Acheampong, chair of the National Redemption Council gives the December 1971 devaluation of the cedi and the harsh economic recovery measures undertaken by the PP as the rationale for the coup.

March 1972 At the fifteenth anniversary of independence Ghana is under military rule with General Ignatius Kutu Acheampong as Chairman of the National Redemption Council.

27 April 1972 President Nkrumah dies in exile in a hospital in Bucharest Romania.

14 May 1972 Nkrumah's body is returned to Guinea for burial.

7 July 1972 Nkrumah's body is subsequently returned to Ghana for burial in his home town of Nkroful.

1974: The population shows its dissatisfaction with the government through strikes organized by student protest groups and union workers reacting to the increasingly hard and unstable economic conditions.

1975. Acheampong disbands his own government and replaces it with a Supreme Military Council of only seven hand-picked members (SMC I).

1976 Acheampong introduces the idea of Union Government ("Unigov") or government by a union of army, police, and civilians that is firmly resisted by the population.

1976 *Ghana, An African Portrait*, published with photogaphs by Paul Strand and an essay by Basil Davidson.

6 March 1977 At the twentieth anniversary of independence Ghana is under military rule with Acheampong as chairman of the supreme military council.

1977 Acheampong tries to impose a re-vamped "UniGov" solution to the economic upheavals and political unrest in the country.

1978 The People's Movement for Freedom and Justice is formed and, insisting on a return to a democratically elected government and the rule of law, becomes the focal point of resistance to Acheampong's plans. Amongst the founding members are Prof. A. Adu Boahen, the distinguished historian and Nana Addo Dankwa Akufo-Addo, lawyer and son of President Edward Akufo-Addo, and General Akwasi Amankwa Afrifa also a former head of state.

July 1978: Acheampong is forced to resign as General William Akuffo takes control of the "Supreme Military Council II" and promises to set the date for elections the following year.

28 August 1978: Busia, exiled prime minister of the Second Republic, dies in a hospital in Oxford, England.

October 1978 Busia's body is returned for a state funeral in Accra before burial in his home town of Wenchi.

December 1978 A new constituent assembly inaugurated.

June-September 1979: Interregnum- The AFRC

January 1979 Ban on political parties lifted.

May 1979 Third republican constitution promulgated introducing a separation between parliament as a legislative assembly and the executive president.

15 May 1979 Flight Lieutenant Jerry John Rawlings heads a military insurrection that leads to his arrest and trial.

4 June 1979: Members of the Armed Forces Revolutionary Council (AFRC) rescue Rawlings and make him chairman. He spearheads a "revolution" in which several hundred government officials and ordinary people, petty traders, property owners, and businessmen in particular are harassed, victimized, and sent to prison in what was called a "house cleaning" exercise. Many are killed in arguably the first bloody change of regime in the country's history.

16 June 1979 General Acheampong and Major General Utuka are discovered in their hiding places and arrested, summarily tried, and executed.

18 June 1979: The AFRC maintains the erstwhile SMC II timetable to return the country to civilian rule and permits the presidential and multi-party parliamentary elections. Dr. Hilla Limann's People's National Party wins the National Assembly with a one seat margin gaining 71 of the 140 seats in parliament; the presidential elections are inconclusive.

26 June 1979: Former Head of State General Akuffo, along with prominent members of the SMC, Air-Vice Marshall Boakye, Major-General Robert Kotei, Rear-Admiral Joy Amedume, and Colonel Roger Felli are summarily executed without due process. Executed with them is General Afrifa, one of the two officers who led the coup against Nkrumah, and a head of state in the early months of the Second Republic.

9 July 1979 Limann wins the presidential elections on the second round.

17 July 1979 H.E. Justice Edward Akufo-Addo, president of the Second Republic dies in Accra, is given a state funeral and buried in his home town of Akropong-Akwapim.

1979-1981: The Third Republic

25 September 1979: Limann becomes president of the Third Republic. Rawlings and the AFRC soldiers return to barracks. In handing over power to Limann, the AFRC warned him to rise to the task and among other things continue their "house cleaning" exercise to the letter, otherwise they would return. Their restless presence presents a threat to an administration faced with severe economic stagnation and weakened civil society structures.

1981-1992: Interregnum- The PNDC

31 December 1981: The government of Limann is overthrown in a military coup. Parliament is dissolved and all political parties banned. Rawlings returns to high office as chairman of the Provisional National Defense Council (PNDC).

6 March 1982: At the twenty-fifth anniversary of independence Ghana is under military rule with Rawlings as chairman of the Peoples' National Defense Council.

30 June 1982. Judges Mr. Justice Fred Poku Sarkodee, Mrs. Justice Cecilia Koranteng Addow, and Mr. Justice Kwadwo Agyei-Agyepong, together with Major Sam Acquah (retd), are abducted, murdered, and their bodies burned at the Bundase Military Range.

1982 and 1983: Unsuccessful coup attempts are made by disgruntled army officers.

1985: The Preventive Custody Law allows the government to imprison opponents for the sake of "state security"; as a result the prisons are crowded with political prisoners.

6 March 1987: At the thirtieth anniversary of independence Ghana is under military rule with Rawlings as chairman of the Peoples' National Defense Council.

April 1987 Prof. Albert Adu-Boahen delivers his lecture, "The Ghanaian Sphinx-Reflections on the Contemporary History of Ghana" to the Ghana Academy of Arts and Sciences, challenging the basis for military intervention in political affairs. This lecture effectively names and breaks the "Culture of Silence" on the repressions

of the Rawlings regime and is credited with precipitating the moves towards the restoration of democratic rule.

March 1991 National Commission on Democracy recommends the establishment of a consultative assembly to draft a new constitution.

6 March 1992 At the thirty-fifth anniversary of independence Ghana is under military rule with Rawlings as chairman of the Provisional National Defense Council, and the longest serving ruler since Independence.

May 1992 A new Fourth Republican democratic constitution is promulgated, political parties come alive again, and political prisoners are released. A vibrant free press begins again, and human rights organizations emerge.

November 1992 General Ankrah of the NLC, the only surviving former military head of state, dies at home in his sleep at the age of 77.

November 1992 Presidential and multi-party parliamentary elections for the first time since 1979. Amidst much controversy Rawlings is declared winner of the presidential elections by the Electoral Commissioner, defeating opposition candidate, Prof. A. Adu Boahen of the New Patriotic Party. In protest the opposition boycotts the parliamentary elections with the result that Rawlings' National Democratic Congress and its smaller coalition partners have complete control of parliament.

1993-Present: The Fourth Republic

1993-1996 The First Parliament of the Fourth Republic
Rawlings, President; Majority National Democratic Congress (NDC 189) NDC Allies 9 Independents 2. The government embarks upon a vigorous IMF and World Bank directed structural adjustment program.

May 1995 The Alliance for Change, headed by a group of concerned citizens of different political persuasion including Nana Akufo-Addo, is formed to organize the "kumepreko" ("kill me quick") anti-government demonstrations which take place in Accra and Kumasi, the largest public demonstrations since the demands for independence in the 1950s. Ostensibly organized around the implementation of VAT, they are a show of resistance to the Rawlings regime.

December 1996 In multi-party presidential and parliamentary elections Rawlings defeats opposition party candidate John Agyekum Kuffuor but with a reduced majority.

1997-2000 The Second Parliament of the Fourth Republic
Rawlings, President; The NDC wins 133 of the 200 seats and the New Patriotic Party becomes the leading opposition party with 60 seats.

6 March 1997: At the fortieth anniversary of independence Ghana under civilian rule with Rawlings of the National Defense Council as president.

23 January 1998: Limann, president of the Third Republic and the last and only surviving civilian head of state dies and is buried in his home town of Gwellu.

January 1999: Members of NDC break out and create the Reform Movement as a large opposition party, led by Goosie Tanoh.

August 1999: The government responds to student demonstrations with police brutality and the forced closure of the Universities.

December 2000: In the third multi-party presidential and parliamentary elections of the Fourth Republic, Rawlings is constitutionally prohibited from running for a third term and his Vice-President John Atta Mills is defeated by NPP candidate, John Agyekum Kufuor. Rawlings retires as Ghana's longest serving ruler since independence, whether as a military leader or an elected president and for the first time there has been a peaceful, democratic transition from one civilian administration to another through the ballot box.

2001-2004 The Third Parliament of the Fourth Republic
Kufuor, (NPP) President. The NPP holds 99 out of the 200 seats in parliament with the NDC the leading Opposition party, with 92 seats.

January 2002 One of the first acts of the new administration is the exhumation and identification of the remains of the officers and heads of state executed by Rawlings in June 1979. Their bodies are returned to their families for burial at the expense of the state.

6 March 2002 At the forty-fifth anniversary of independence Ghana is under civilian rule with Kufuor as president. For the first time since the presidency of Limann over twenty years earlier, the head of state of the Republic is a man unconnected with the military in any way.

May 2002: A reconciliation commission starts investigating human rights abuses during the many years of military rule.

December 2004 The fourth multi party presidential and parliamentary elections of the fourth republic. Incumbent president Kufuor wins a second term and the NPP is returned with an increased majority. The NDC remains the leading minority party.

2005-2007 Fourth Parliament of the Fourth Republic Kufuor (NPP) President, The NPP holds 128 out of the 230 seats in parliament with the NDC the leading opposition party, with 94 seats.

6 March 2007 At the fiftieth Anniversary of independence, Ghana is under civilian rule with Kufuor of the New Patriotic Party as president of the republic.

Ghana

AN AFRICAN PORTRAIT REVISITED

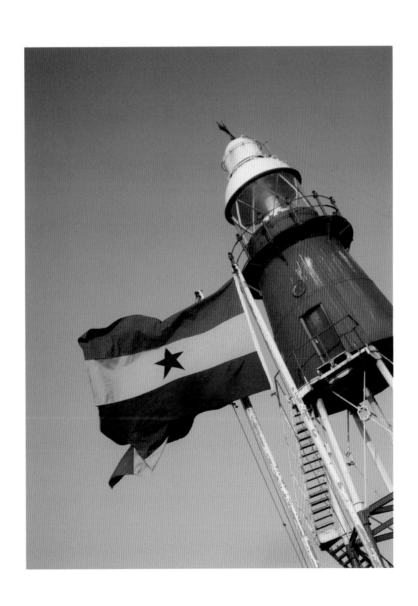

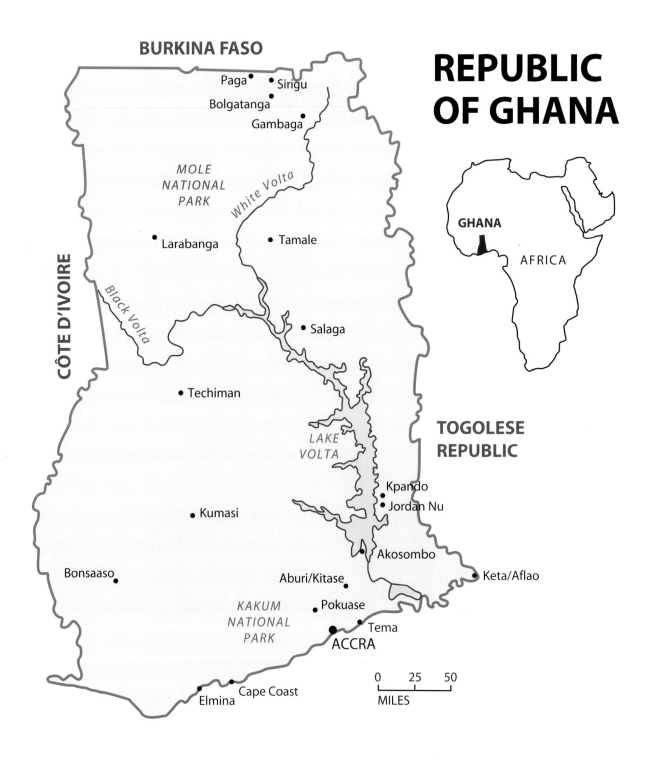

REPUBLIC OF GHANA

BURKINA FASO

Paga
Sirigu
Bolgatanga
Gambaga

CÔTE D'IVOIRE

MOLE NATIONAL PARK

White Volta

Larabanga

Tamale

Black Volta

Salaga

Techiman

LAKE VOLTA

TOGOLESE REPUBLIC

Kpando
Jordan Nu

Kumasi

Akosombo

Bonsaaso

Aburi/Kitase

Keta/Aflao

KAKUM NATIONAL PARK

Pokuase

Tema

ACCRA

0 25 50
MILES

Cape Coast

Elmina

GHANA

AFRICA

(Previous page) Ghana's only lighthouse. Keta, 2006, Peter Randall. (Opposite page) Modern high-rise buildings photographed from Zenith Bank: left to right, Cedi House; Standard Trust; new unnamed building; Valco Tower, headquarters of the aluminum company; and in the foreground is the National Theater. Accra, 2006. Peter Randall. Map by Grace Peirce.

2

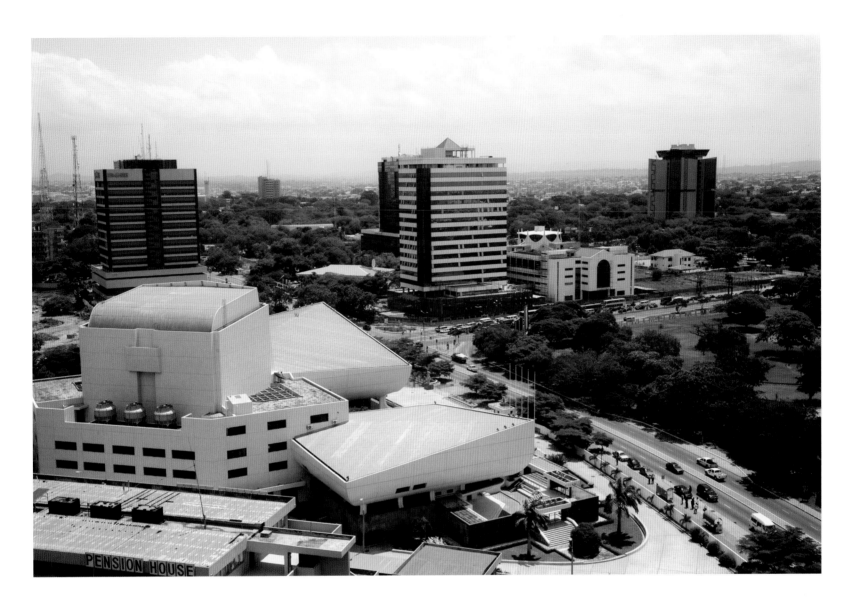

His feet grew wings;
But perched atop the tallest edifice of all
At last his heart misgave:
 Though high above the world
 No nearer was he to the stars;
Miles below him
 Life roared on
 And still there was great stir;

And men,
 Grown smaller now than mice,
Raced round, about their narrow business
 Among the debris
 Of a synthetic
 Unsympathetic world.

From DO NOT TELL ME, FRIEND
 Joe De Graft

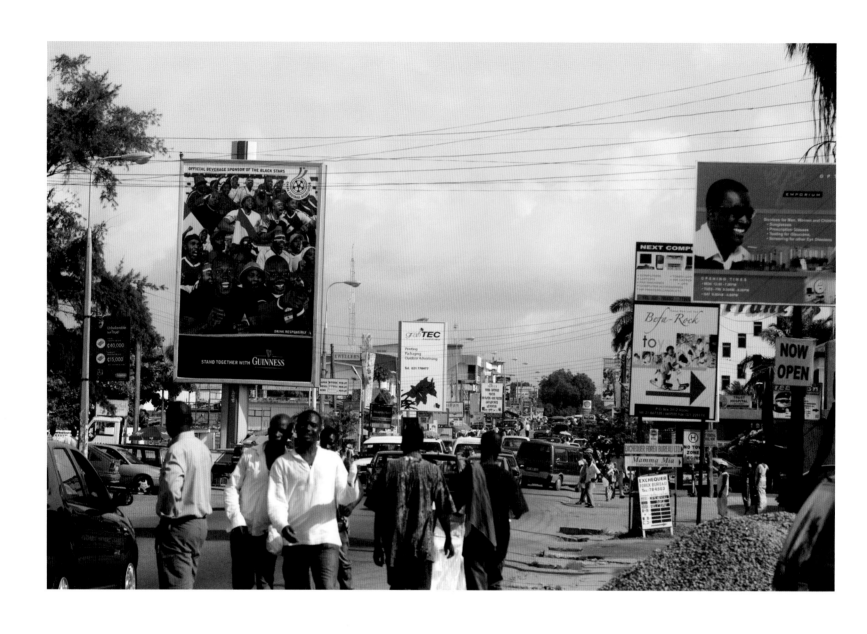

Downtown Osu. Accra, 2006, Nancy Grace Horton.

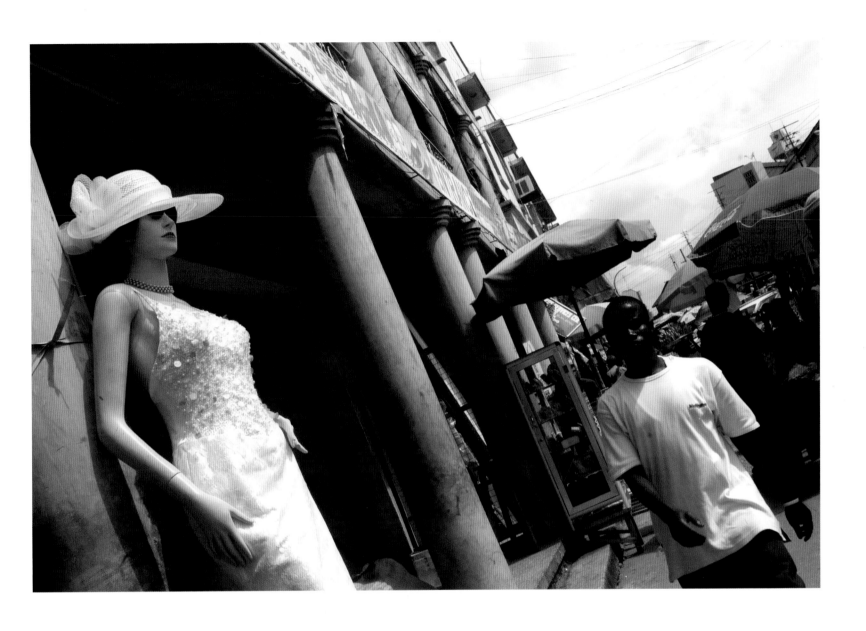

Street scene with mannequin. Kumasi, 2006, Nancy Grace Horton.

World Cup Soccer fever. Accra, 2006. Barbara Bickford.

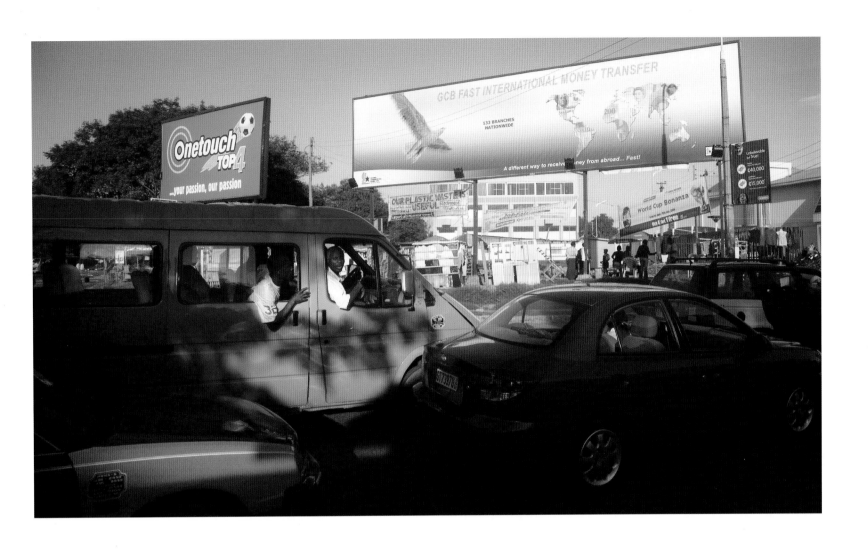

Tro-tros and signs at Danquah Circle, Osu. Accra, 2006, Peter Randall.

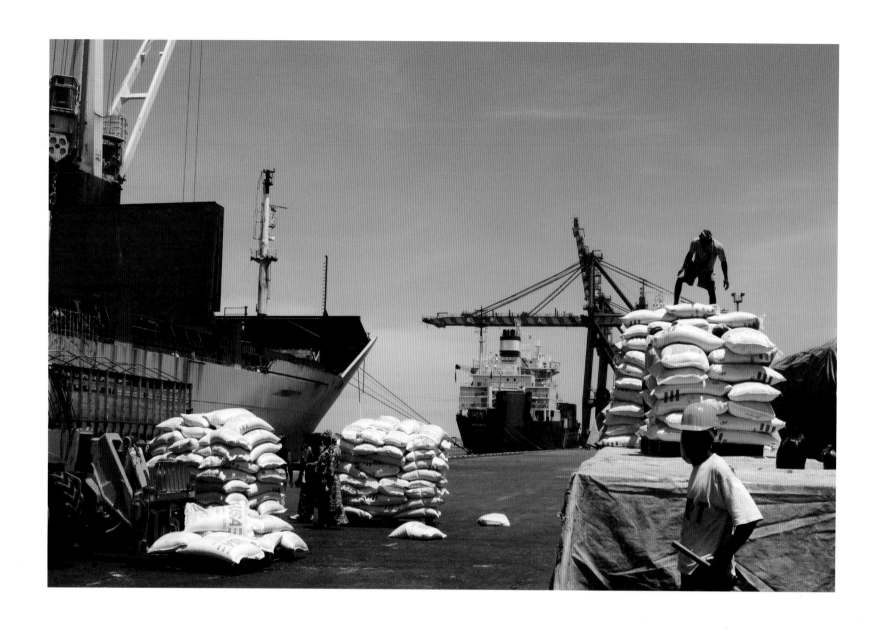

Unloading rice donated by the United States for transshipment to Burkina Faso. Tema, 2006, Nancy Grace Horton.

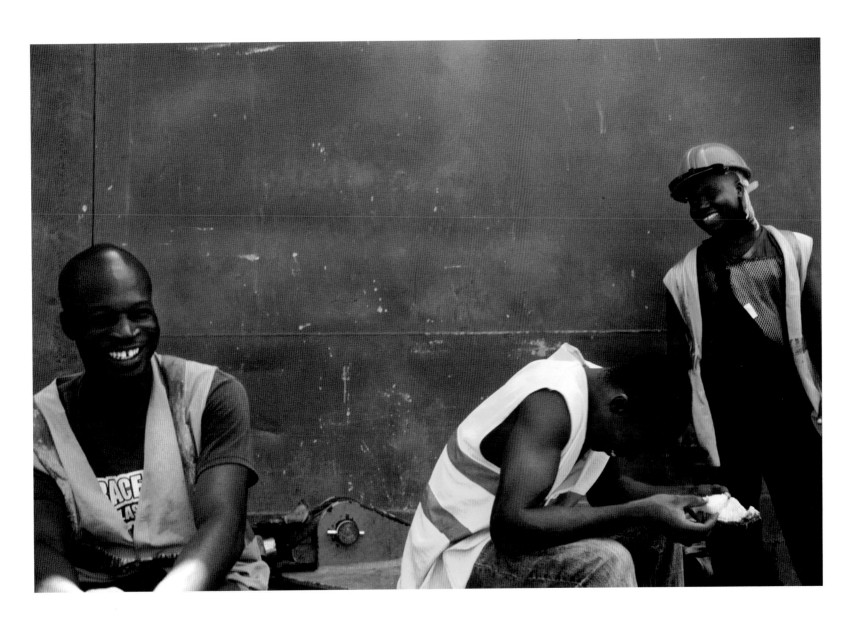

Port Workers. Tema, 2006, Charter Weeks.

Tug boat engineer. Tema, 2006, Gary Samson.

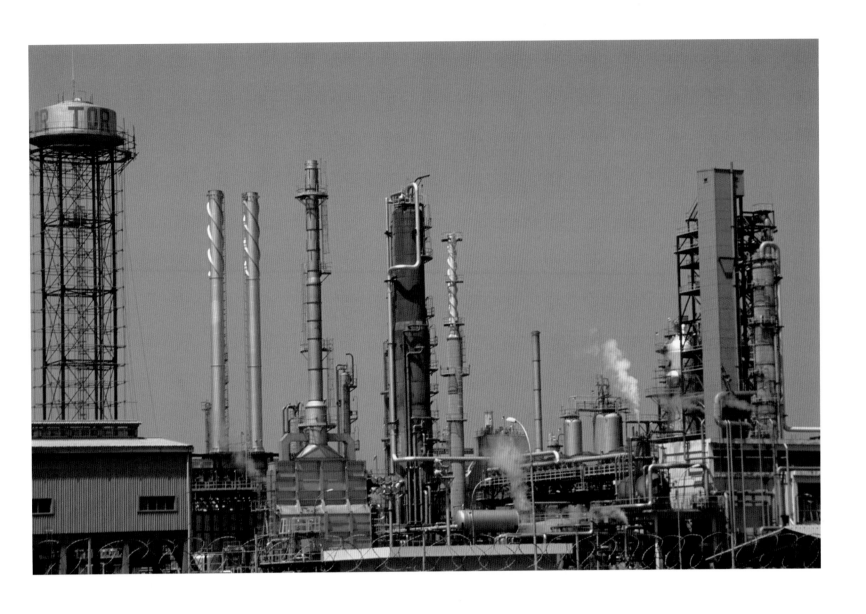

Refinery. Tema, 2006, Charter Weeks.

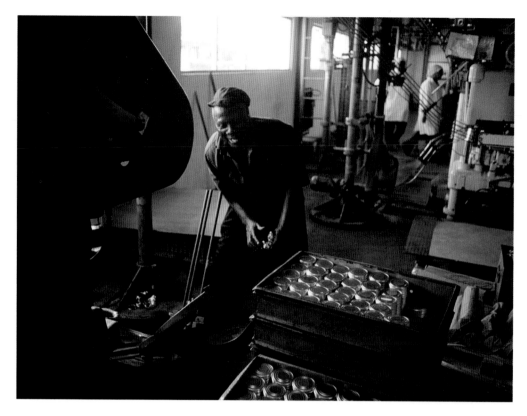

Now—
A ceaseless roar of machines,
 Metal gods
 That acknowledged not his presence
 But demanded endless service

From DO NOT TELL ME, FRIEND
 Joe De Graft

Nestlé can manufacturing.
Tema, 2006, Charter Weeks.

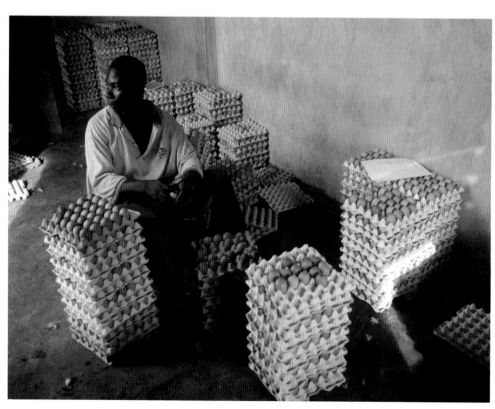

Grading eggs. Kumasi,
2006, Charter Weeks.

TIME
Kojo Gyinaye Kyei

Time
 an accomplice of waste
 is an image of expense
it is always spilling
 its angry hands
 wheeling
its consummate skill
 pounding
 like a drill on the brain
never to be stopped
 retrieved
 or
 replenished
forever whittling
 whittling
 whittling
 away
 away
 away
 away
away
all the vast stores
 of
 being!

Junk yard. Kumasi, 2006, Charter Weeks.

13

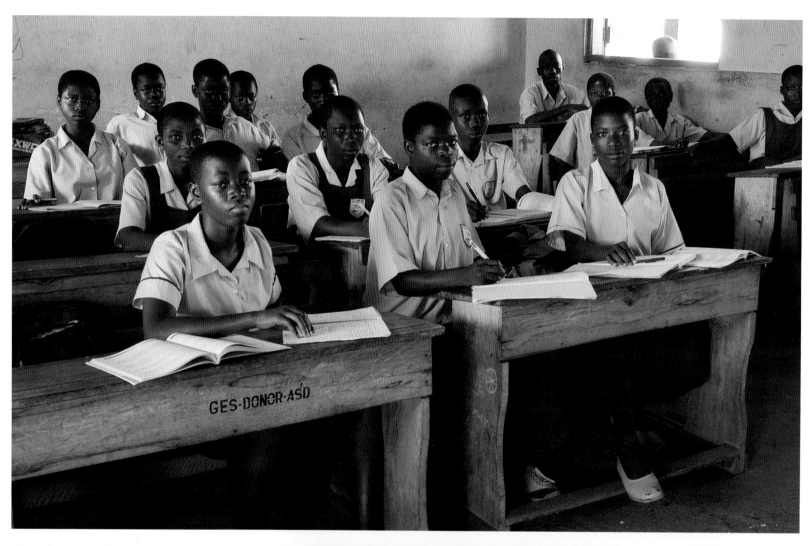

*Secondary school classroom,
Kitase, 2006, Gary Samson.*

*Miss Precious Evedume, Teacher,
Kitase/Aburi Junior Senior
Secondary School. Aburi, 2006, Gary
Samson.*

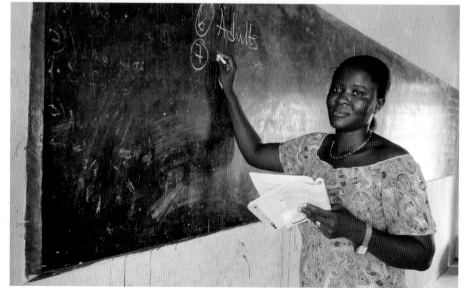

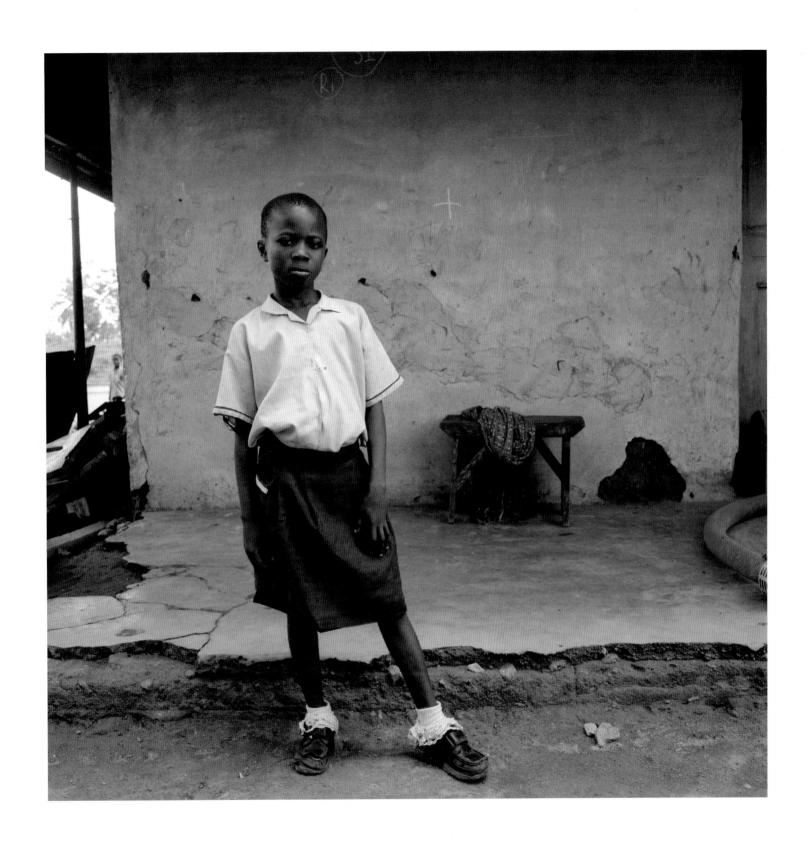

School child home for lunch. Ekumfi Abomtsen, 2006, Nancy Grace Horton.

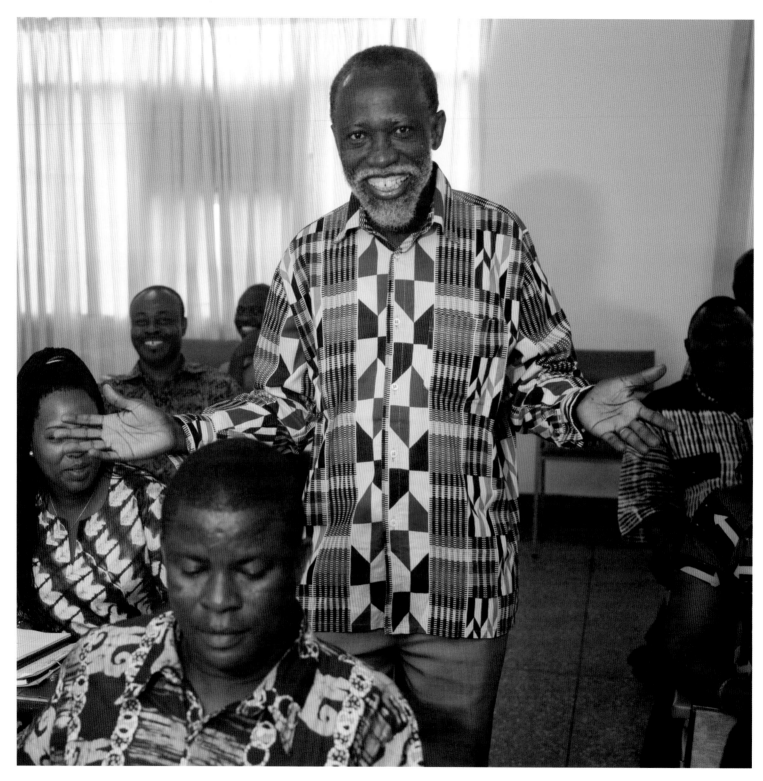

Professor Stephen Adei, Rector/Director-General, Ghana Institute of Management and Public Administration (GIMPA). This unique African institution has a goal to become the best management development institute in sub-Saharan Africa, known for quality program delivery in leadership, management, and administration. Accra, 2006. Peter Randall.

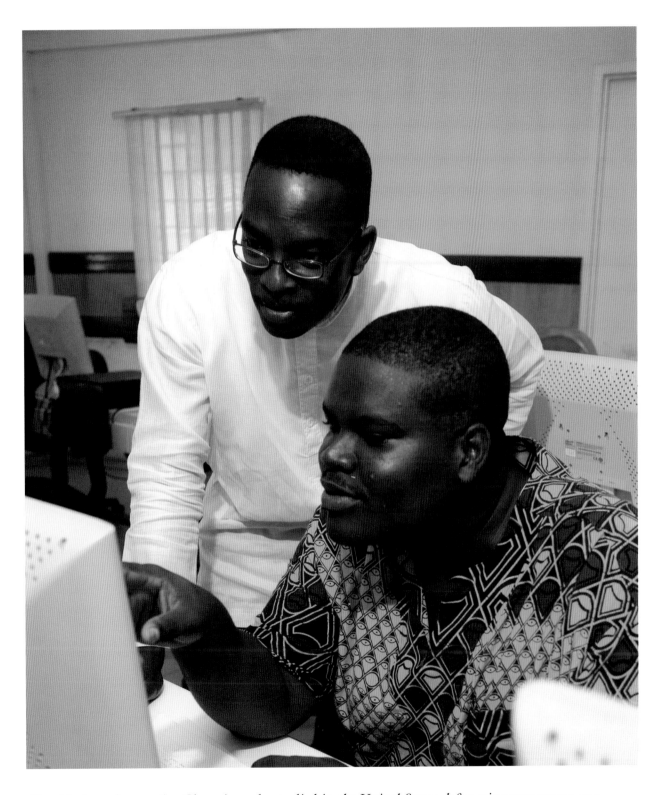

Patrick Awuah, a native Ghanaian who studied in the United States, left a nine-year career as a Microsoft manager and returned home to start Ashesi University, a four-year college that awards bachelor of science degrees in business administration and computer science. Accra, 2006, Peter Randall.

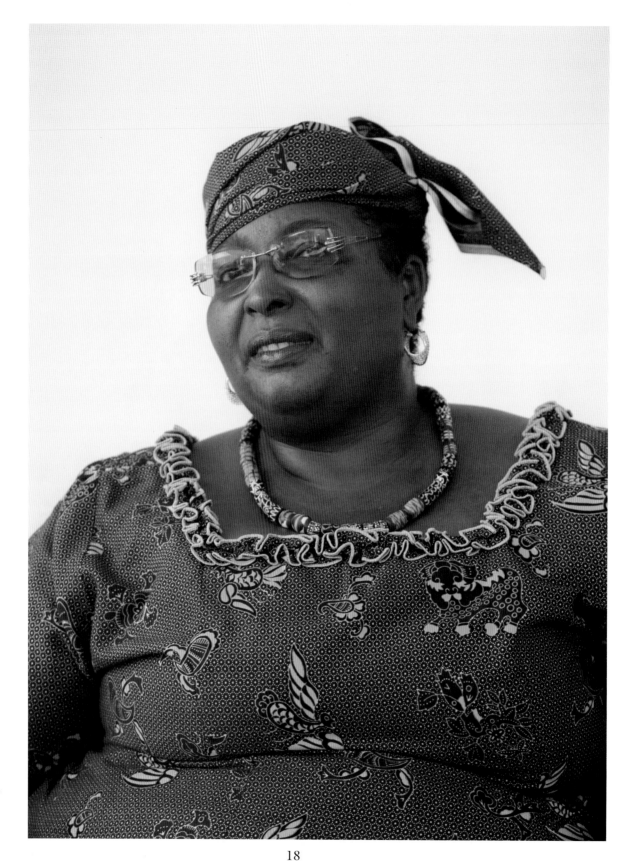

Esi Sutherland-Addy, Senior Research Fellow, Institute of African Studies, University of Ghana at Legon. Accra, 2006, Peter Randall.

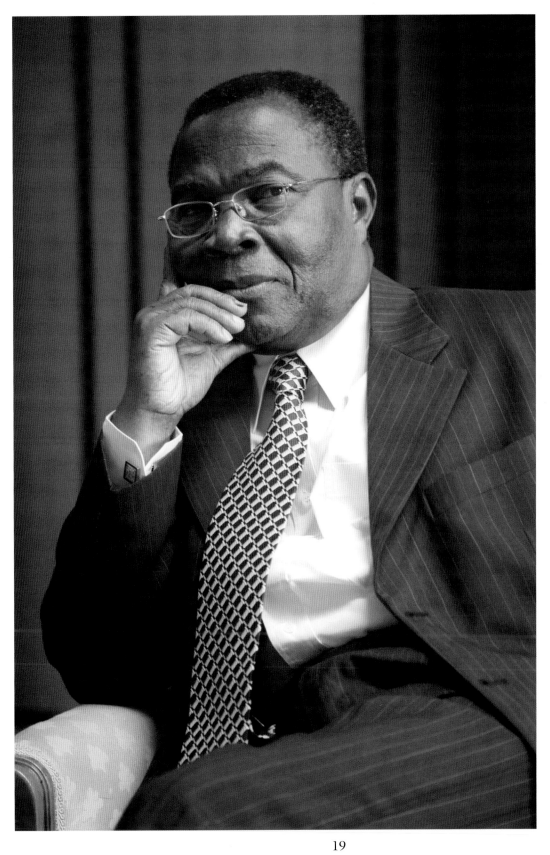

The Hon. G. K. Acquah,
Lord Chief Justice of the
Republic of Ghana. Accra,
2006, Peter Randall.

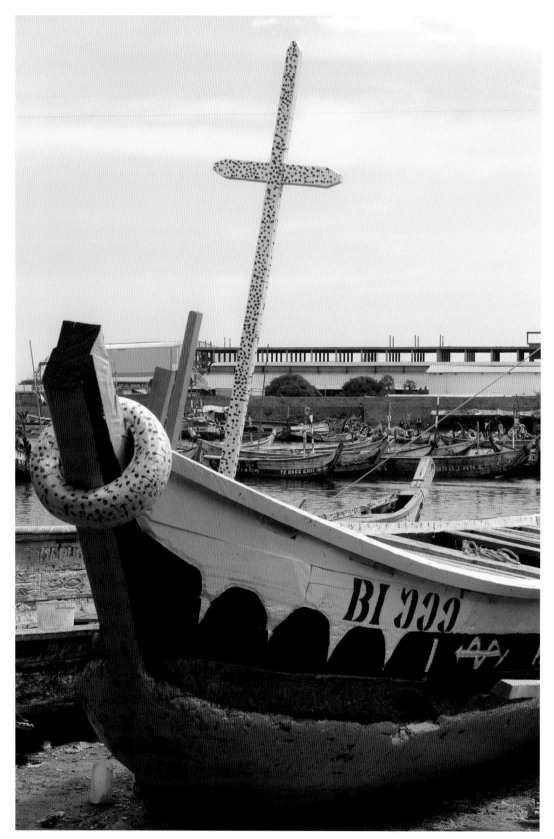

Fishing pirogue. Tema, 2006, Tim Gaudreau.

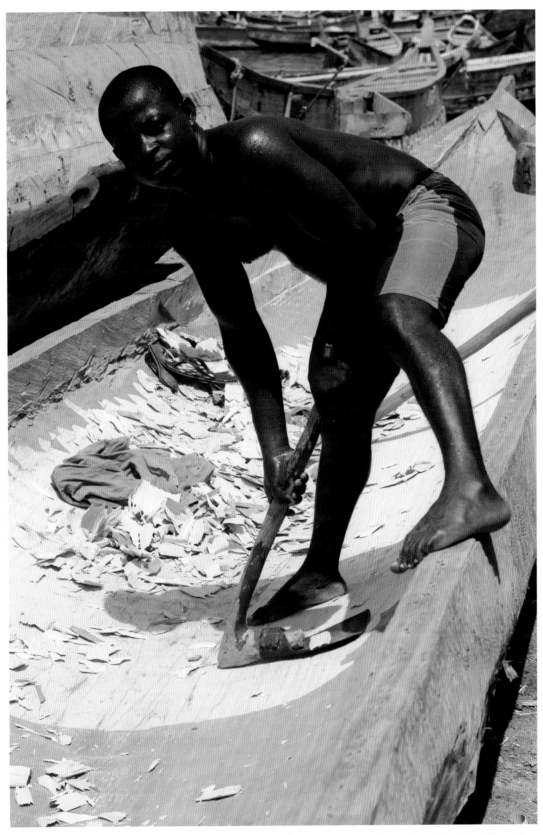

*Using an adze to
make a pirogue.
Tema, 2005,
Peter Randall*

21

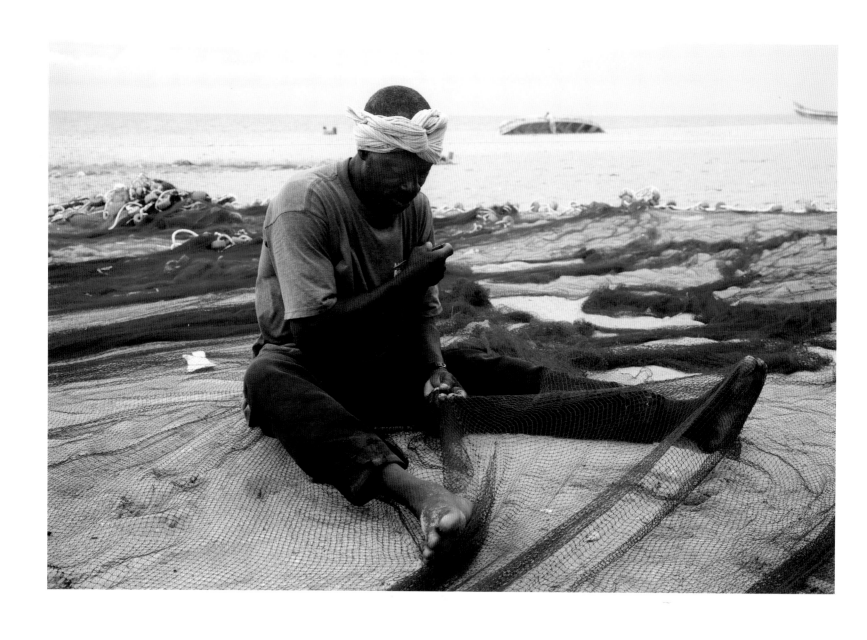

Net mending is an endless task. Aflao, 2006, Peter Randall.

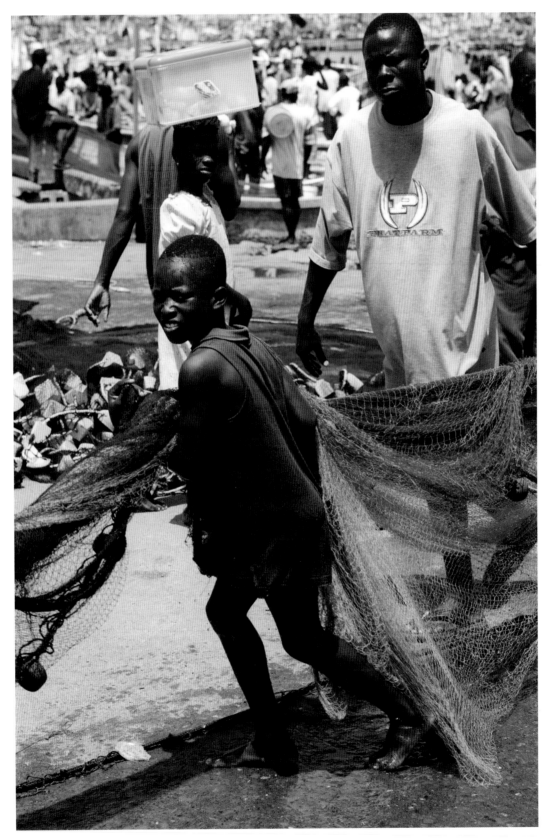

Unloading net from fishing pirogue. Tema, 2005, Peter Randall.

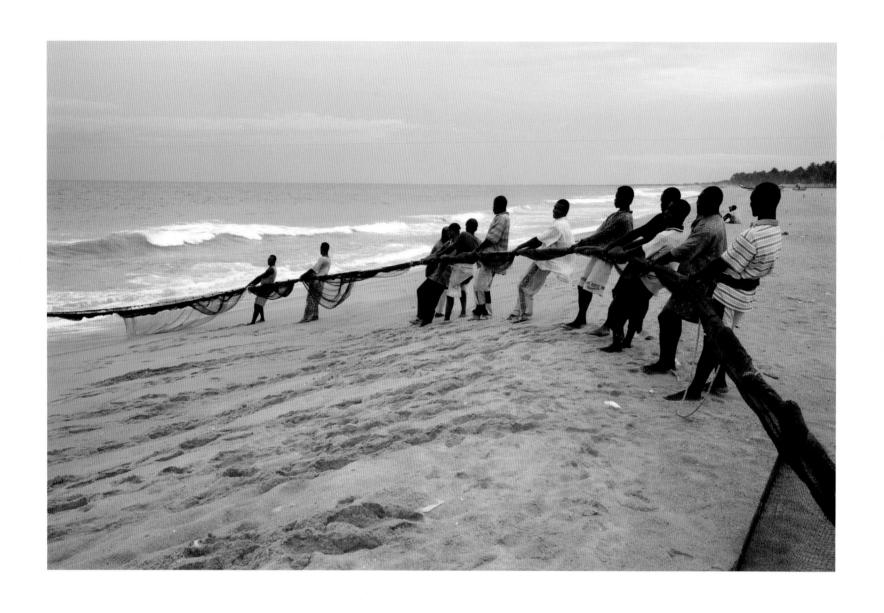

Fishermen hauling in beach net. Aflao, 2006, Peter Randall.

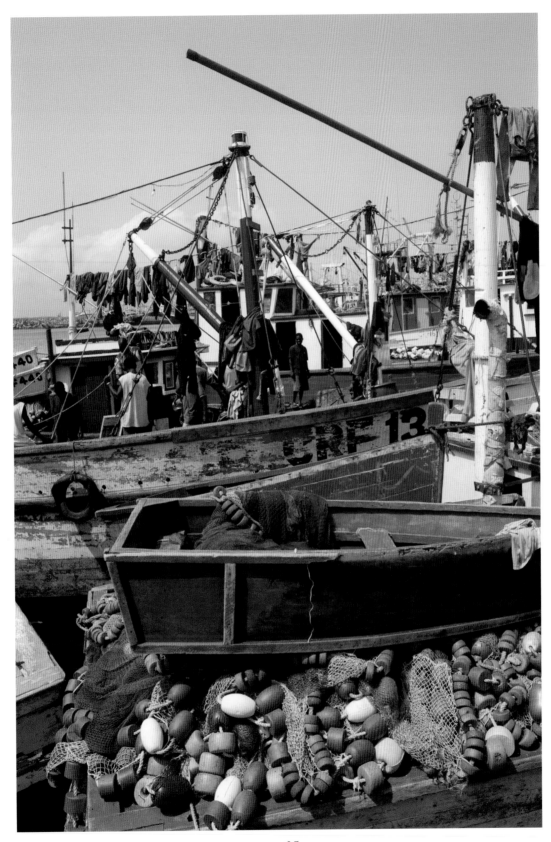

Fishing boats.
Tema, 2005,
Peter Randall.

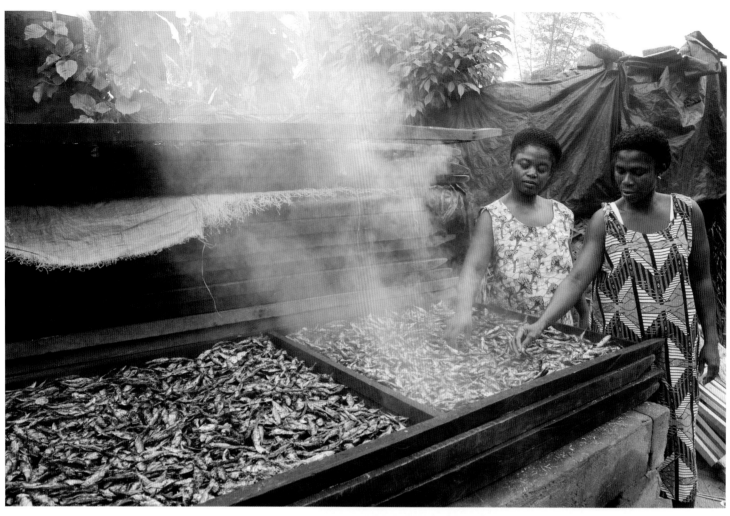

Women smoking fish. Aflao,
2006, Peter Randall.

Basin of fish. Tema,
2006, Gary Samson.

26

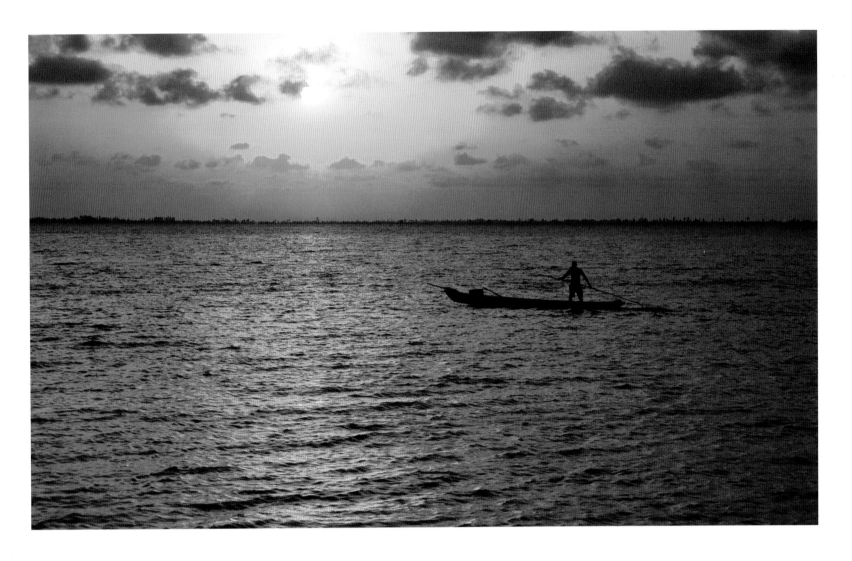

I want to go to Keta
Before it's washed away,
Before the palm-trees wither
And drown outside the bay.

I want to go to Keta
Where the boys drum all the day
And the girls dance agbadza
To keep the tears away.

I want to go to Keta
While yet they live who care
To point out like a star
That frothing spot out there

Where they would sit with dada
Those days the sea was land.
I want to go to Keta
While yet there's place to stand.

I want to go to Keta
Before the tenderness
Of grief so keen and bitter
Chills to cold callousness

And the vagueness of laughter
Drowns the shared joy of pain.
I want to go to Keta—
It might not long remain.

I WANT TO GO TO KETA
Kobena Eyi Acquah

*Fisherman. Keta Lagoon, 2006
Peter E. Randall.*

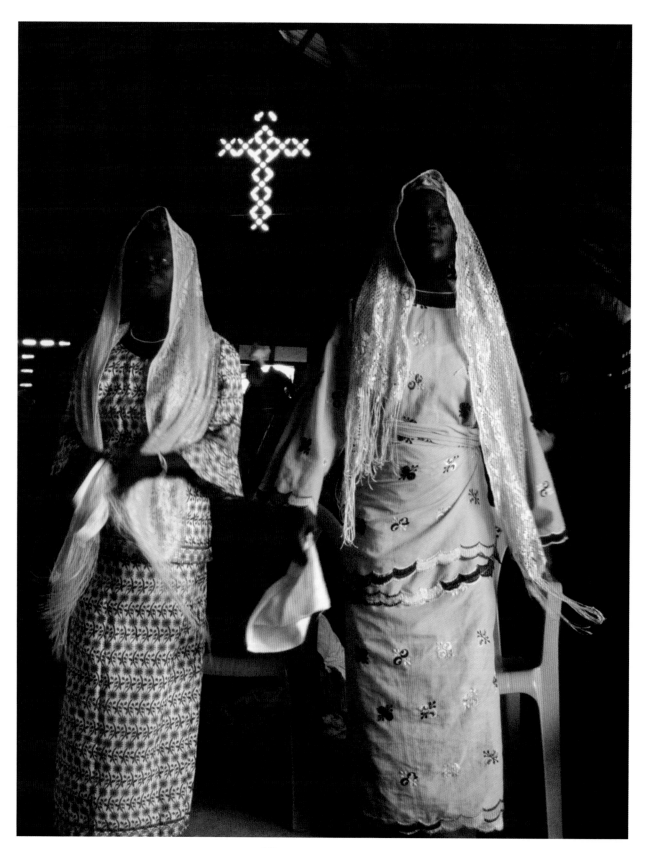

Praise the Lord.
Jordan Nu White
Cross Mission.
2006, Charter
Weeks.

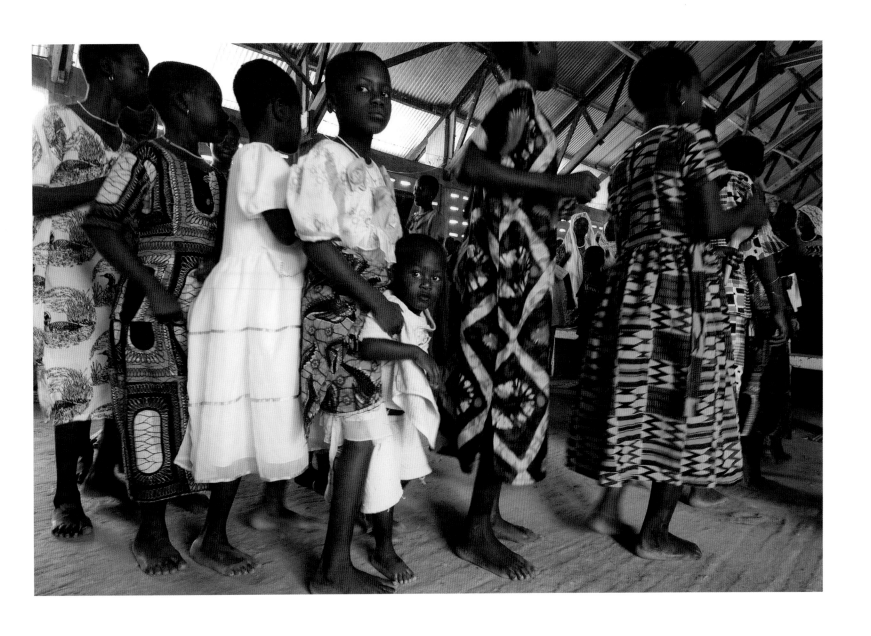

The collection. Jordan Nu White Cross Mission, 2006, Gary Samson.

29

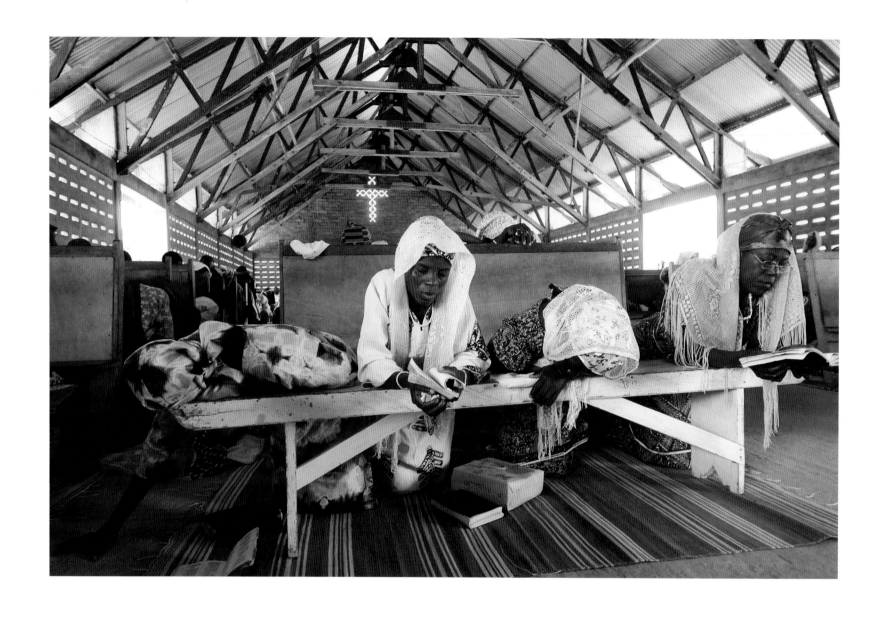

THE QUEST
Amu Djoleto

The conflict, if any, is not with God.
I cannot have a quarrel with force
I have been trying much to understand.
It is, then, with the word and the servant.
Of the servant and the word, I prefer
The word to which, in freedom, I refer.

Worship service. Jordan Nu White
Cross Mission, 2006, Gary Samson.

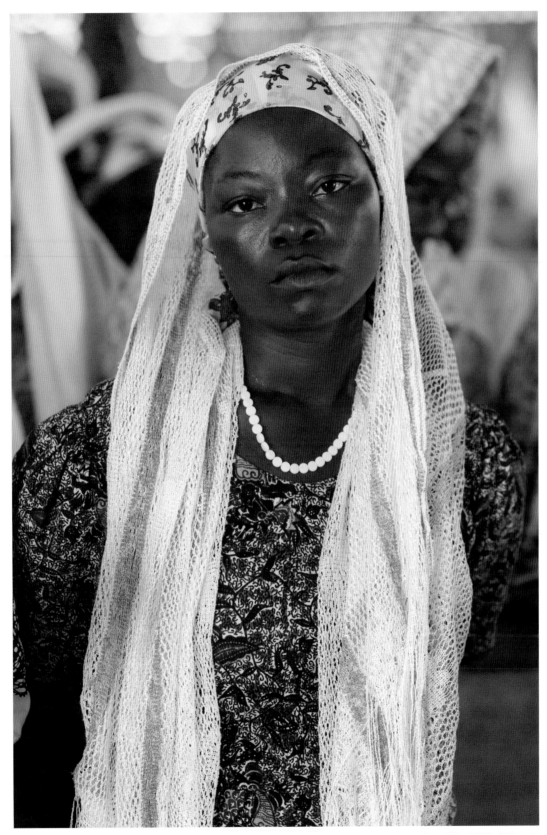

Jordan Nu White
Cross Mission, 2006,
Gary Samson.

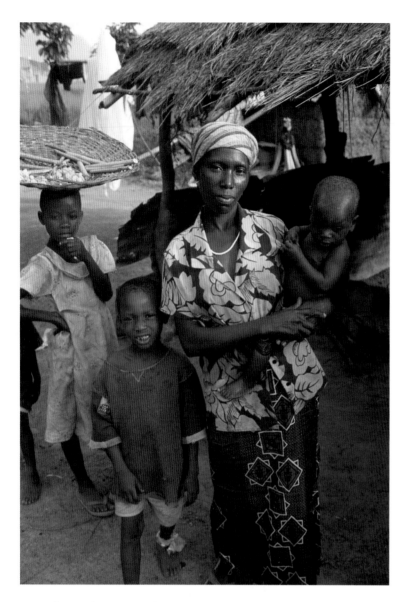

*Family. Jordan Nu White
Cross Mission. 2006,
Charter Weeks.*

*Making supper. Jordan Nu White Cross
Mission. 2006, Charter Weeks.*

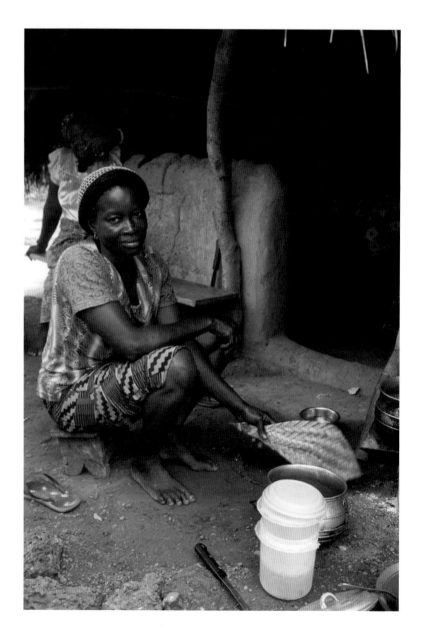

32

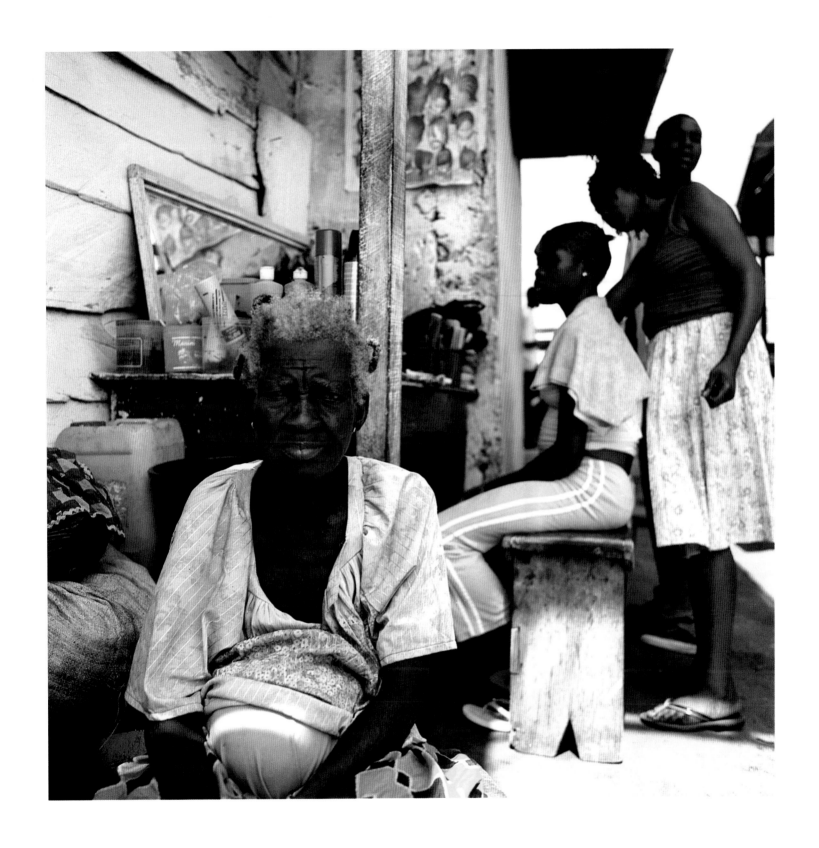

Grandmother and hairdresser. Accra, 2006, Nancy Grace Horton.

33

2006, Charter Weeks.

The goat does not know it, but a few yards away a slaughterfest is happening. It will end up there shortly. Kumasi 2006. Barbara Bickford.

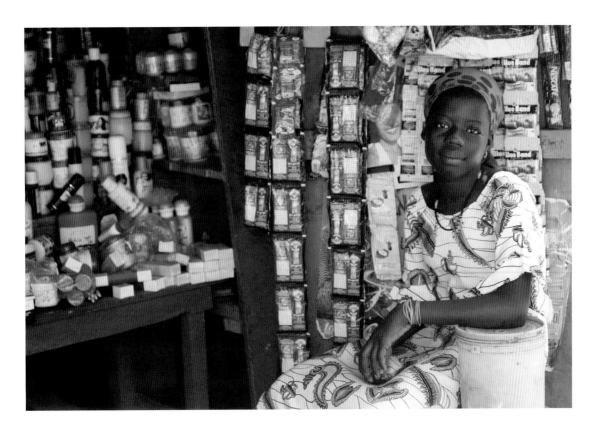

Young shopkeeper. Kumasi, 2006, Tim Gaudreau.

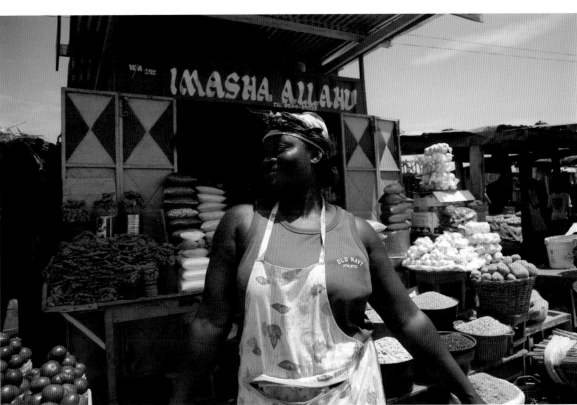

Shopkeeper dancing. Accra, 2006, Barbara Bickford

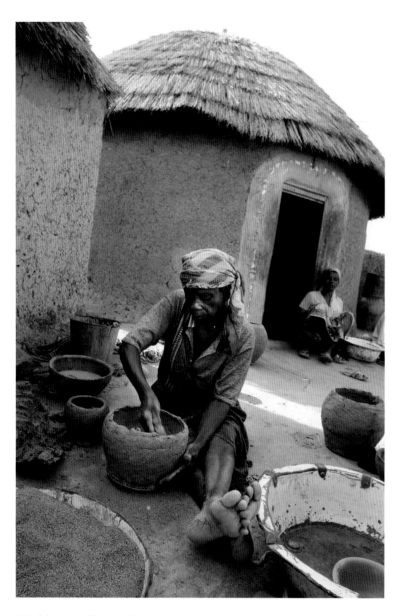

Making traditional water pots.
Tamale, 2006, Tim Gaudreau.

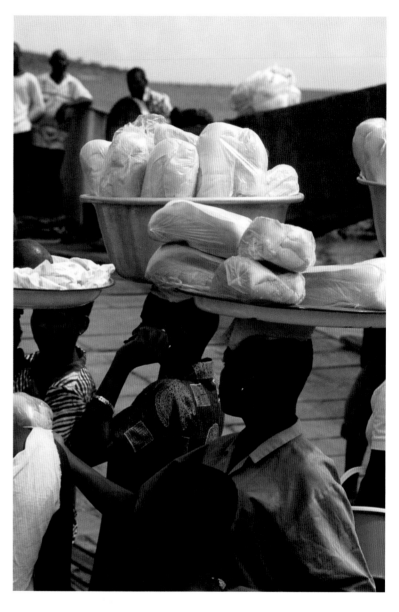

Bread for Sale, cell phone in use. Kpando, 2006, Charter Weeks.

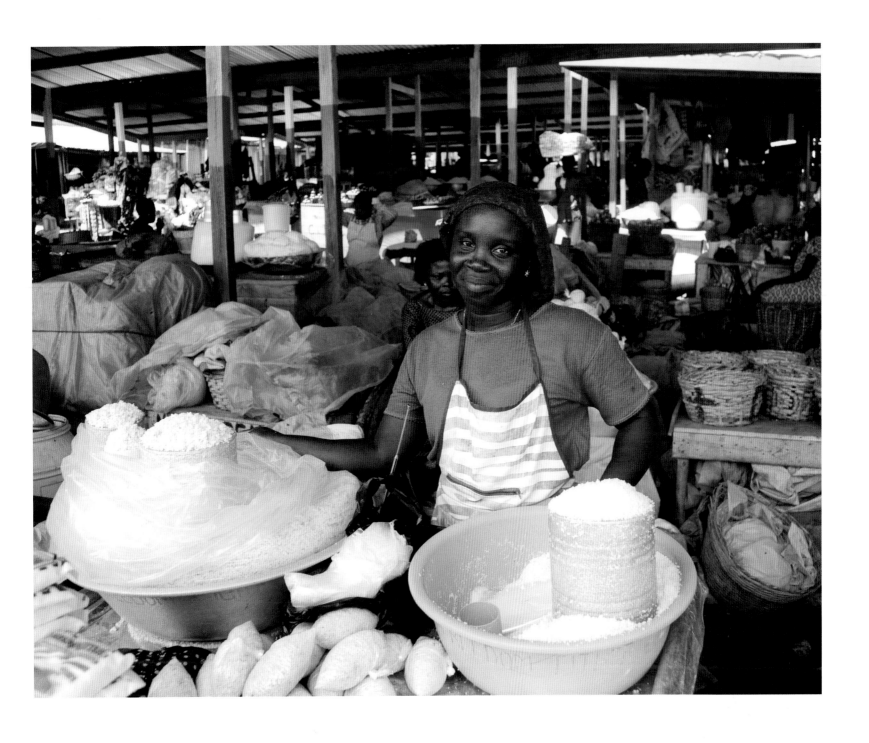

Market woman. Accra, 2006, Barbara Bickford.

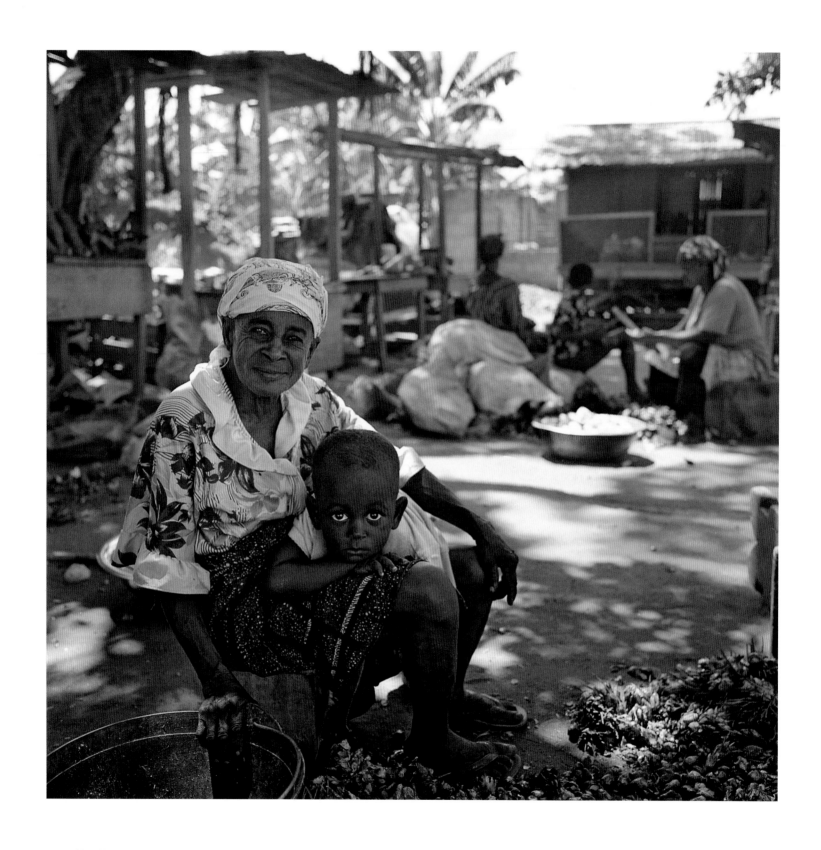

Small village market. Ayeduase, 2006, Nancy Grace Horton.

Taking care of business. Kumasi, 2006, Barbara Bickford.

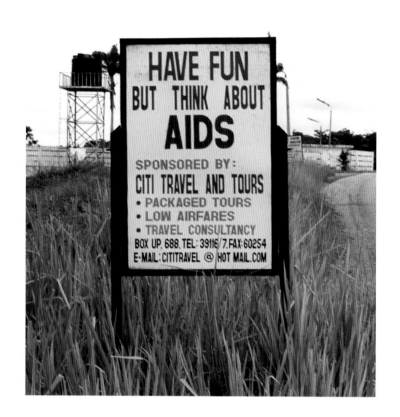

This page, 2006, Charter Weeks.

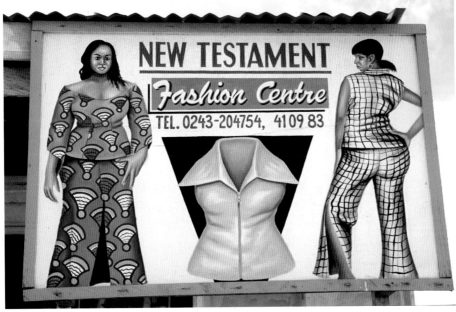

"Special Bush Meat." Pokuase, 2006, Peter Randall.

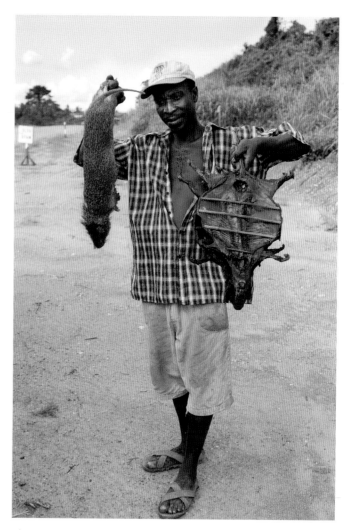

Bush meat offered at roadside. Winneba, 2006, Tim Gaudreau.

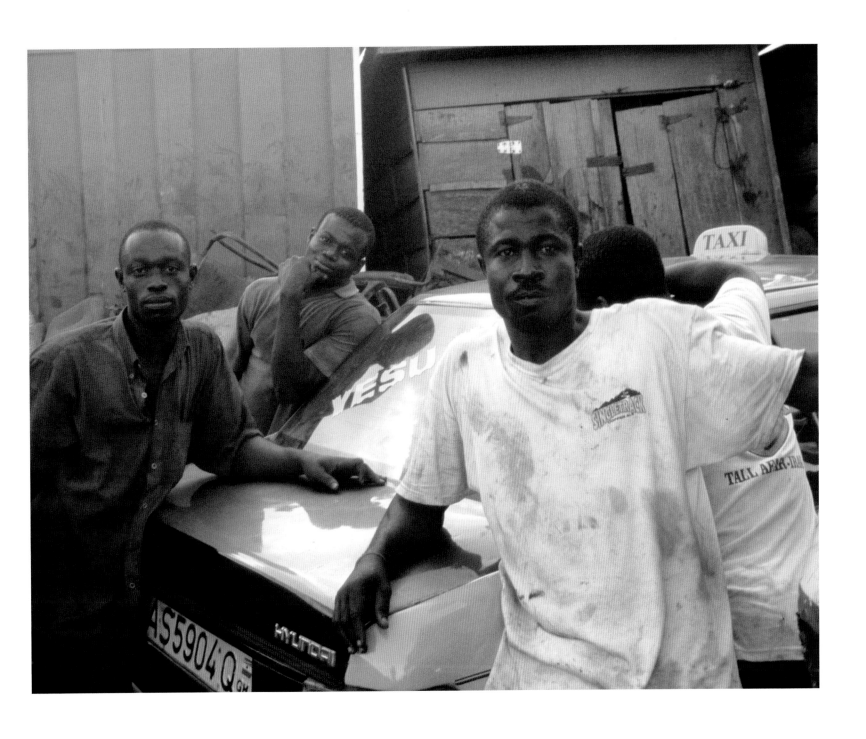

Taxi stand. Kumasi, 2006, Charter Weeks.

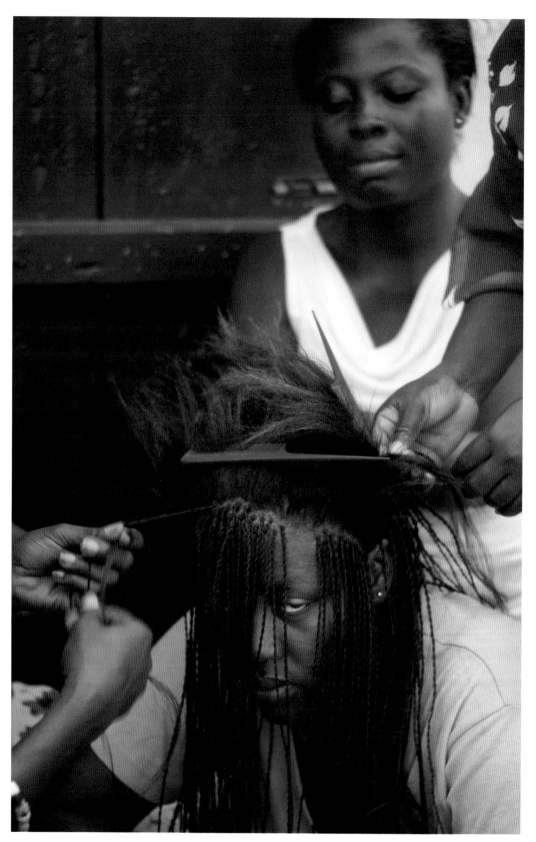

Hair braiding. Kpando, 2006,
Charter Weeks.

44

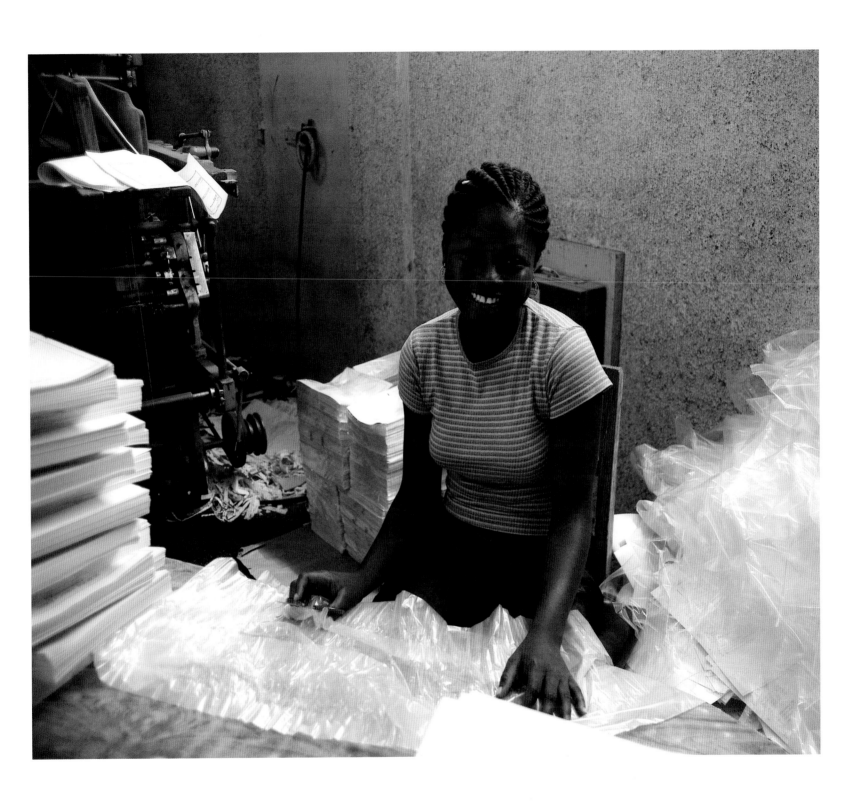

The young worker in a print shop said it took twelve hours to braid her hair. Accra 2006, Barbara Bickford.

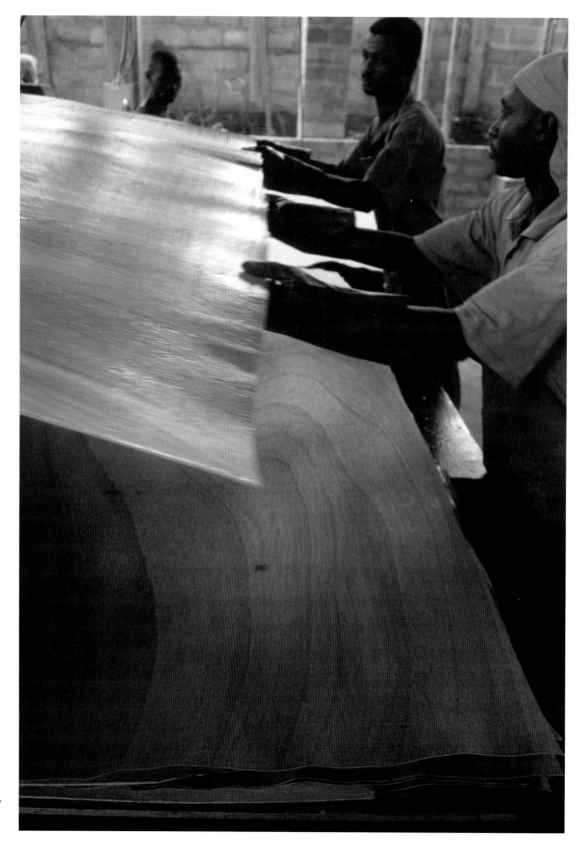

Plywood Mill. Kumasi, 2006, Charter Weeks.

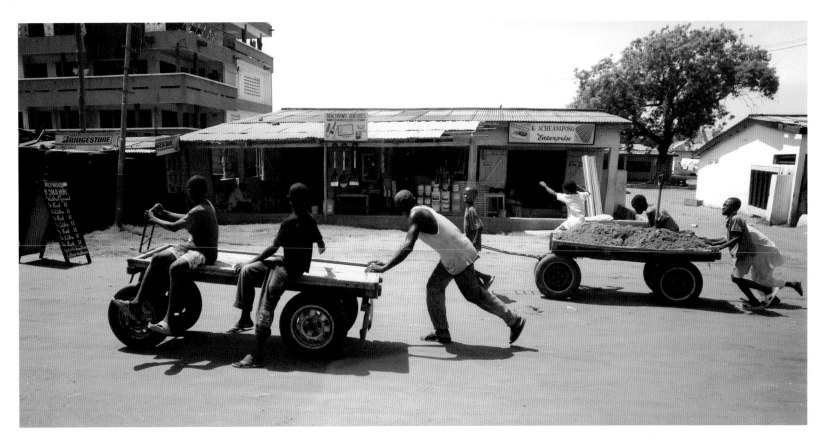

Boys racing carts. Tema, 2006, Tim Gaudreau.

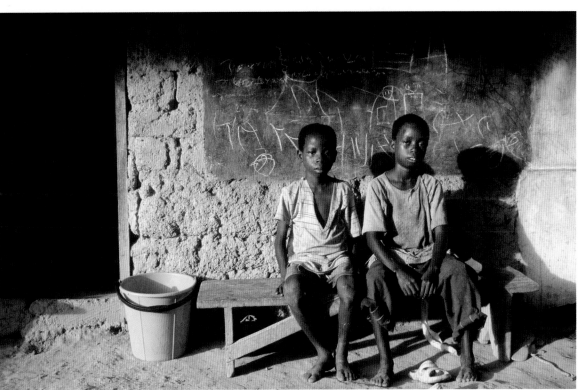

Two boys at school. Jordan Nu White Cross Mission, 2006, Charter Weeks.

47

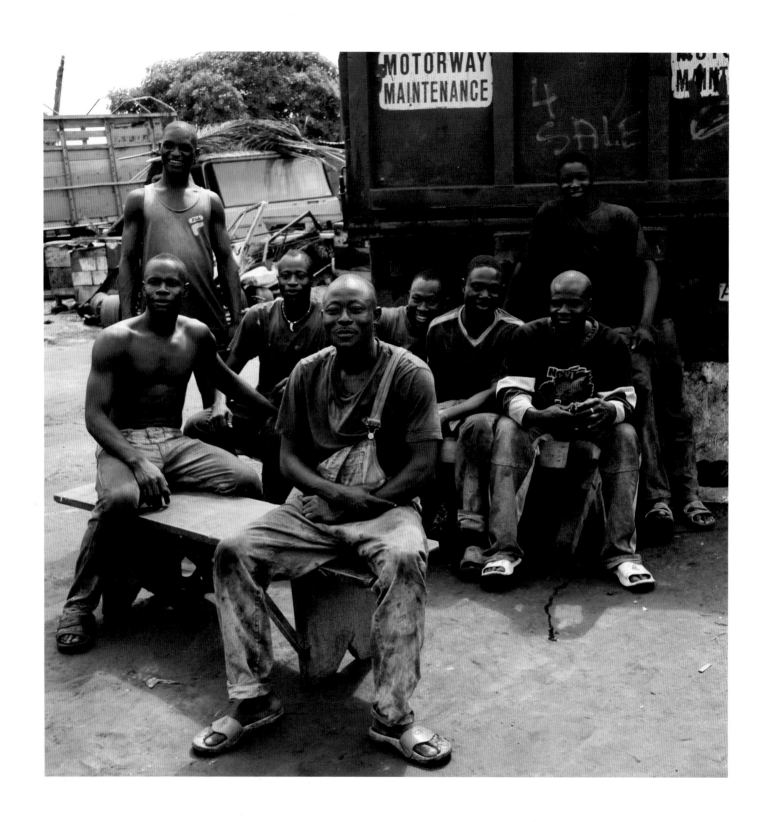

Workers in a junk yard. Kumasi, 2006, Barbara Bickford.

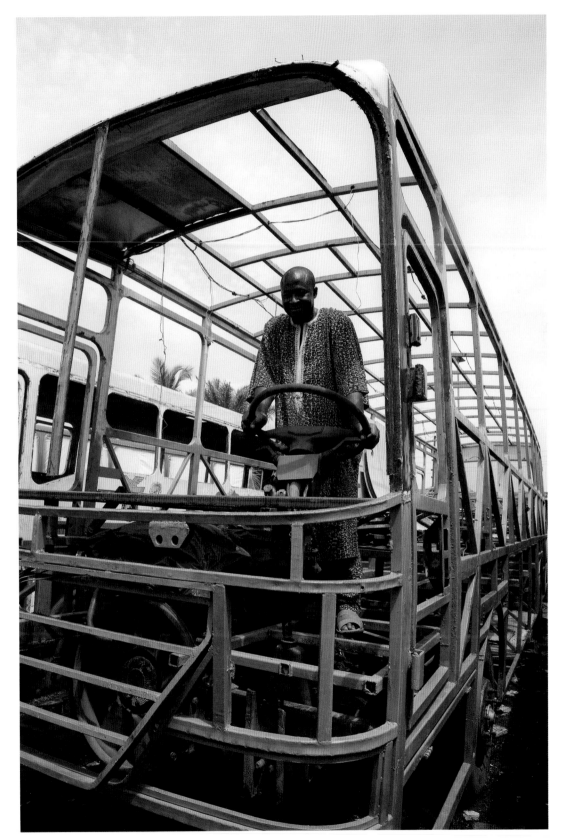

To return this bus to working order would require three months of effort and $43,000. Kumasi, 2006, Barbara Bickford.

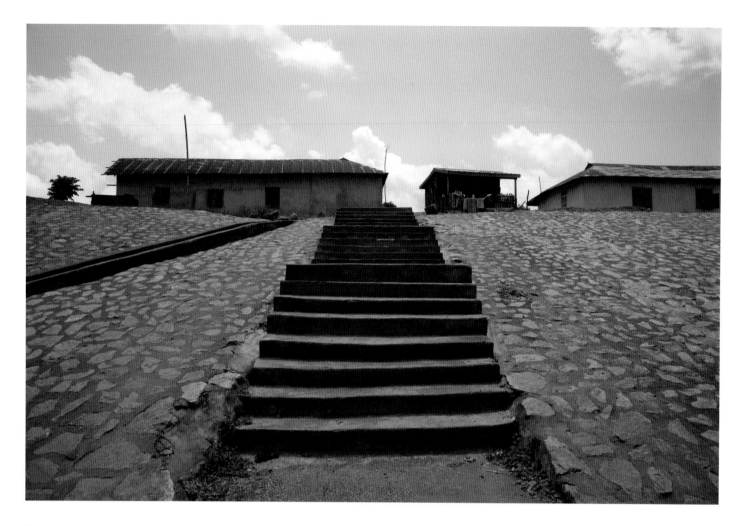

GENTLY
Kobena Eyi Acquah

Brothers, break them gently.
People used to live there.

Those were not always mere mud walls
To be bulldozed and leveled down
To make way for a new highway.

Heaven only knows what scars those walls
Now naked and bald bear; what secrets

They hold of the dreams and doubts of those
Who lived, who loved and hated them.

To them this was home. Here they came
At night to their meager meal; here
They hoped in wearied sleeplessness
For better days that never came.

They were such ones as you,
With their joys and their frustrations.
Then one day they were told to leave, to go
And start from scratch elsewhere, rootless.

Stairway to typical Ghanaian houses. Near Kumasi, 2006, Barbara Bickford.

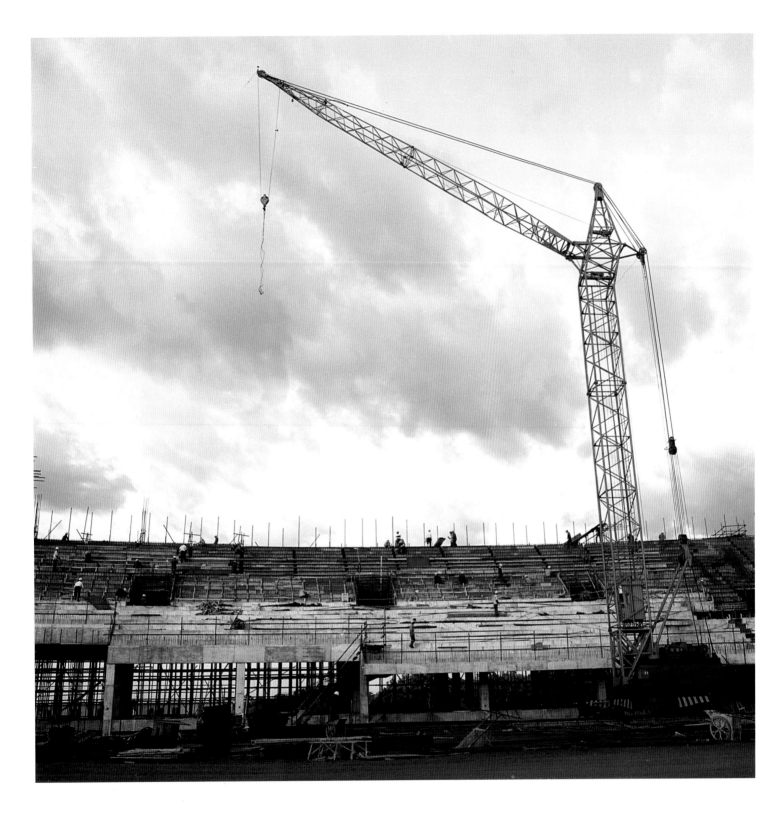

Chinese workers building a stadium for the soccer 2008 African Cup of Nations, to be hosted by Ghana, Tamale, 2006, Nancy Grace Horton.

51

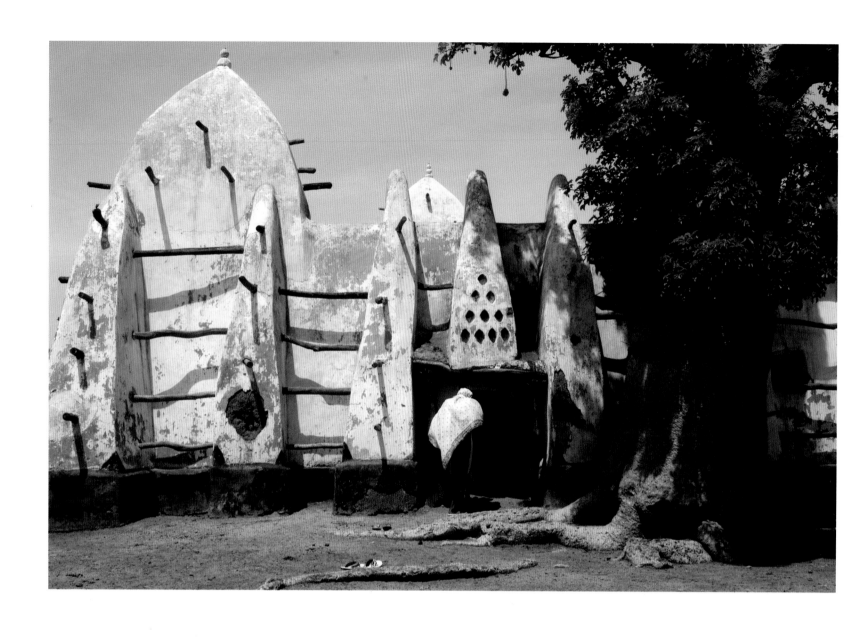

Women's mosque entrance. This ancient building, a world heritage site, is made of mud and sticks, and must be renovated every year. Larabanga 2006, Nancy Grace Horton.

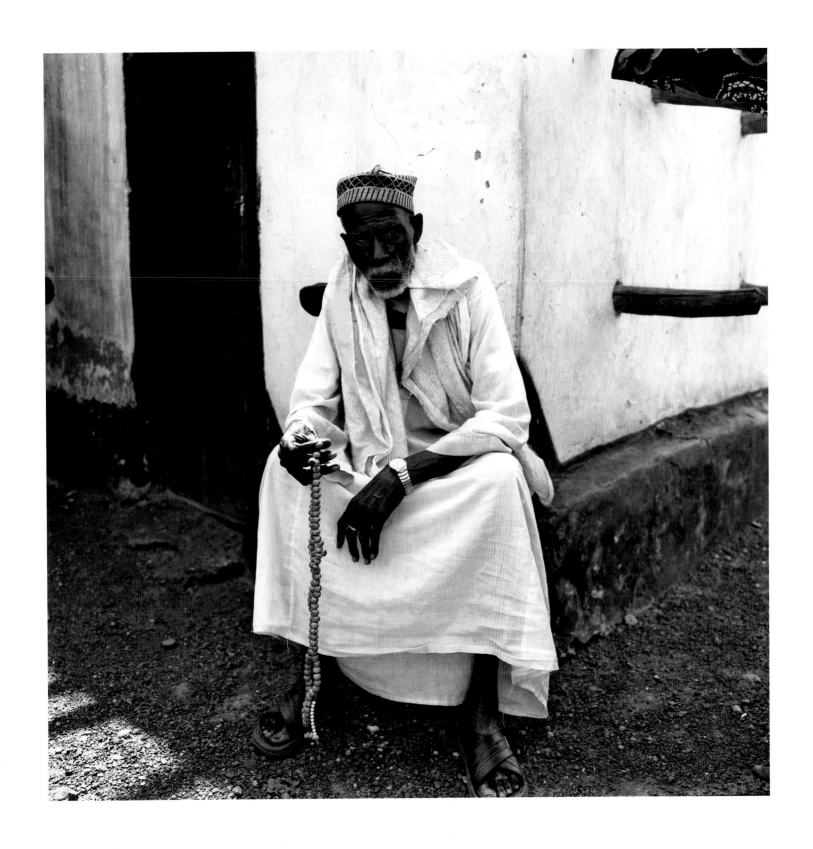

Imam (prayer leader) of Larabanga Mosque. 2006, Nancy Grace Horton.

53

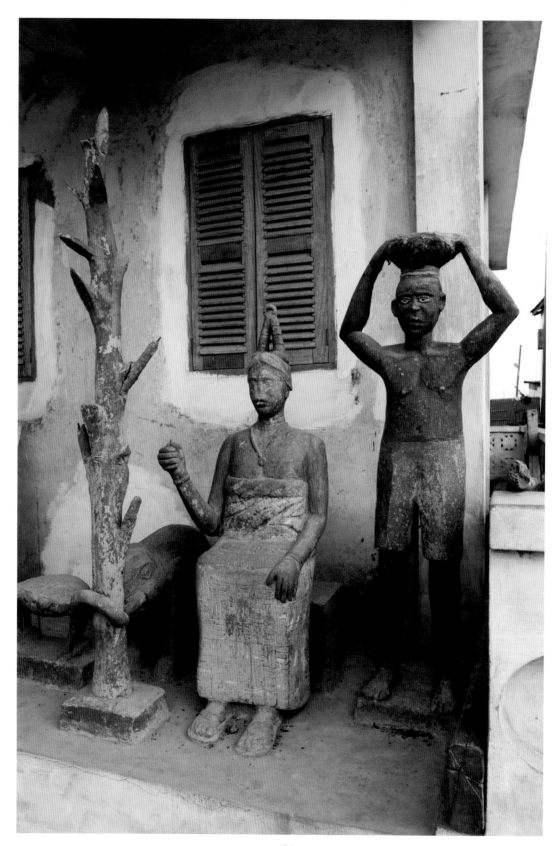

Posuban shrine.
Elmina, 2006,
Peter Randall.

54

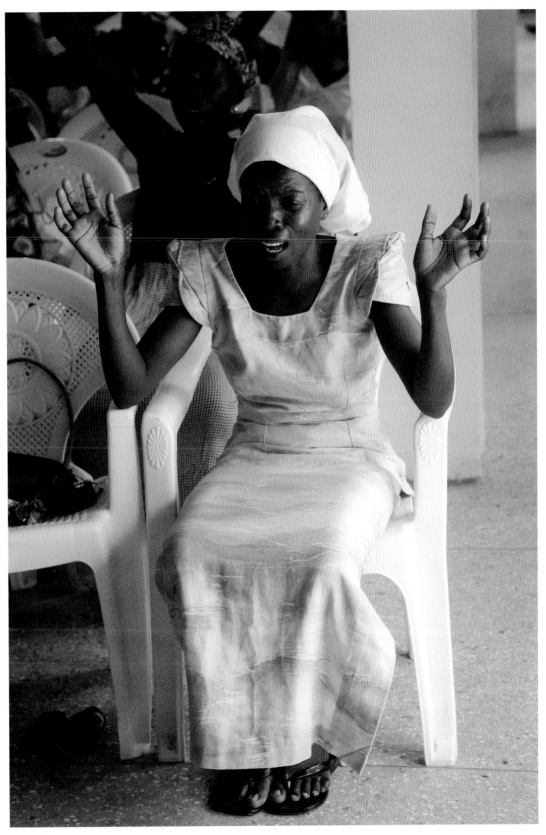

Revival Service. Grace Presbyterian Church, West Legon, 2006, Peter Randall.

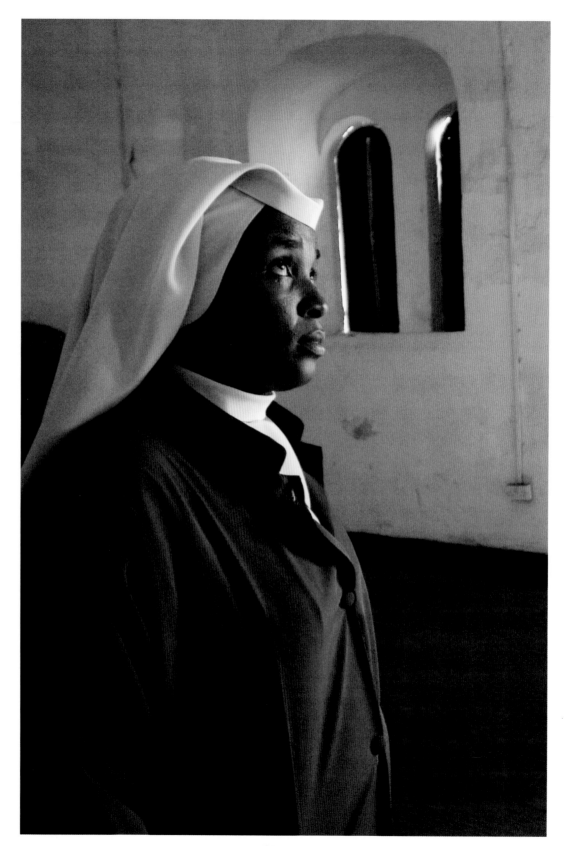

Nun visiting former slave fort, Cape Coast Castle. Cape Coast, 2006, Tim Gaudreau.

56

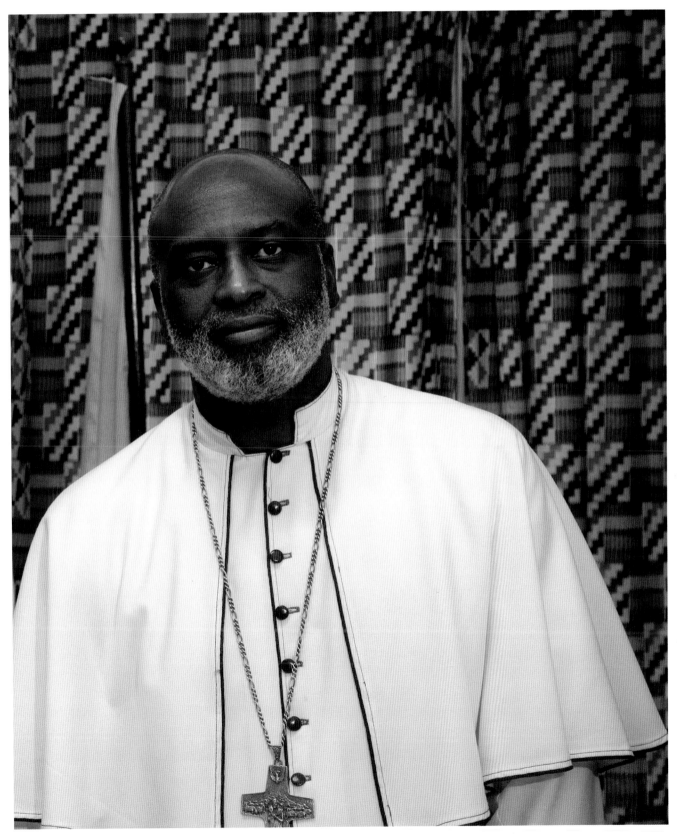

The Most Rev. Charles Gabriel Palmer-Buckle, Metropolitan Bishop of Accra. 2006, Peter Randall.

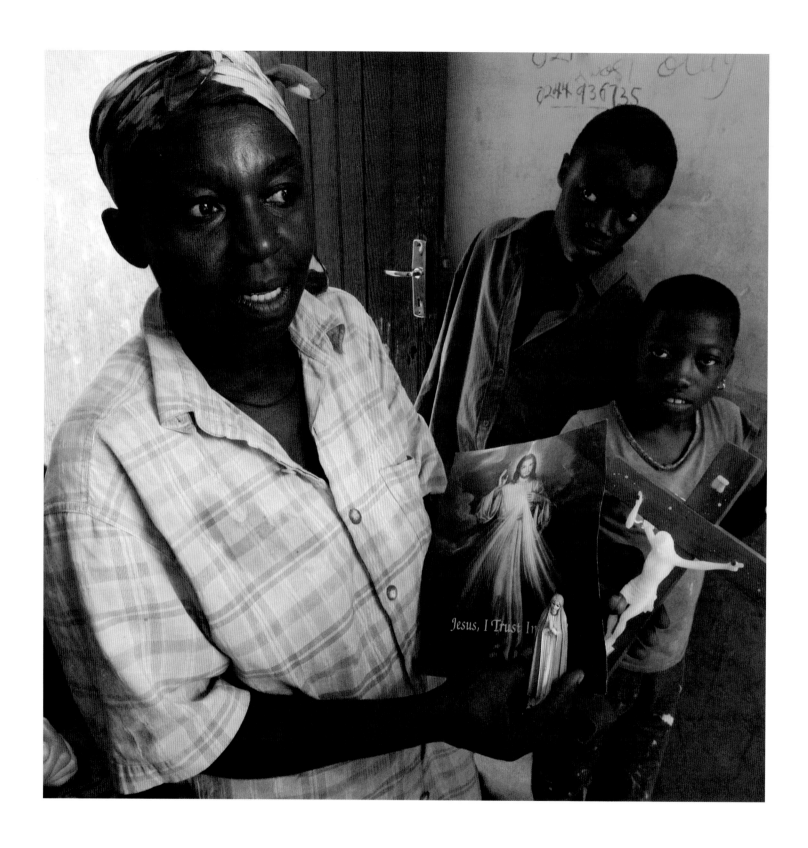

Displaying Christian icons. Ayeduase, 2006, Tim Gaudreau.

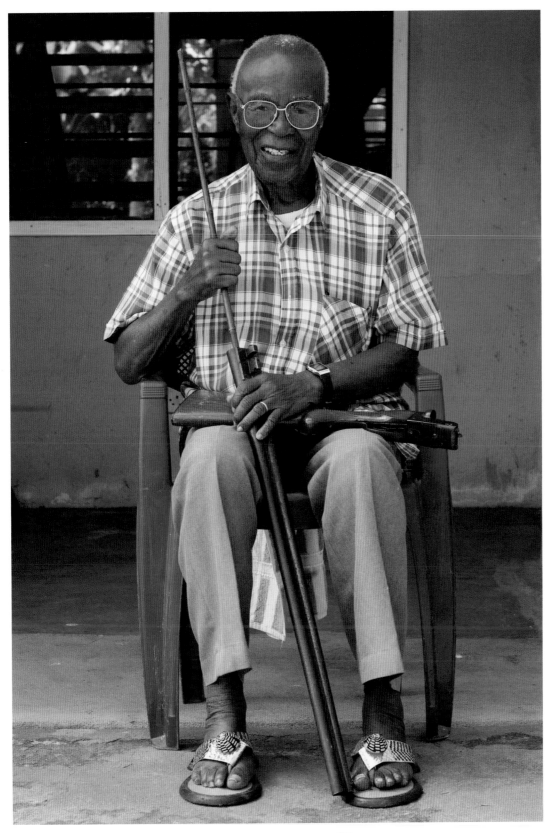

The Rev. A. L. Kwansa, 92 years old, Presbyterian Church. He founded the Aburi Medical Clinic. Aburi, 2006, Gary Samson.

Black is the traditional color for mourning; however the skull was a uniquely morbid flourish. near Lake Bosumtwi, 2006. Barbara Bickford.

The Rev. John Wesley is honored by women in the AEM church who wear kerchiefs with his name and image. Elmina, 2006, Barbara Bickford.

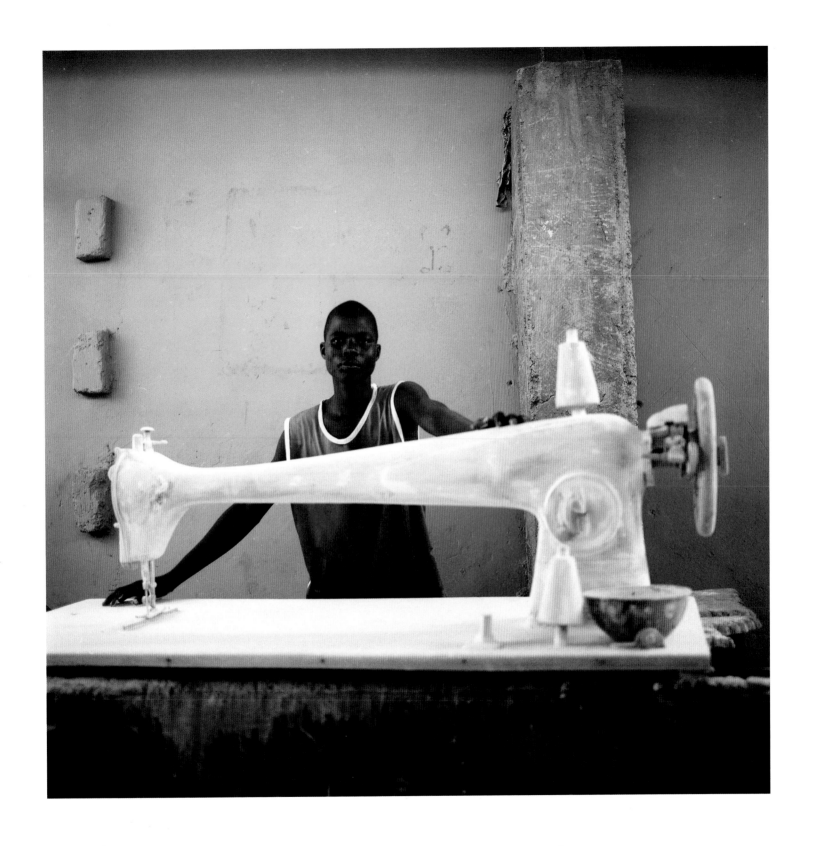

Hello Furniture Work, sewing machine, cover of a casket. Accra, 2006, Nancy Grace Horton.

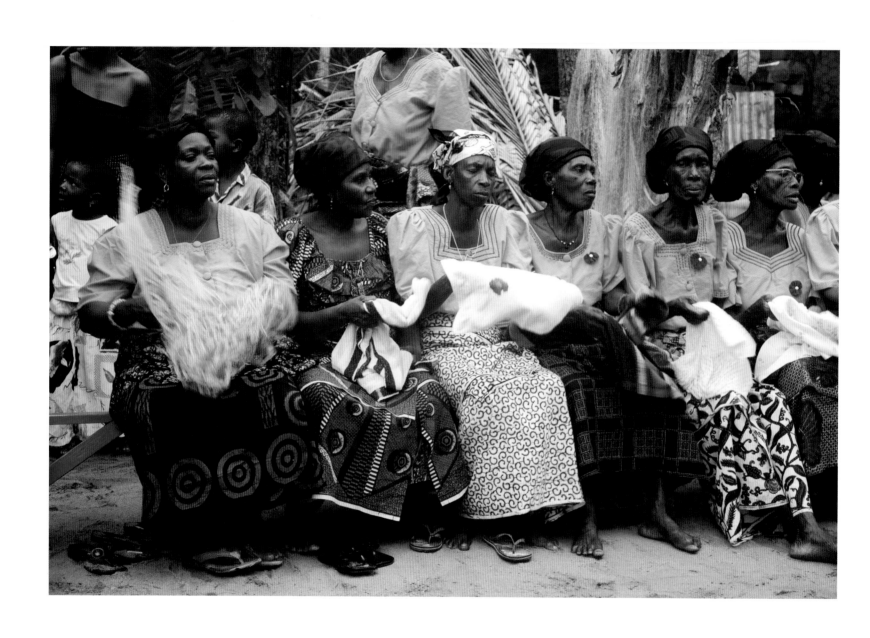

Funeral anniversary. Keta, 2006, Peter Randall.

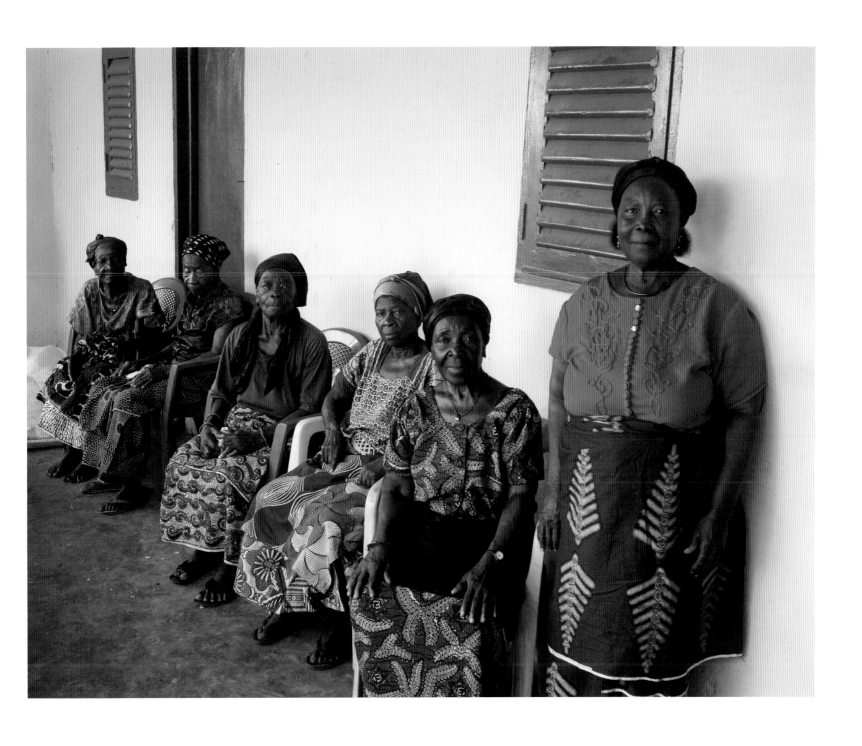

King's "mothers." Kitase, 2005, Peter Randall.

ANCESTRAL MILK

i. White Calico
Beyond the market
on the outskirts of Salaga,
in what used to be wilderness,
you will find a solitary baobab tree,
wrapped in white calico
in a vegetable garden planted with corn.

Baobab trees are sacred
they grow large, live long and are strong
strong enough to contain the spirits of ancestors
and the unquiet dead.
White calico rings this ancient tree of accidental sanctity
where the dead en route were dumped.
Not buried, but deposited as refuse
beside the still living abandoned dying,
chained by the neck to the trunk.
Through the centuries bark has encrusted the iron staples
like scabs over sores
obscuring the cause of the infection with a scaley patina
gnarled by time and circumstance and silent sorrow.

ii. White Beads
A priestess, the white beads of office on her neck and wrists
tends to the crop to keep the garden tidy.
Interrupted, she pauses to explain
the functions of her office:
Every Friday and Every Monday, year after year
she nourishes spirits with milk,
to keep them safe under this tree,
performing her lonely office
of tending the unmarked graves
of the abandoned dead of unknown family
feeding fresh milk to the spirits of captives
who died walking to or marching from
this market of slaves.
Every Friday and every Monday

Through the centuries,
while Muslims raided the peoples to the north
and sold them to the Christians in the south
her family of traditional priests have fed the spirits of the dead.
And continue to do so long after the trade in flesh has stopped
and Muslims and Christians trade peacefully
in whatever new commodity needs exchanging in their age-

gold, gunpowder, kola nuts,
leather goods, fabrics, second hand car parts.

What is the depth of anguish, and what the faith
that commits mother, sister, daughter niece
week in week out, through the centuries,
to perform this lonely office
unwitnessed, unsupported, unacknowledged.

iii. White Milk
Once this was wilderness, and foreboding forest
where vultures preyed on the bones of those
who would not be missed, or could never be found.
But these women found you, and knew someone would miss you.

Too late to tend to your bodies,
year after year they nourish your spirits with milk,
to keep you safe under this tree.
For fed spirits can be satiated and made happy,
can be made to dance under the protection of these branches.

So here, in a place where named ancestors
drink greedily the clear spirits poured
by those of their own blood,
you unnamed lost spirits
crave cow's milk for food
in your limbo of time.

So come, eat, you who marched the trail of tears and died here;
you the rebellious and you the weak,
come, eat, you whose sprits were broken by the flesh markets and the
 forts;
you the heroic and you the conspirators,
come, eat you who tried to just make a way to live, and faltered.

You of unnameable ancestors, and unknown descendants, come
Here, after all, you are safe.
Here every Friday and every Monday
one woman at a time, through the centuries, has prayed for you
has fed you milk under a baobab tree scarred by your iron
and swathed in calico to greet you through the centuries
unwitnessed, unacknowledged, unmemorialized.

Abena P. A. Busia

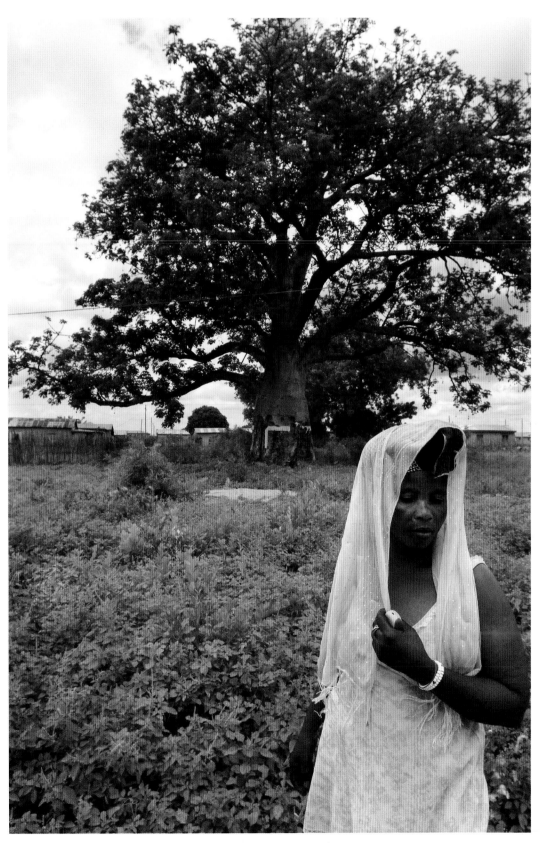

Caretaker of the ancient baobab tree, and cemetery, where slaves were once tied in the sun as punishment at the Slave Market. Salaga, 2006, Tim Gaudreau.

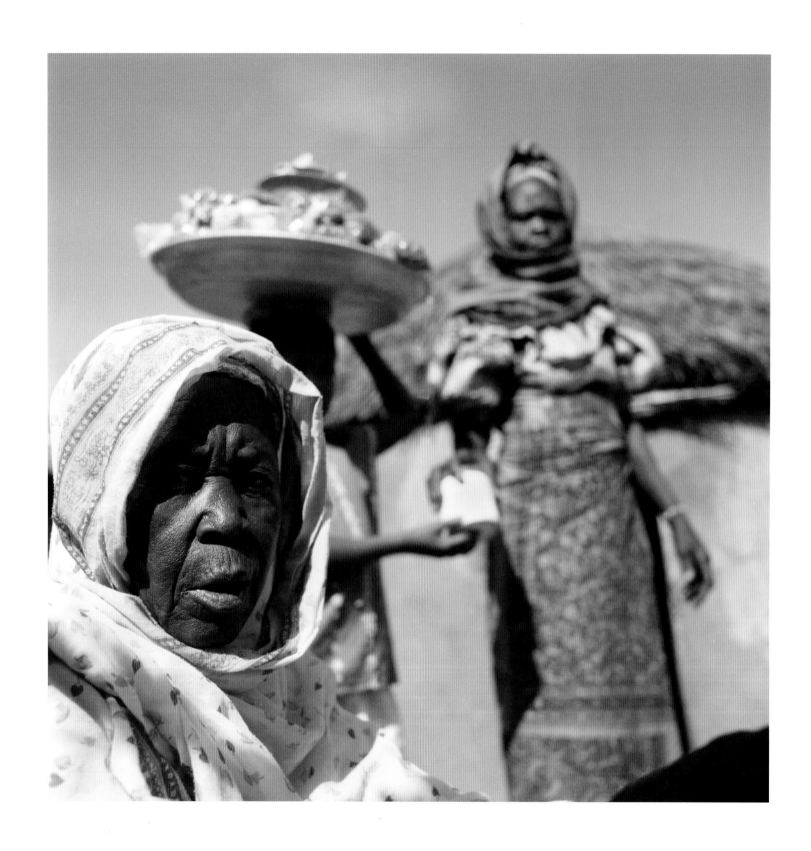

Kukoa (witch camp). Gambaga, 2006, Nancy Grace Horton.

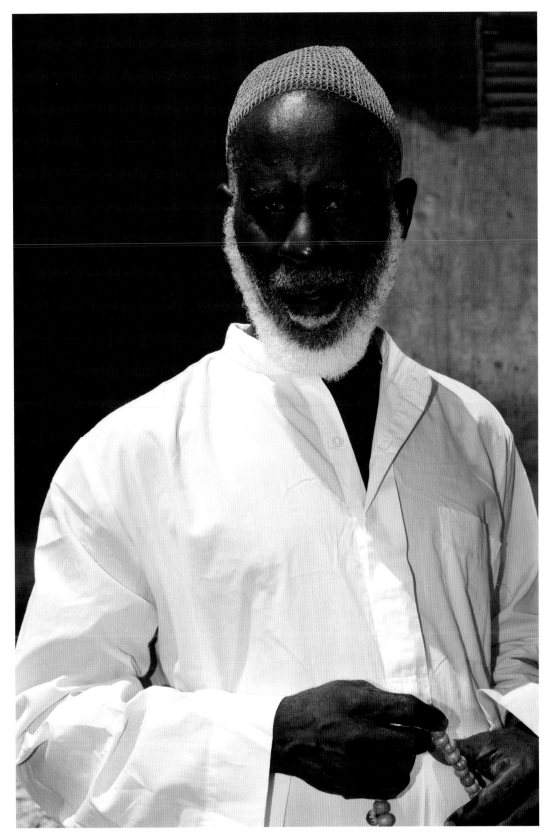

Imam. Salaga, 2006, Tim Gaudreau.

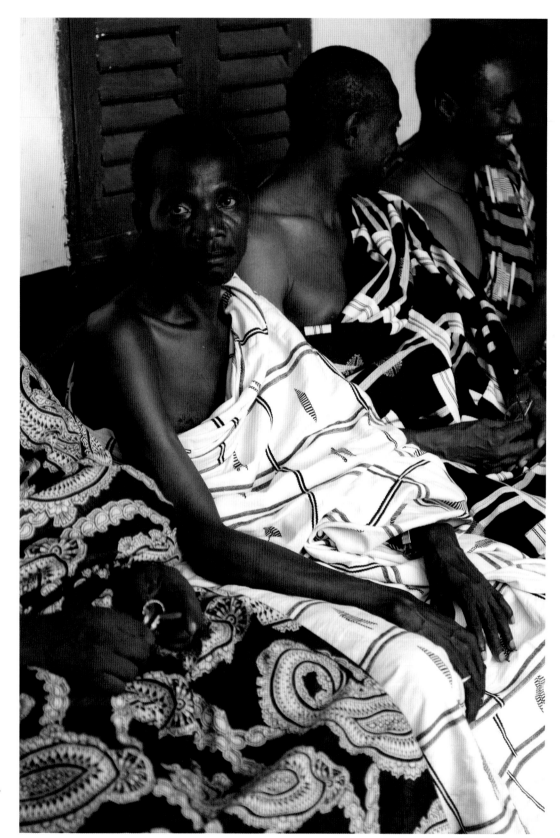

Nana Yaw Mensah, Fetish Priest. Techiman, 2006, Tim Gaudreau

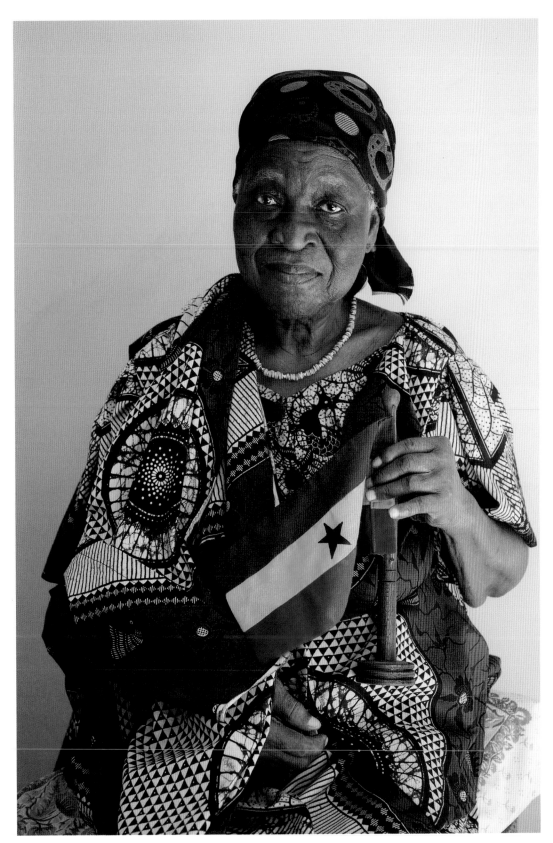

Mrs. Theodosia Okoh designed Ghana's first flag fifty years ago. She wrote, "I decided on the three colors of red, gold, and green because of the geography of Ghana. Ghana lies in the tropics and blessed with rich vegetation. The color gold was influenced by the mineral rich nature of our lands and red commemorates those who died or worked for the country's independence. The five pointed lone star is the symbol of African emancipation and unity in the struggle against colonialism." Accra, 2006, Peter Randall.

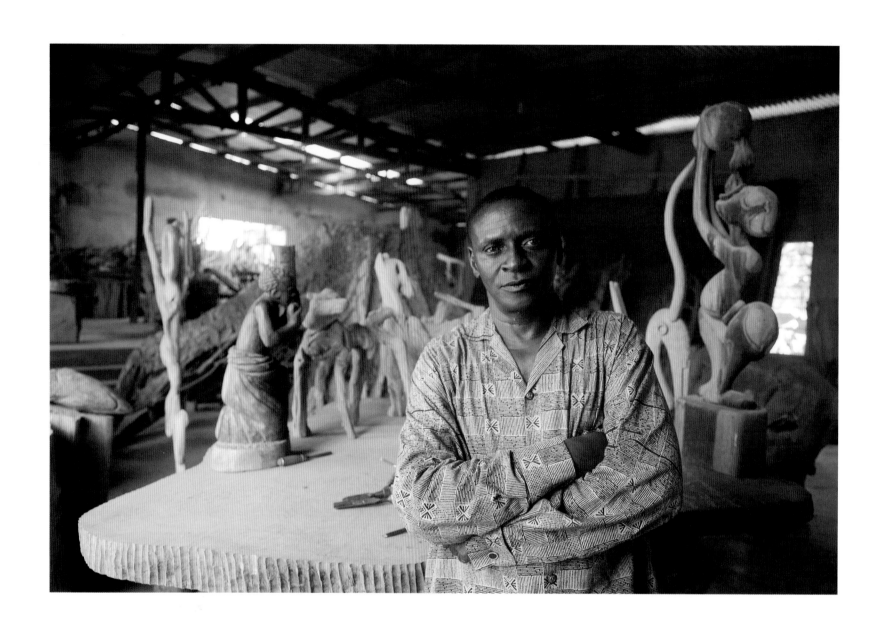

Alex Sefah Twerefour, sculptor, director, Center for National Culture. 2006, Peter Randall.

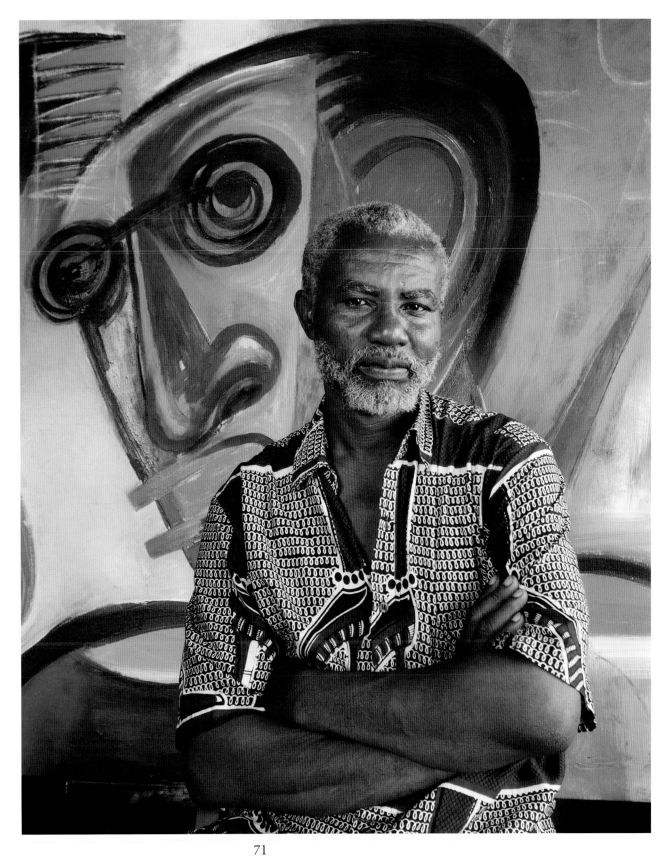

Kofi Setordji, well-known painter and sculptor. Madina, 2006, Gary Samson.

71

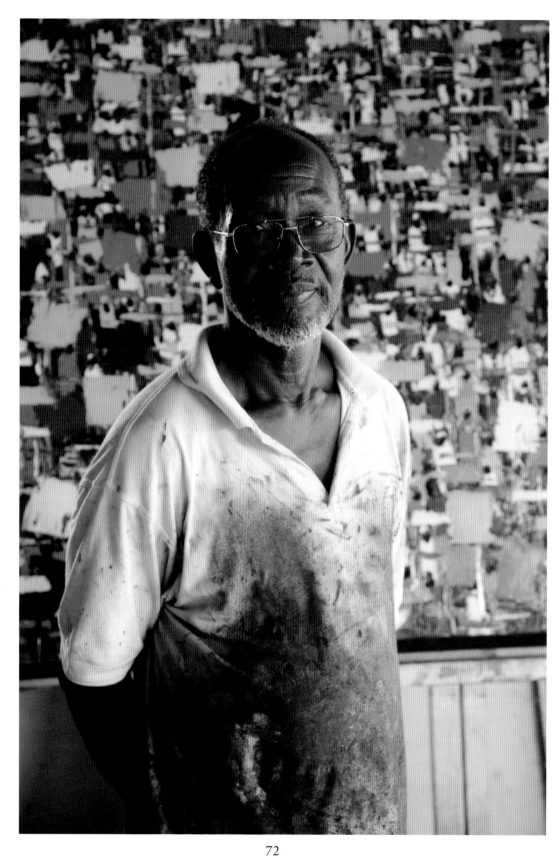

Prof. Ablade Glover, educator, artist, gallery owner. West Legon, 2006, Peter Randall.

72

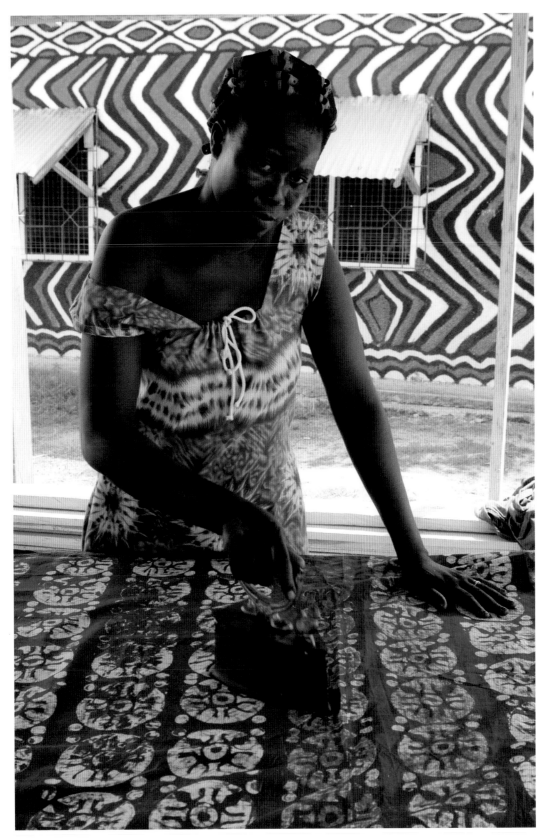

Batik fabric making, ironing with British coal iron, Sirigu Woman's Organization for Pottery and Arts (SWOPA), an organization to preserve traditional crafts. Sirigu, 2006, Nancy Grace Horton.

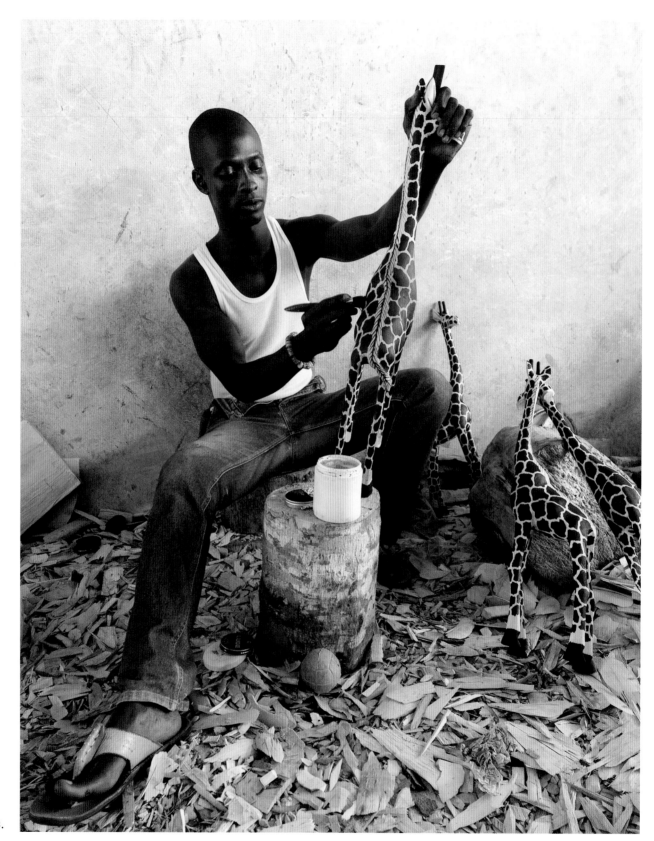

Wood carver.
Aburi, 2006,
Gary Samson.

74

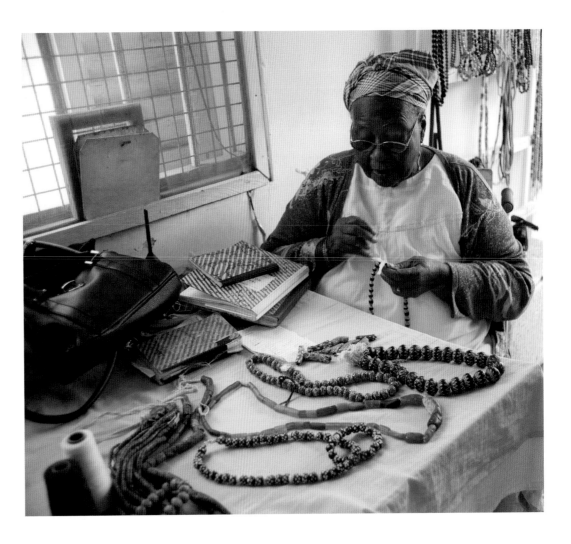

After retiring from teaching school, Esther Esi Degbor, now in her eigthties, started Gold Coast Beads. She arranges trade fairs and dance exhibitions where girls doing traditional performances are dressed in kente cloth and wear beads. Accra 2006. Barbara Bickford.

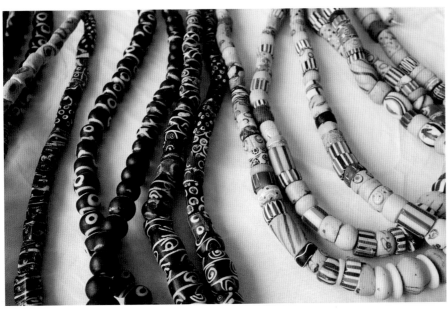

Esther Esi Degbor's beads.
Accra, 2006, Gary Samson.

75

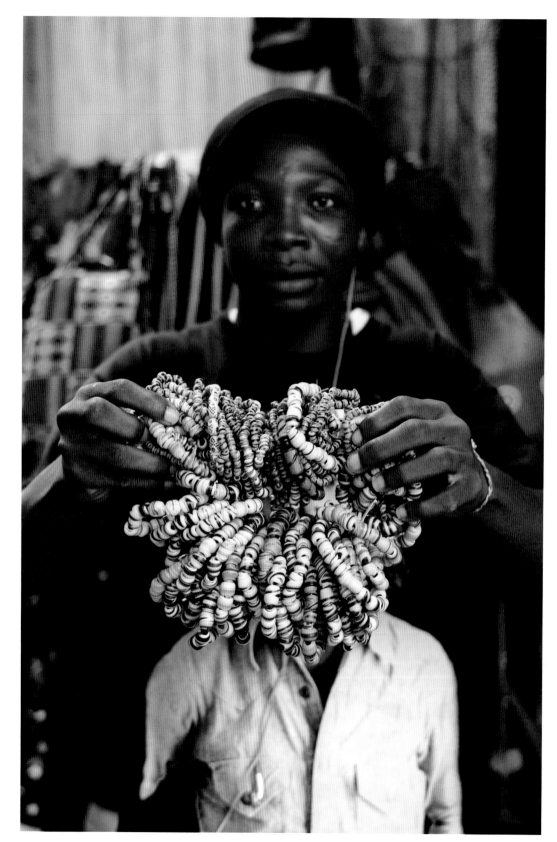

Man hawking
bracelets.
Kumasi, 2006,
Tim Gaudreau.

THE DRUM IN LABOUR
Adali-Mortty

O! for the hand
And the listening ear!
The hushed throb of the drums—
Rhythming in pent-up labour—
Awaits the drummer's hands.

Silent drums with Bob Marley on a
tray. Accra 2006. Barbara Bickford.

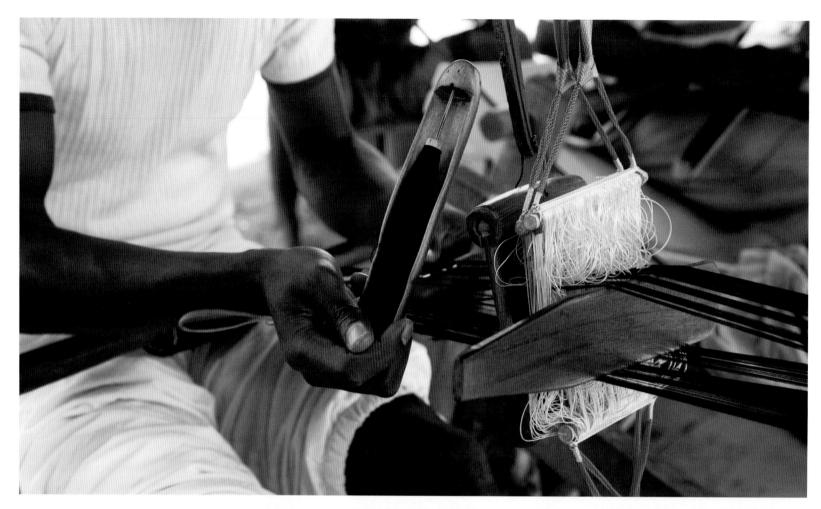

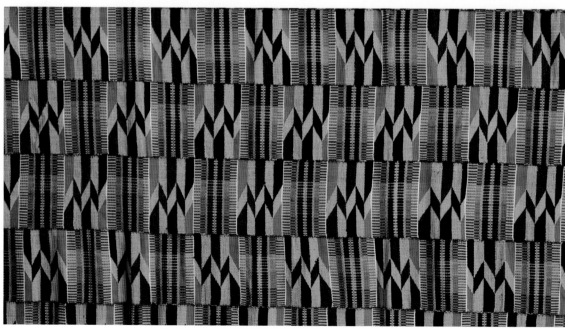

Kente cloth and weaver.
Accra, 2006, Peter Randall.

Making rope.
Tamale, 2006,
Tim Gaudreau.

79

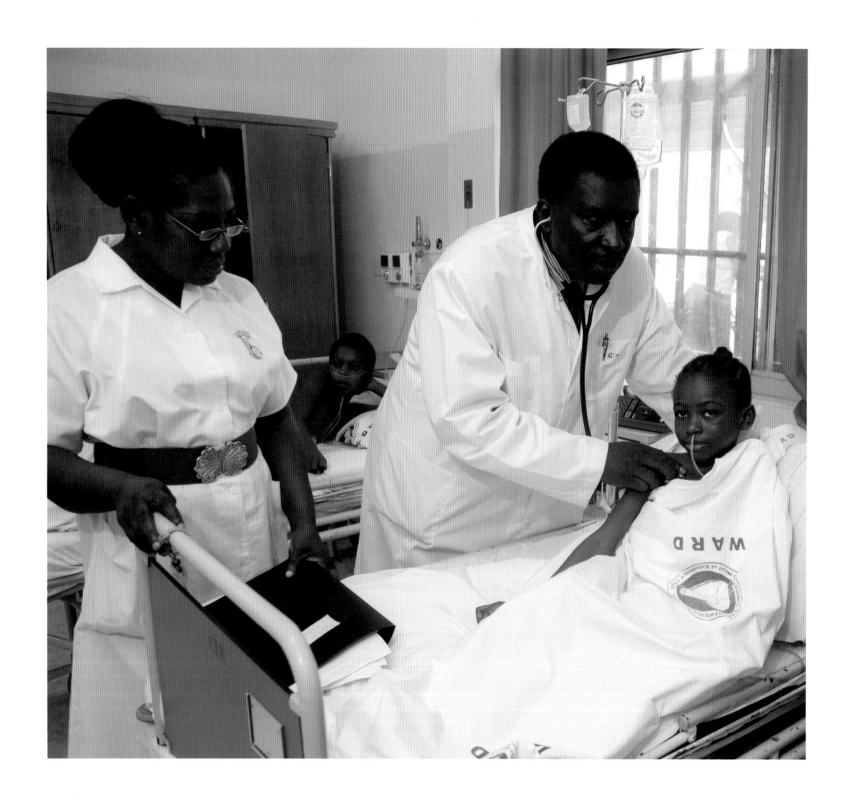

Doctor Prof. K. Frimpong Boateng and nurse Rebecca Essilfie with patient Agnes Oduro, Korle-Bu Teaching Hospital. Accra, 2006, Peter Randall.

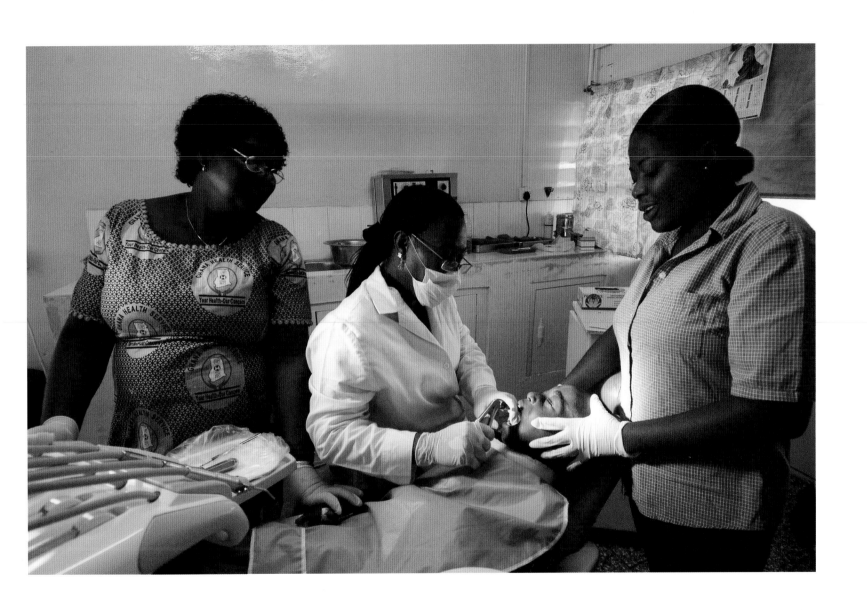

Dr. Margaret Kwakye and dental surgery assistants Selina Ako, right, and Sandra Atiase. Accra, 2006, Gary Samson.

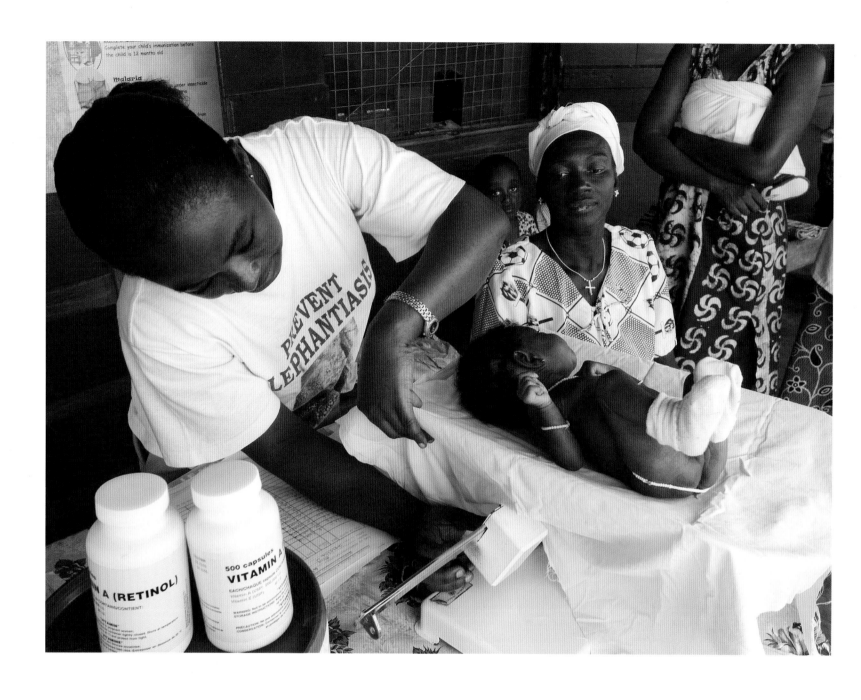

Checking out a new baby in the local clinic. Aburi, 2006, Gary Samson.

Patients at the clinic. Aburi, 2006, Gary Samson.

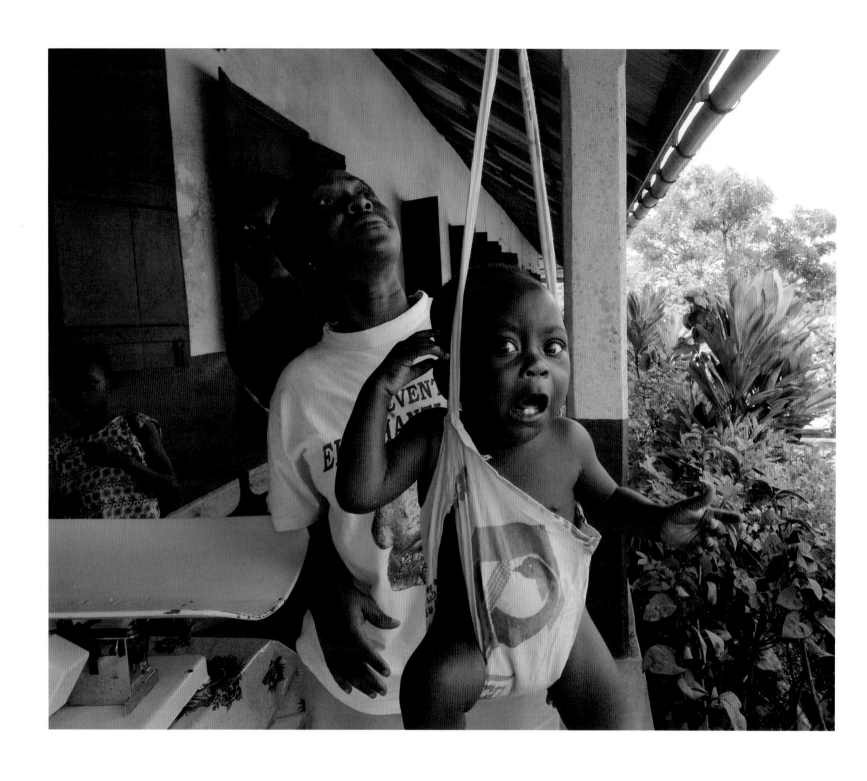

Weighing in at the clinic. Aburi, 2006, Gary Samson.

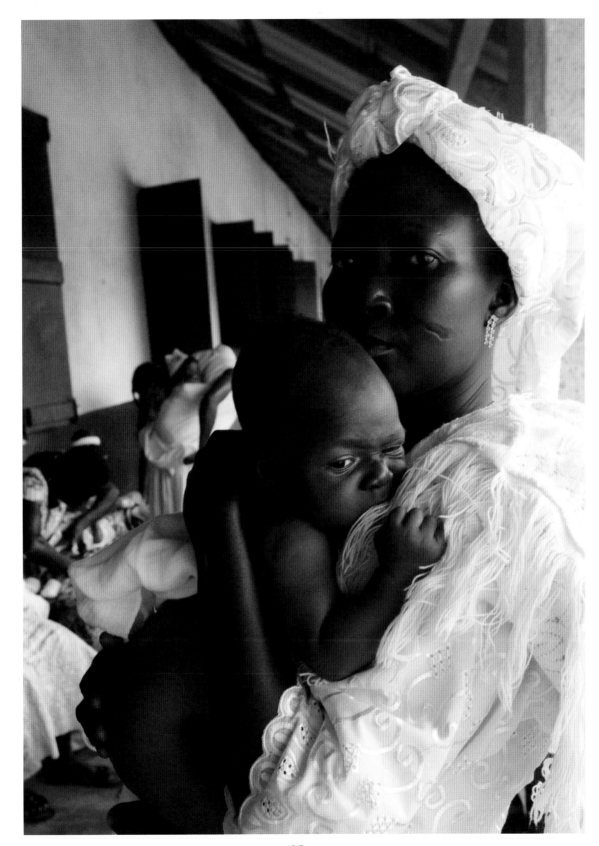

Waiting at the clinic. Aburi, 2006, Gary Samson.

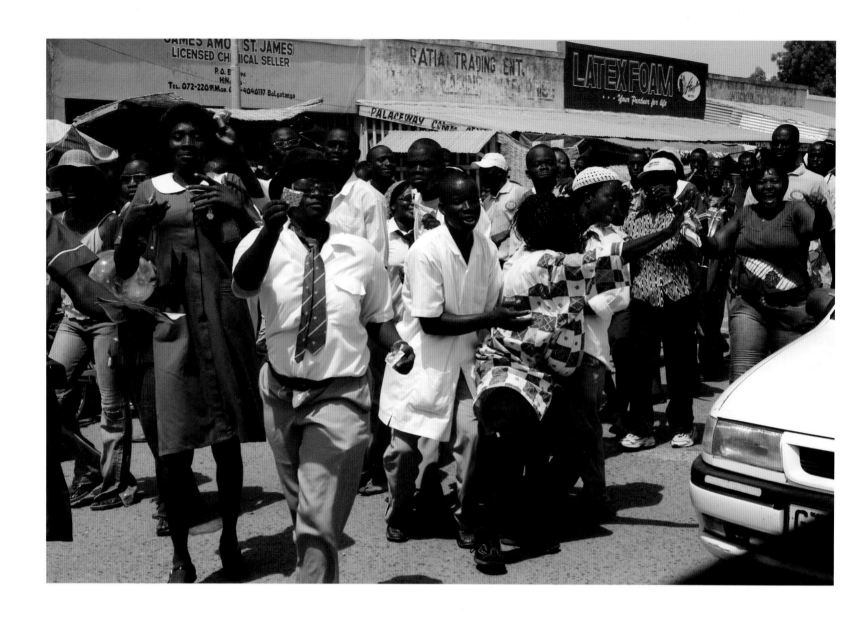

AIDS and birth control demonstration. Bolgatanga, 2006, Nancy Grace Horton.

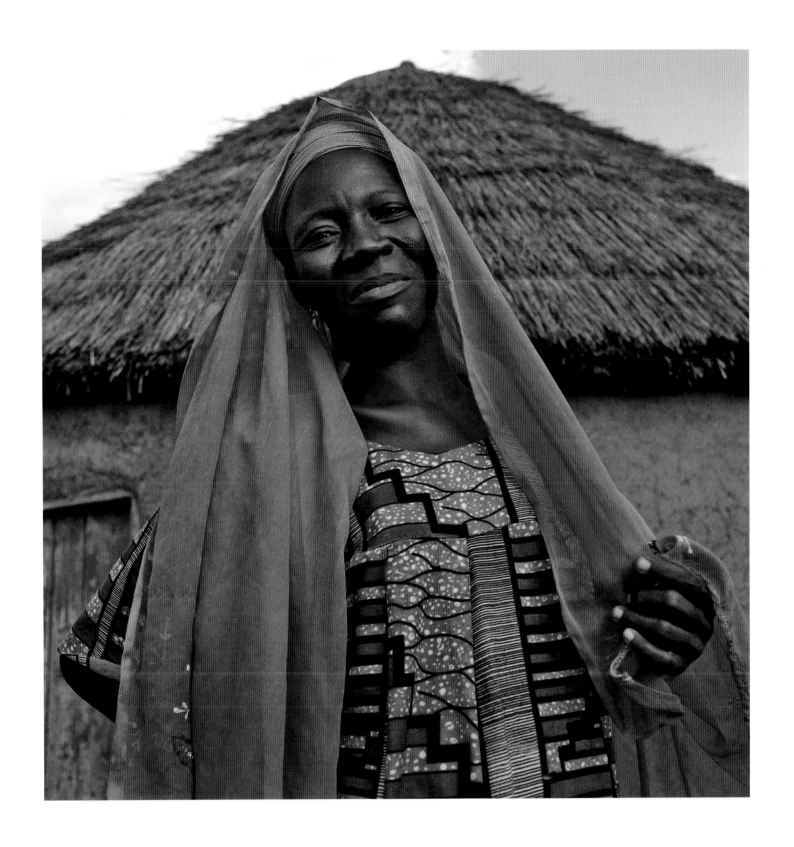

Woman in traditional dress, pottery village. Tamale, 2006, Nancy Grace Horton 2006.

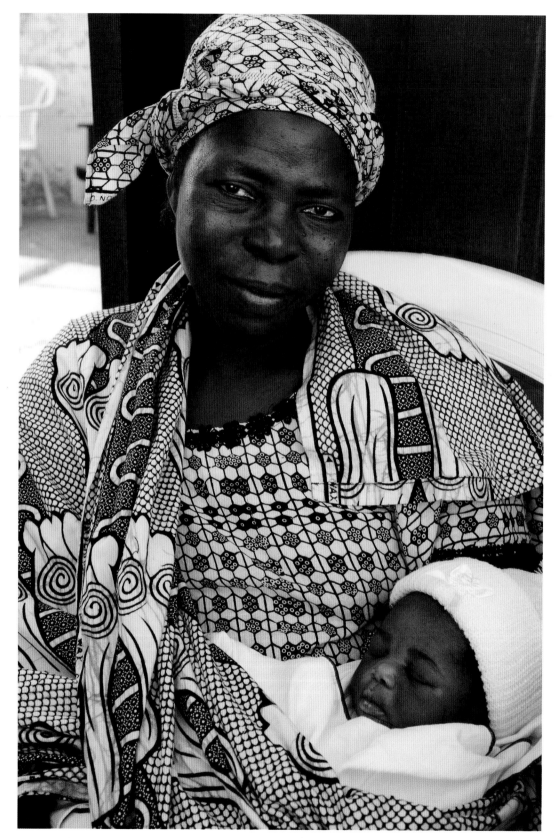

Outside a postnatal clinic. Accra, 2006. Barbara Bickford.

88

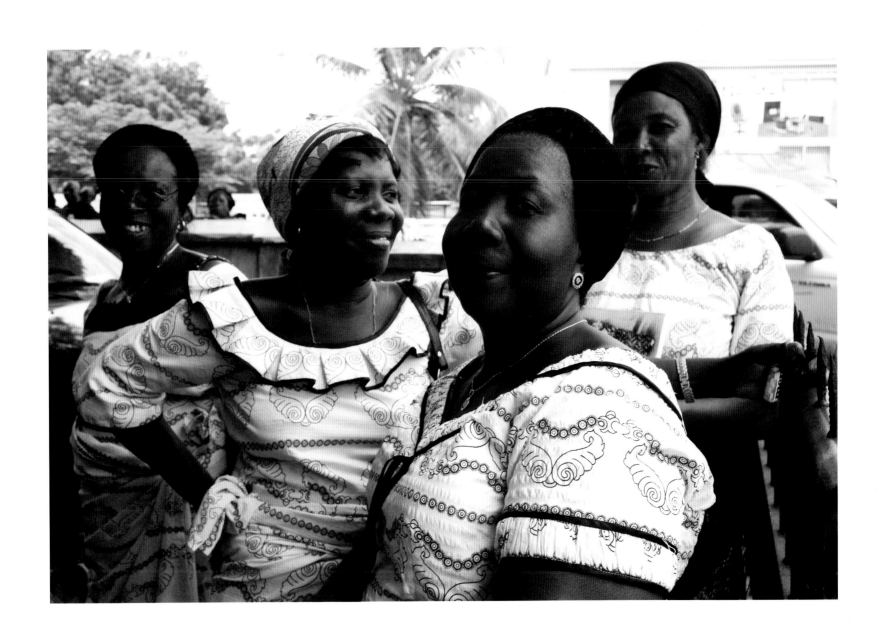

Mourners at a funeral. Near Accra, 2006, Barbara Bickford.

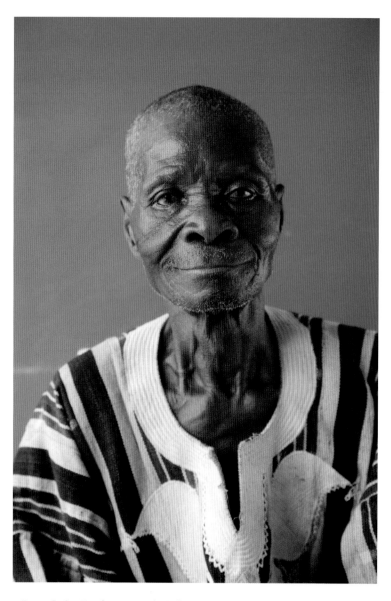

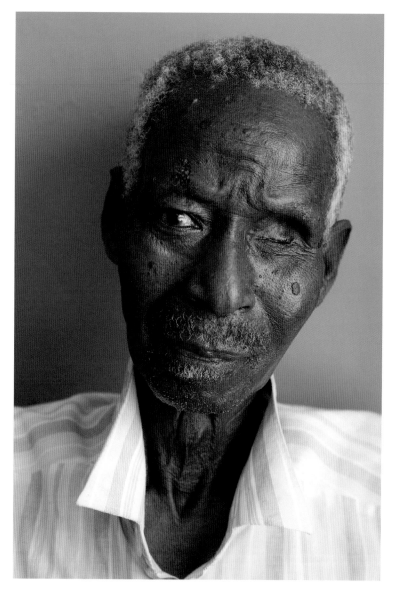

Pvt. Otia Badu, served eighteen months in Burma during World War II with the West African Frontier Force. Pokuase, 2006, Peter Randall.

World War II veteran of the Burma campaign. Pokuase, 2006, Gary Samson.

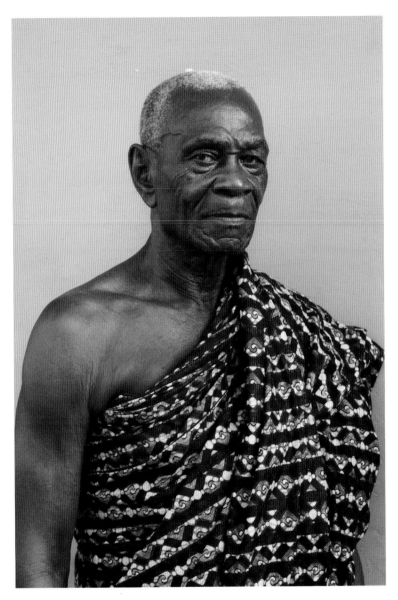

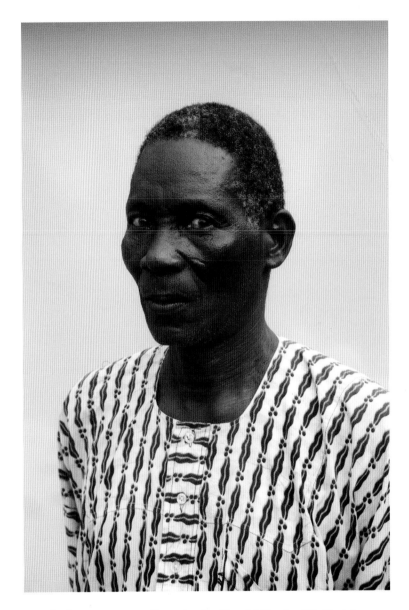

Nana Kwame Takyi I of Aburi/Agyimanti. Nana Takyi was one of Nkrumah's bodyguards and traveled with him in 1966 to China. While they were out of the country, a coup occurred and Nkrumah never returned. Nana Takyi remained with Nkrumah until the latter's death in 1972, then returned to Ghana. Aburi, 2005, Peter Randall.

Mekedoge Bowman, linguist for Torgbi Dzelu IV. Petitioners speak to the king through the linguist. Dzelukope, 2006, Peter Randall.

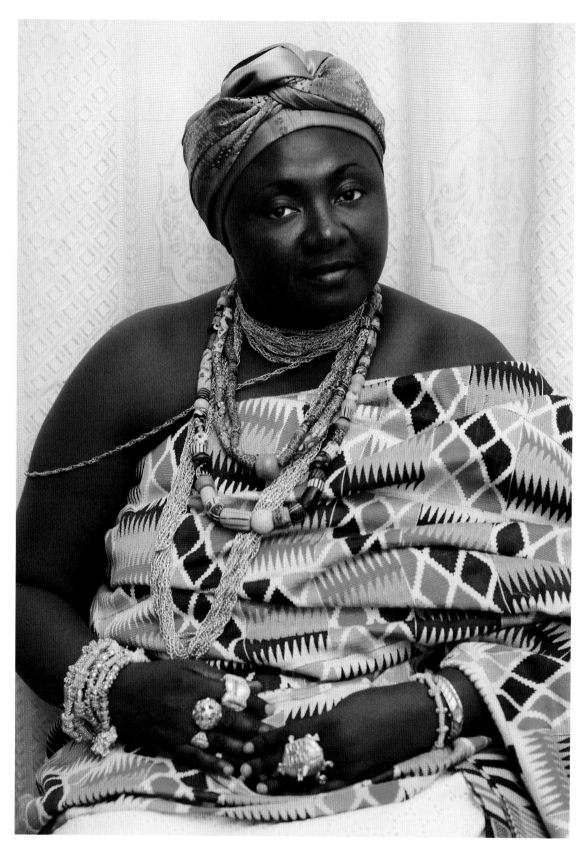

*Nana Ama
Ayensua Saara III,
queen mother of
Denkyira
Traditional Area.
Accra, 2006,
Gary Samson.*

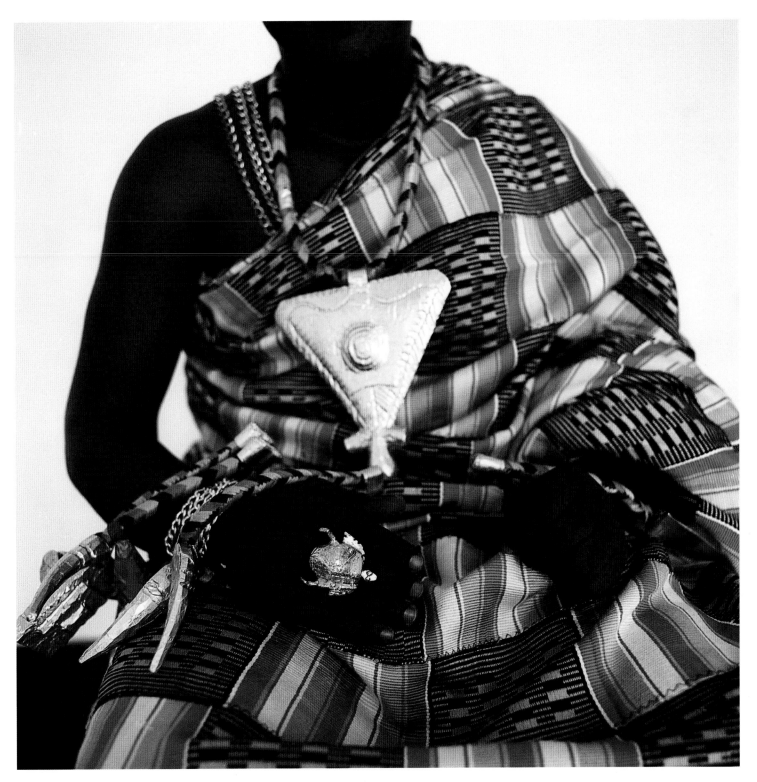

Gold jewelry called dehyee nsu with kente. Dehyee *means royal and* nsu *means weep not, hence, literally meaning the royal weeps not. It is worn for durbars, parties, weddings, and other joyful events. Nana Adontenhene, Techiman, 2006, Nancy Grace Horton.*

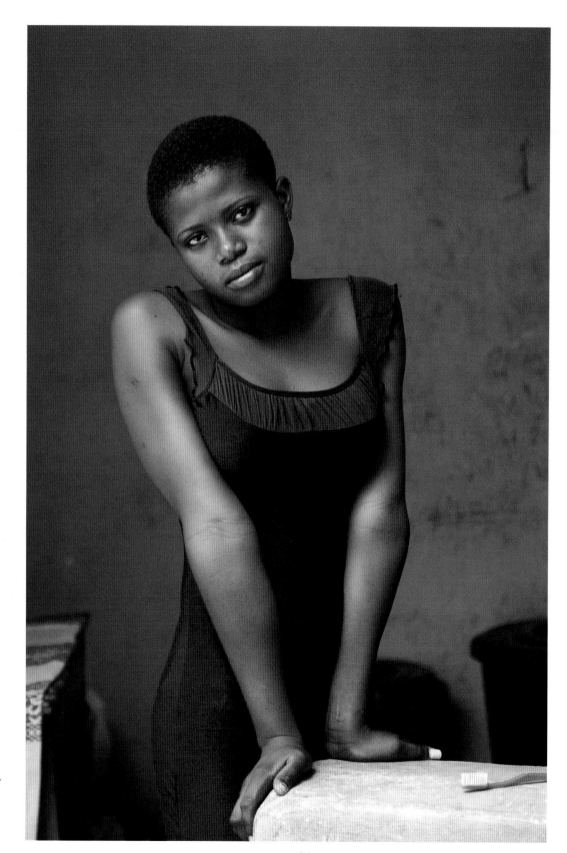

*Young woman.
Ayeduase.
2006, Tim
Gaudreau.*

94

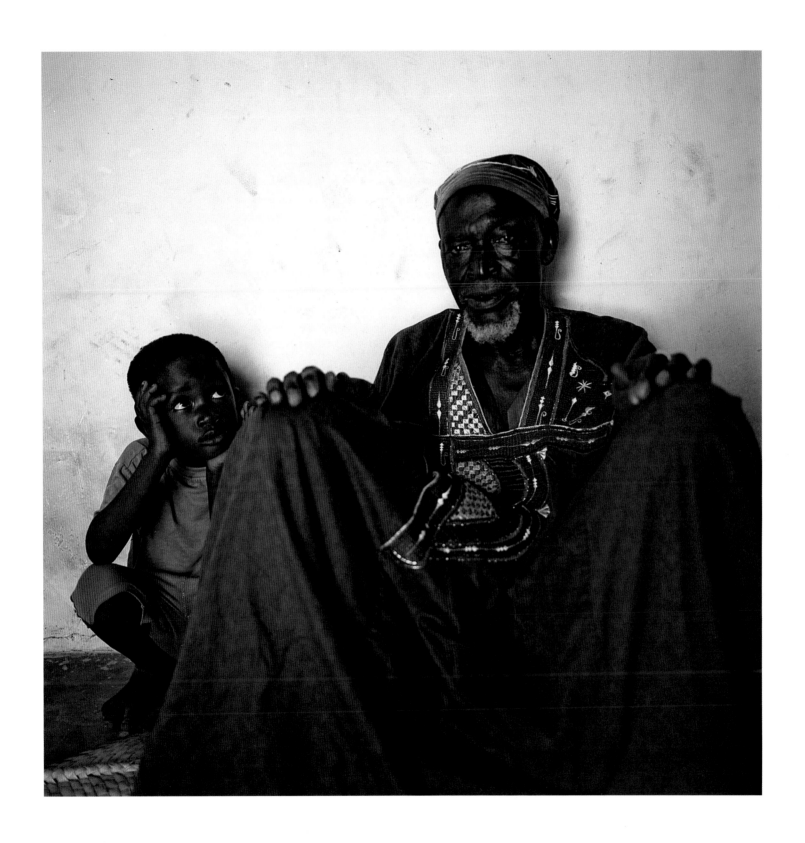

King and future king. Gambaga, 2006, Nancy Grace Horton.

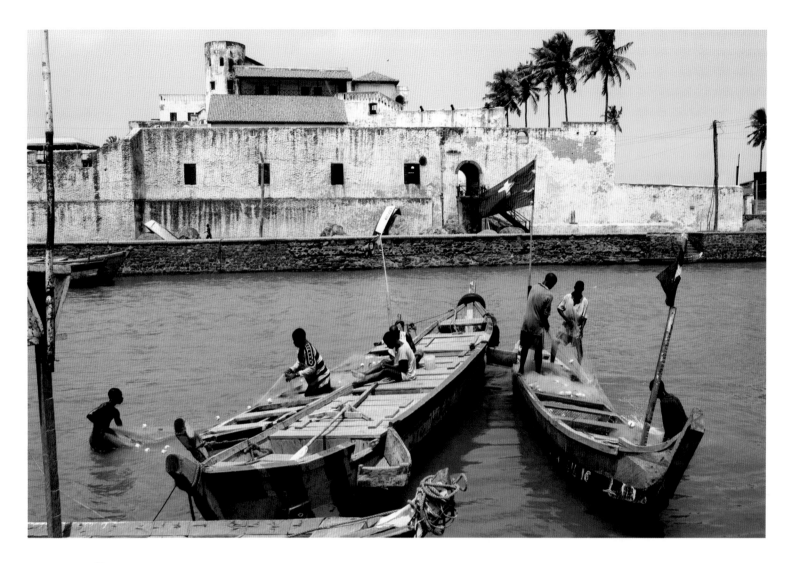

ECLIPSE

Nothing could be simpler:
History simplified as a castle
The wind stands mouthing
Nothing can be heard
Except the rainroar of the past.

To hear the rain
recount its story to the roof
Flash silver and sorrow
This history: a drop of amnesia
Widening in its pool
It hates to intrude; fears to offend:

The past with its averted eyes
Is careful not to impose:
A gift of absence to the present.

The weight of braided days
A whirlwind coming home
The sun slowly blinded by the clouds

It was dark then, it is dark now
Give memory nothing
and it is darker still tomorrow

I can feel the sea gently rock our earth to sleep.
 Kwadwo Opoku-Agyemang

St. George's Fort, built in 1482, was used to hold slaves prior to their shipment across the Atlantic. Elmina, 2005, Peter Randall.

96

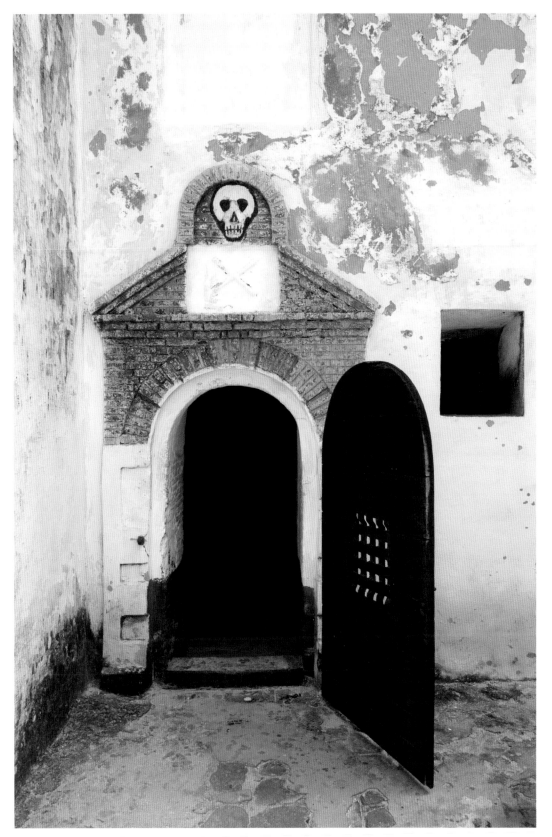

Entrance to male slave dungeon, St. Georges Fort. Elmina, 2005, Peter Randall.

97

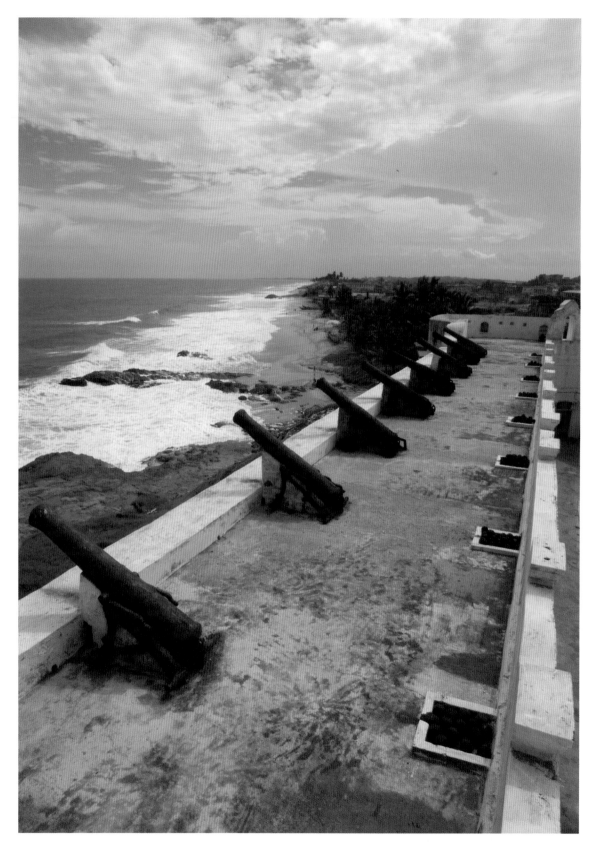

Cape Coast Castle.
Cape Coast, 2006,
Tim Gaudreau.

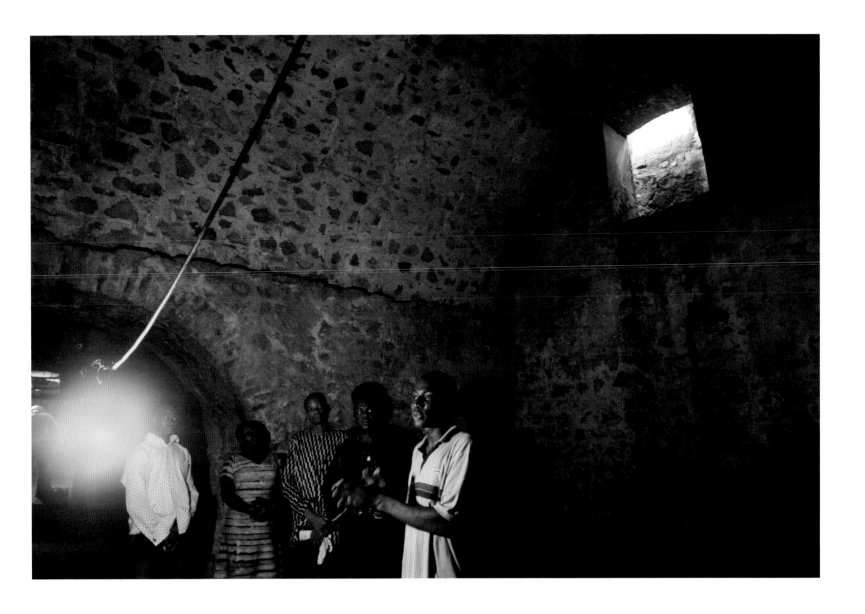

The Swedish Africa Company built the first Cape Coast Castle on this site in 1653 to conduct trade in timber and gold. It was later rebuilt in stone. After the Gold Coast was seized by the Danes, the Castle and Dungeon was then taken by the British, rebuilt, and became a center for the slave trade. Thousands of men and women were held here, sometimes for months while waiting for shipment. Tour guides here and in Elmina tell the terrible stories of how the people were mistreated while chained to the walls. In 1844 it became the seat of the colonial government of the British Gold Coast. Restored first in the 1920s by the British, it was restored again in the 1990s by the Ghanaian government, with funds from the United Nations Development Programme, the Smithsonian Institution, and other NGOs. It is now a world heritage site. Cape Coast, 2006, Tim Gaudreau.

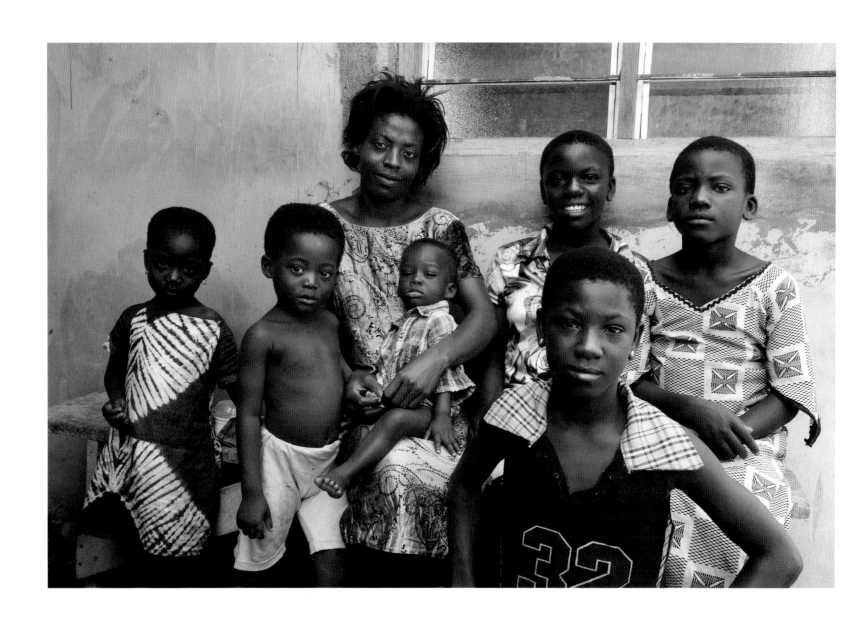

A family in Aburi. 2006, Gary Samson.

Christiana Cudjo. Accra, 2006, Gary Samson.

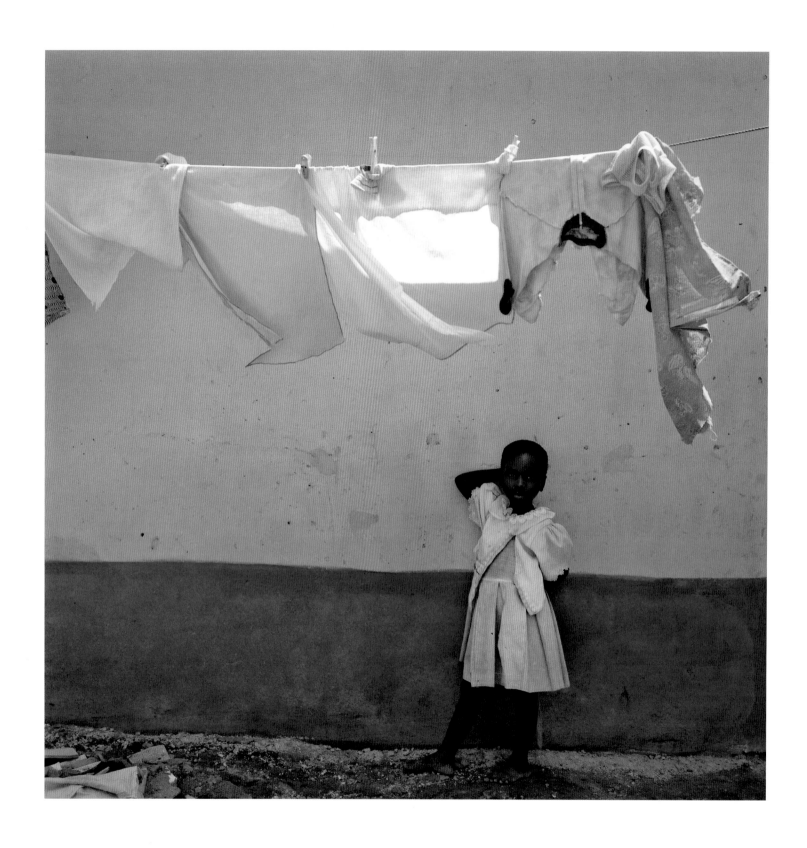

Young girl with laundry. Essueshyai, 2006, Nancy Grace Horton.

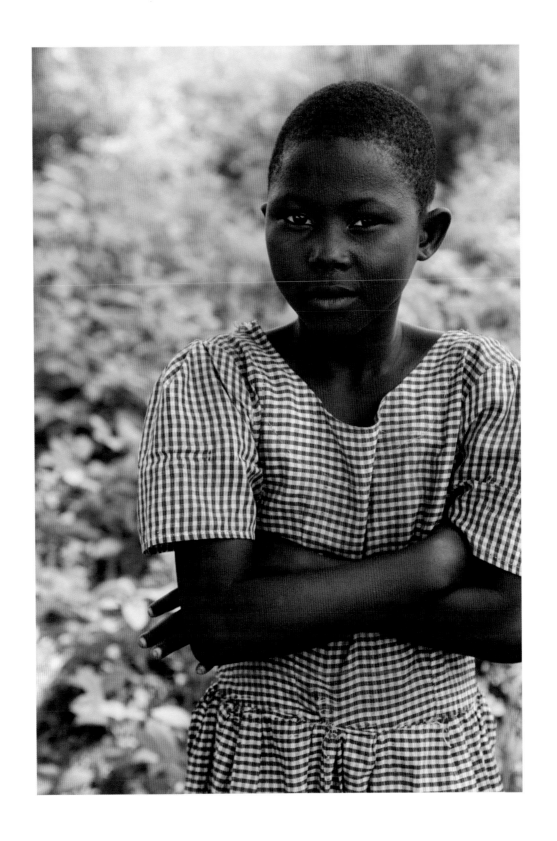

Young girl. Salaga, 2006, Tim Gaudreau.

103

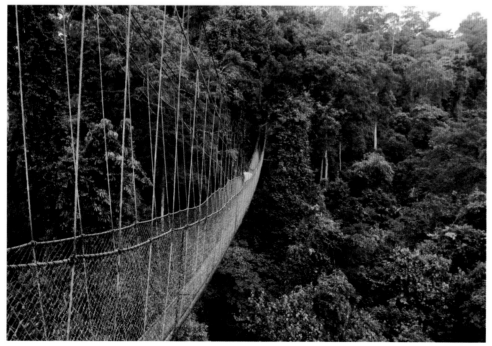

Plains behind Accra, from Aburi Hills. This is the scene that Nkrumah saw from his weekend retreat. Aburi, 2006, Peter Randall.

Rope walkway and rain forest. Kakum Forest Reserve, 2005, Peter Randall.

Landscape in the central region, 2006. Barbara Bickford.

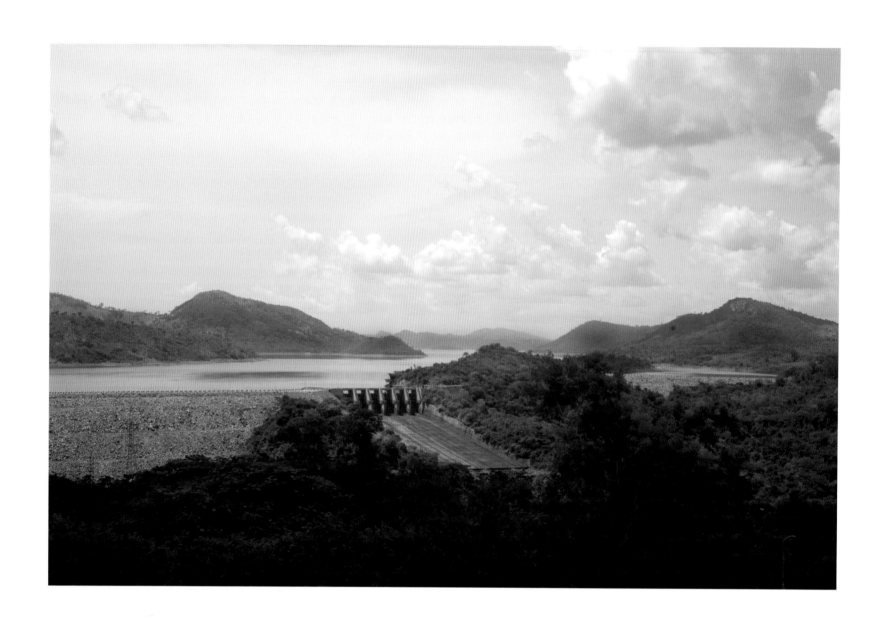

The Akosombo dam produces electricity for Ghana and its neighbors Togo, Benin, and Côte d'Ivoire. The dam has created Volta Lake, the largest man-made lake in the world. Akosombo, 2006, Peter Randall.

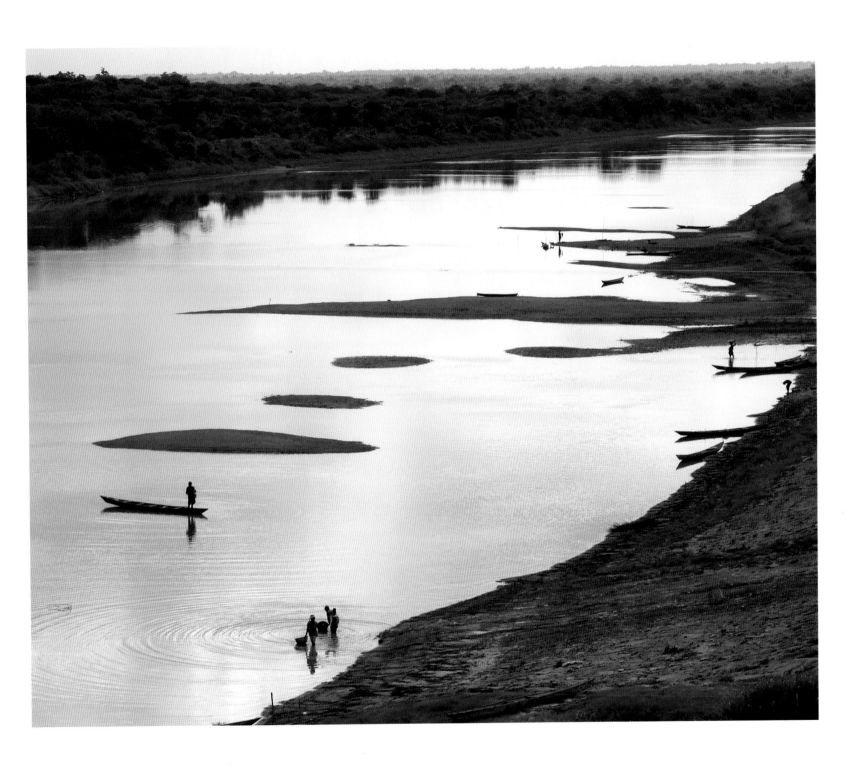

White Volta River. Bolgatanga, 2006, Tim Gaudreau.

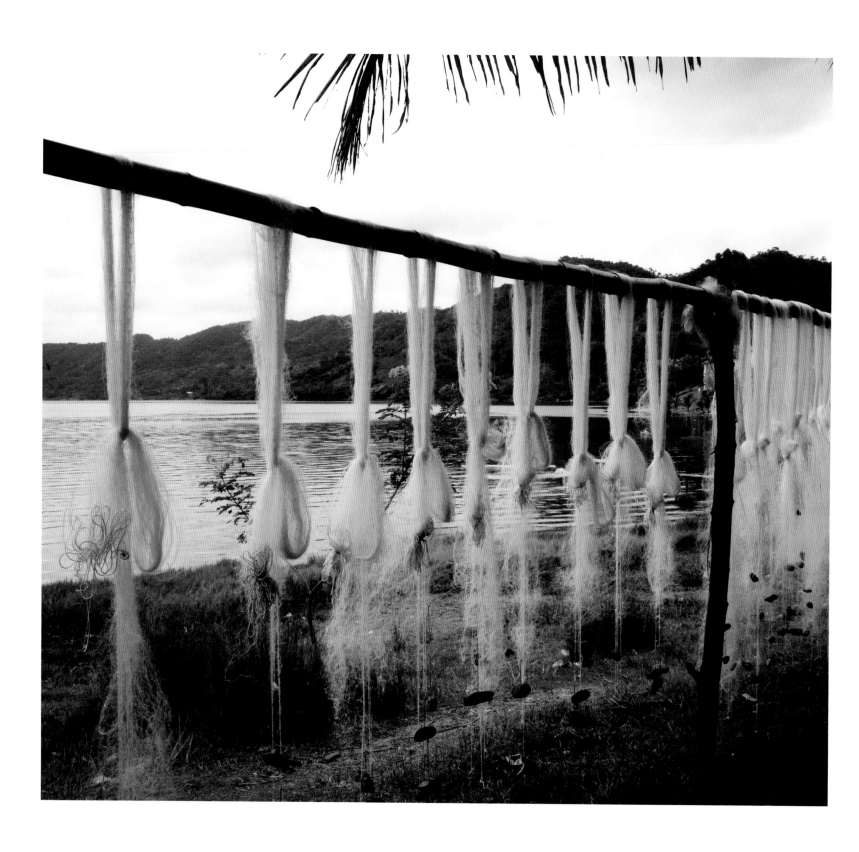

Fishing nets drying. Lake Bosumtwi, 2006, Barbara Bickford.

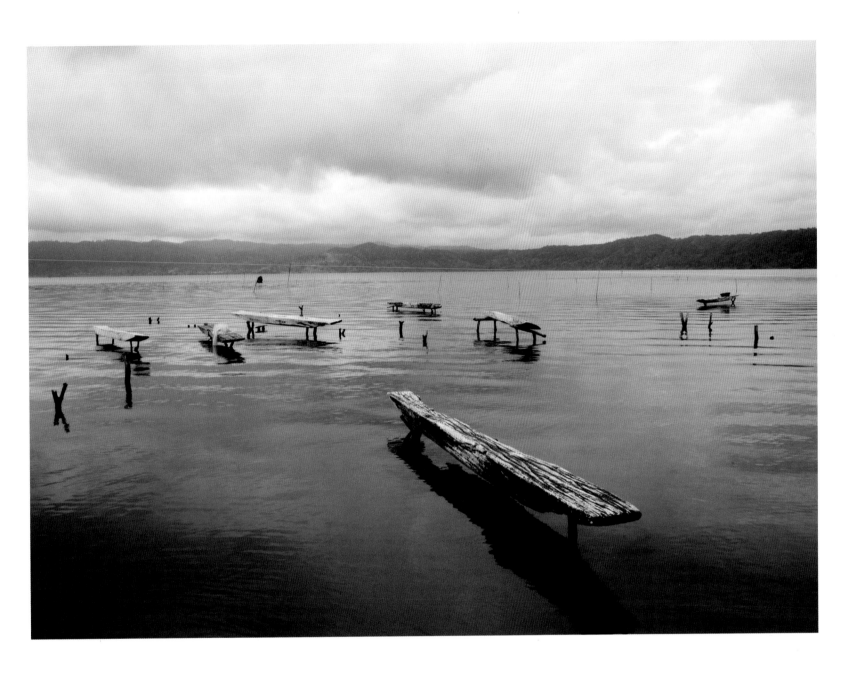

The largest natural lake in Ghana was created by a meteor. Bosumtwi is sacred to the Ashanti. According to traditional beliefs, the souls of the dead come here to bid farewell to their god Twi. Because of this, residents only consider it permissible to fish in the lake from wooden planks, rather than traditional canoes. Lake Bosumtwi, 2006, Barbara Bickford.

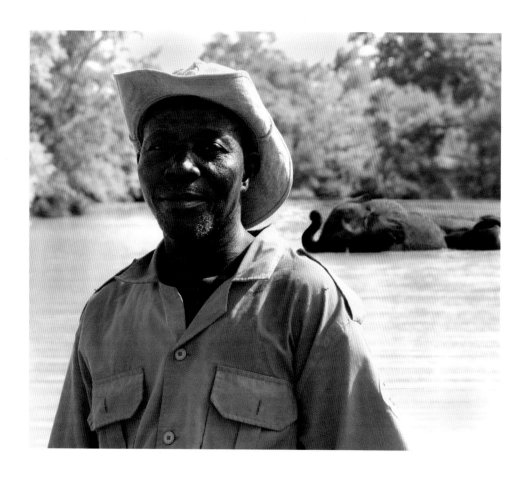

Park ranger. Mole National Park, 2006.

Warthogs. Mole National Park. 2006, both Tim Gaudreau.

Sacred crocodile. Panga, 2006, Nancy Grace Horton.

Between two worlds. Accra 2006, Barbara Bickford.

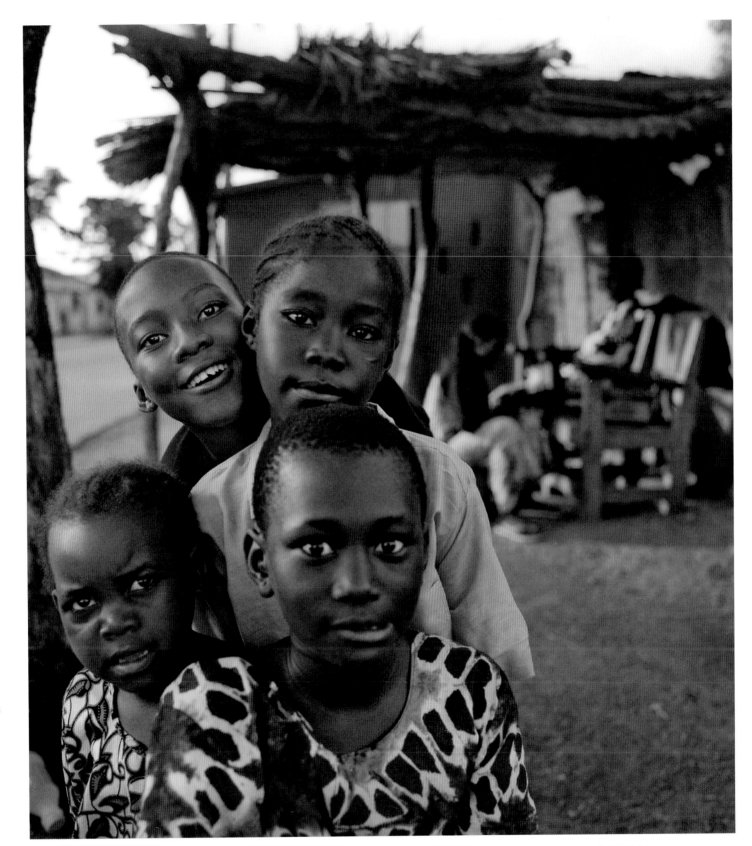

Children outside tannery. Tamale, 2006, Nancy Grace Horton.

113

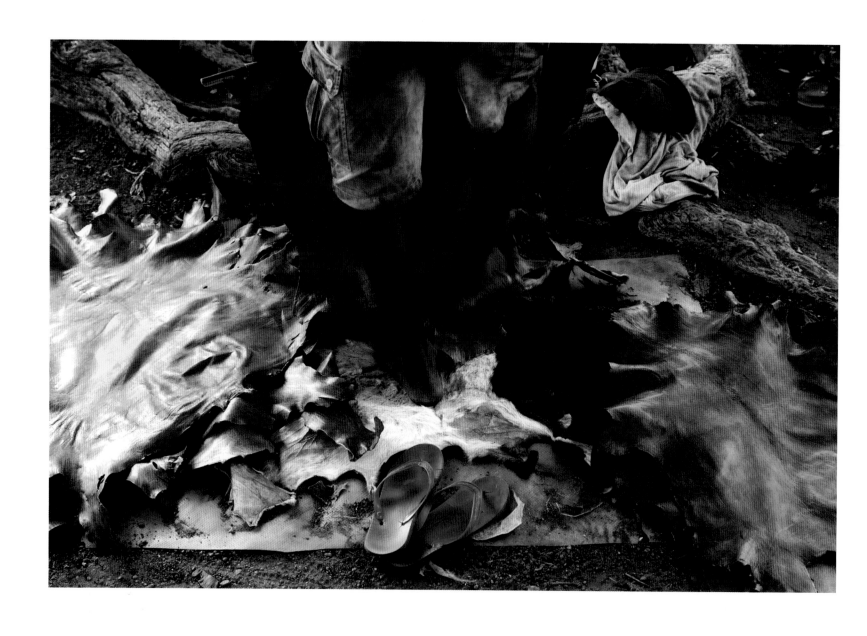

Open air tannery. Tamale, 2006, Nancy Grace Horton.

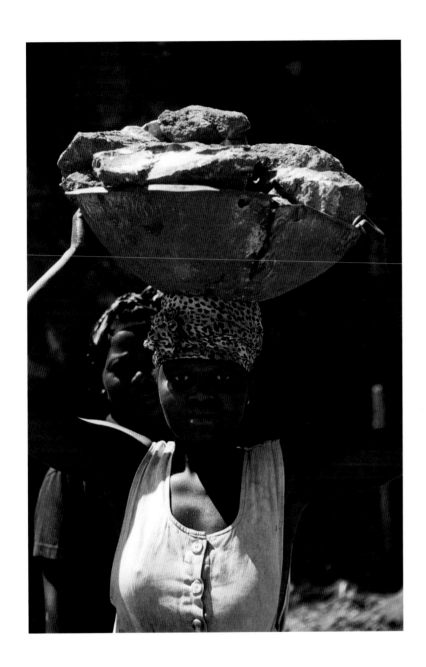

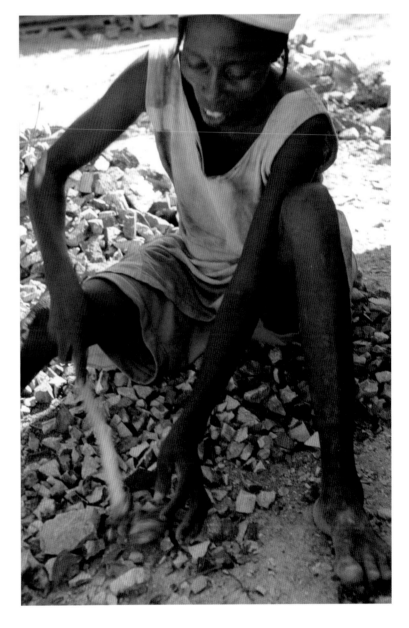

Quarry workers. Pokuase, 2006, both Charter Weeks.

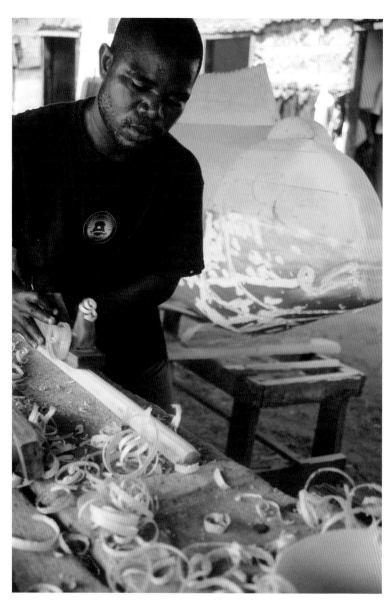

Coffinmaker. Teshie, 2006, Charter Weeks.

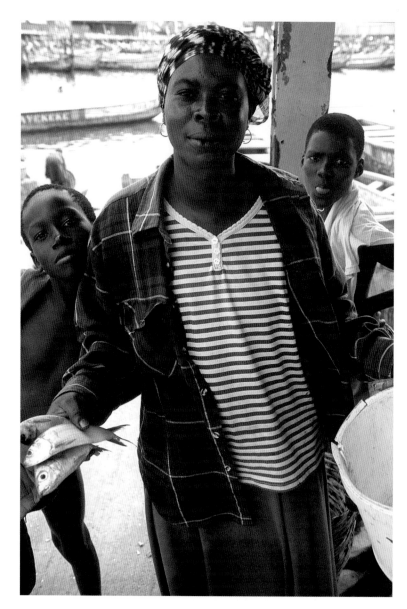

Selling fish. Tema, 2006, Charter Weeks.

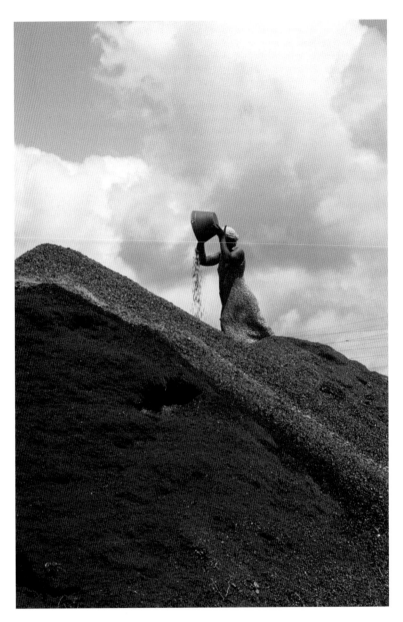

Dumping palm oil shells. Obuasi, 2006, Charter Weeks.

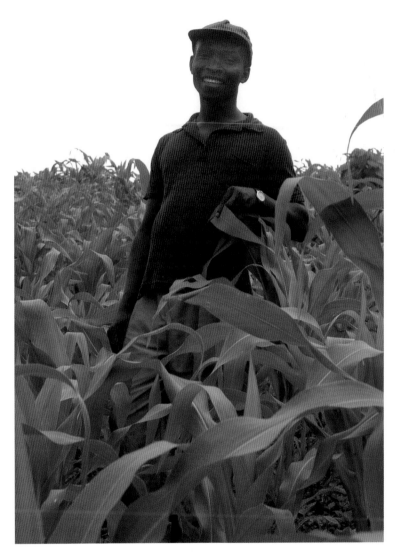

Farmer. Bonsaaso, 2006, Nancy Grace Horton.

117

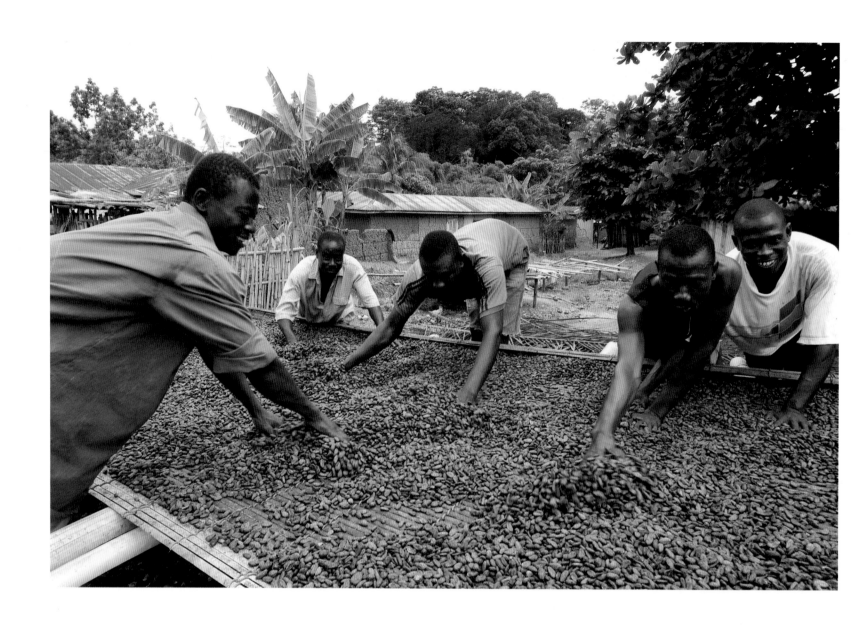

Drying cocoa beans. Central Region, 2006, Tim Gaudreau.

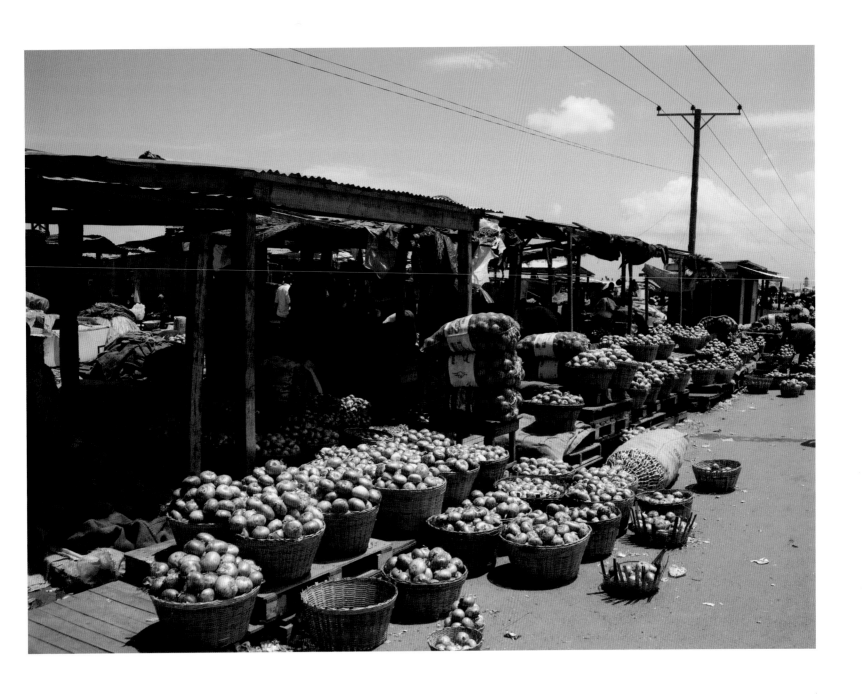

Onion market. Accra, 2006, Barbara Bickford.

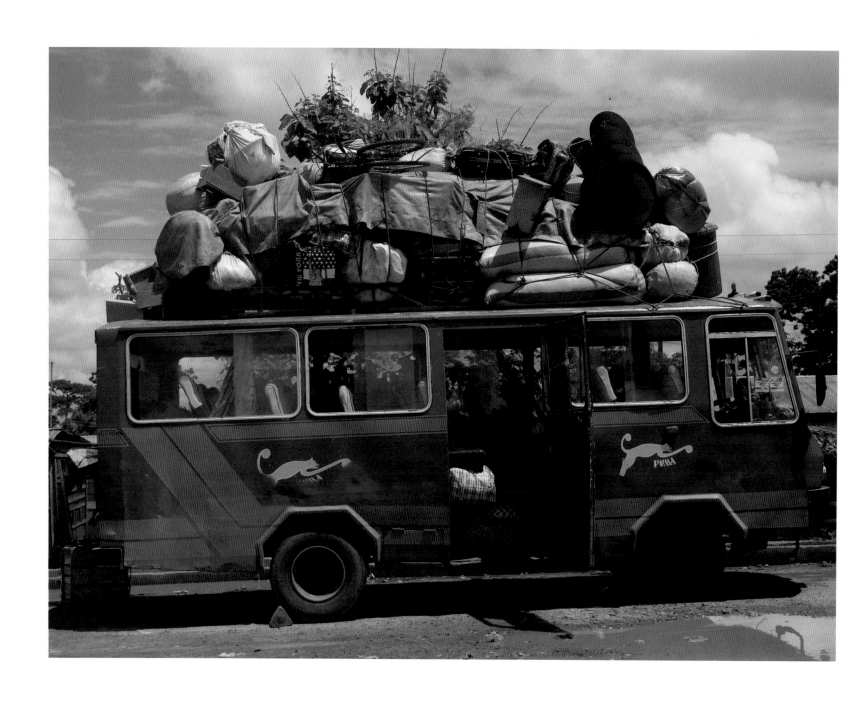

Tro-tro on market day. North of Accra, 2006, Nancy Grace Horton.

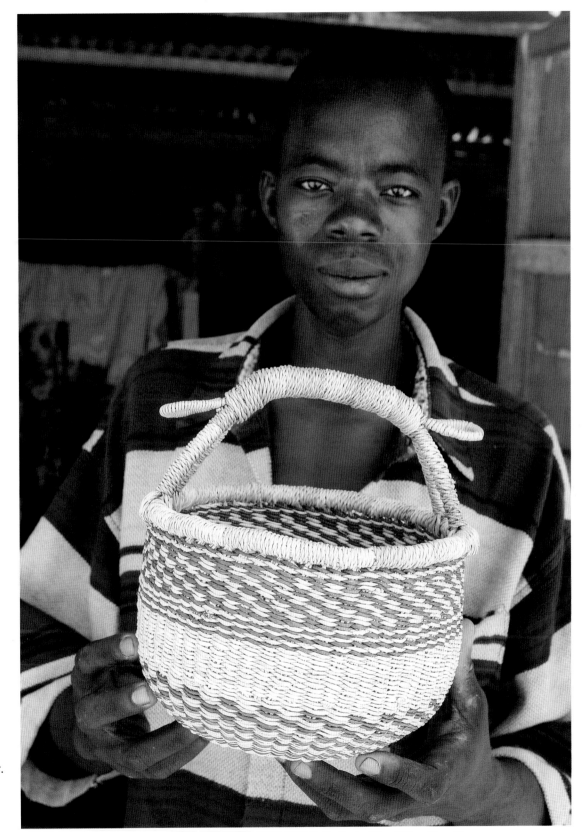

*Making the sale.
Bolgatanga,
2006, Tim
Gaudreau.*

121

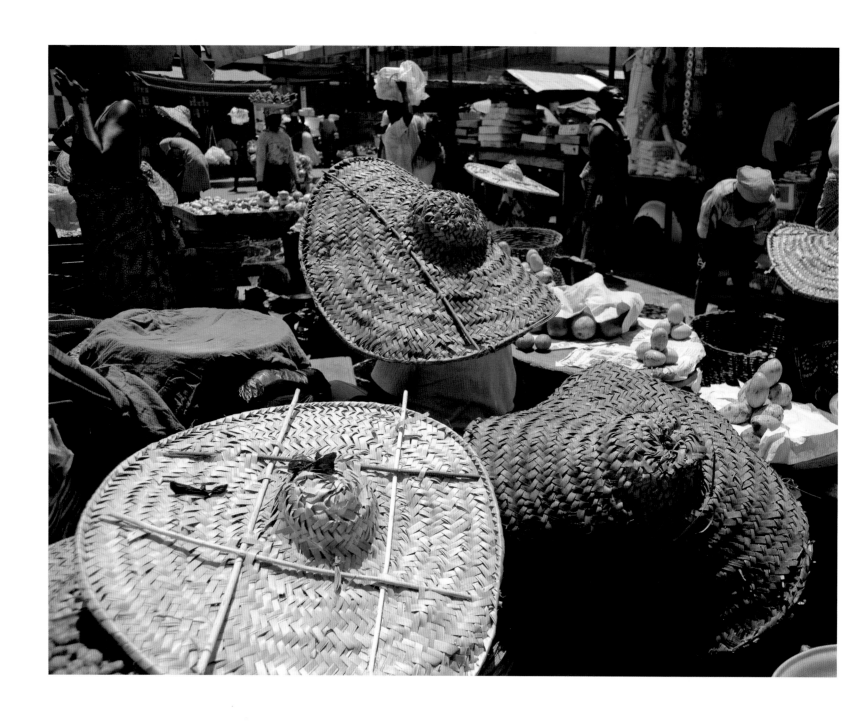

Market women with well-worn hats to keep off the sun. Accra, 2006, Barbara Bickford.

122

Construction worker. Salaga, 2006, Tim Gaudreau.

Emmanuel Obeno Bonsoo, MFA graduate of Kumasi University of Science and Technology. Kumasi, 2006, Tim Gaudreau.

ONCE UPON A TIME
Efua Sutherland

And he planted his labour in grain,
He rested his hopes in trees of wine,
And his harvest was in sight
And his sap was soon to surge.

Since once upon a time is still our time,
A little to eat and a little to drink
Could still restrain a curse on the brink.

What else is there to say?

Village leader. Salaga, 2006, Nancy Grace Horton.

Wall pattern. Sirigu, 2006, Nancy Grace Horton.

Nakarisi father and son standing before their traditional painted homestead. Sirigu, 2006, Nancy Grace Horton.

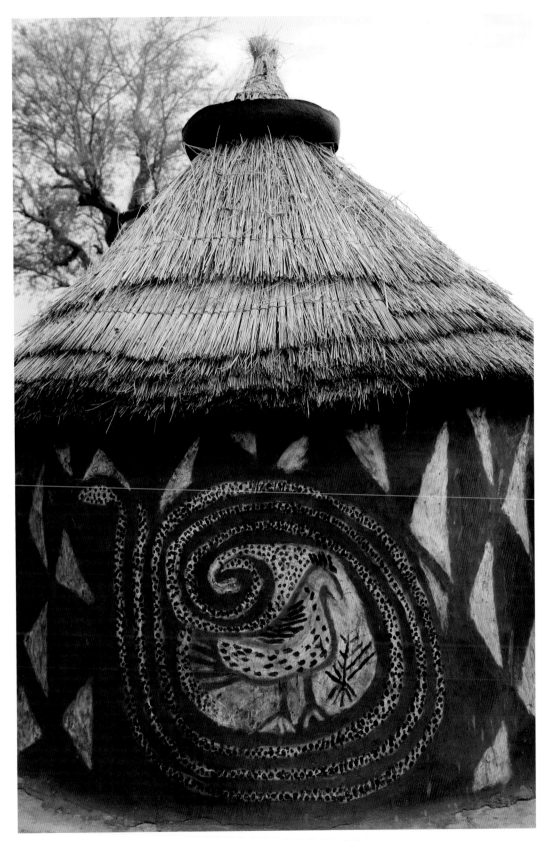

Traditional painting on Sahelian adobe house. Sirigu, 2006, Tim Gaudreau

Tim Gaudreau

Gary Samson

Barbara Bickford

Nancy Grace Horton

Nancy Grace Horton

Barbara Bickford

Gary Samson

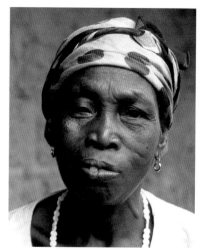

Charter Weeks

Gary Samson

Charter Weeks

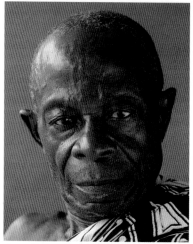

Gary Samson

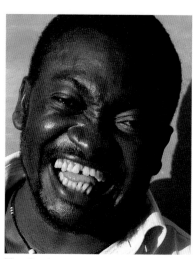

Tim Gaudreau

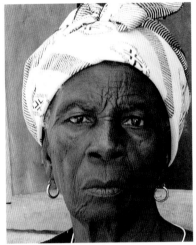

Tim Gaudreau

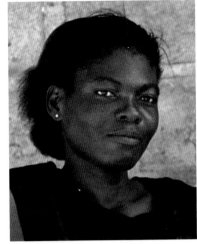

Charter Weeks

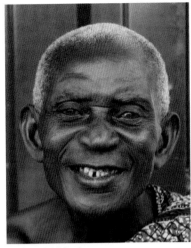

Barbara Bickford

Gary Samson

Nancy Grace Horton

Barbara Bickford

Peter Randall

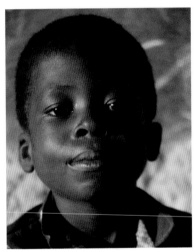

Charter Weeks

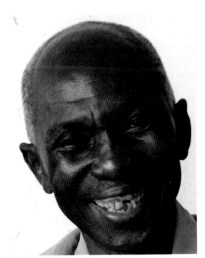

Tim Gaudreau

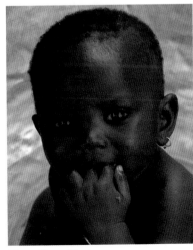

Nancy Grace Horton

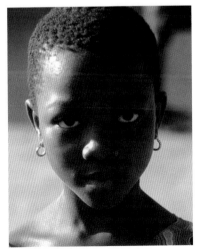

Charter Weeks

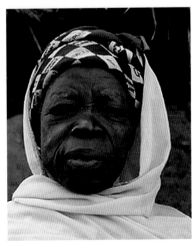

Nancy Grace Horton

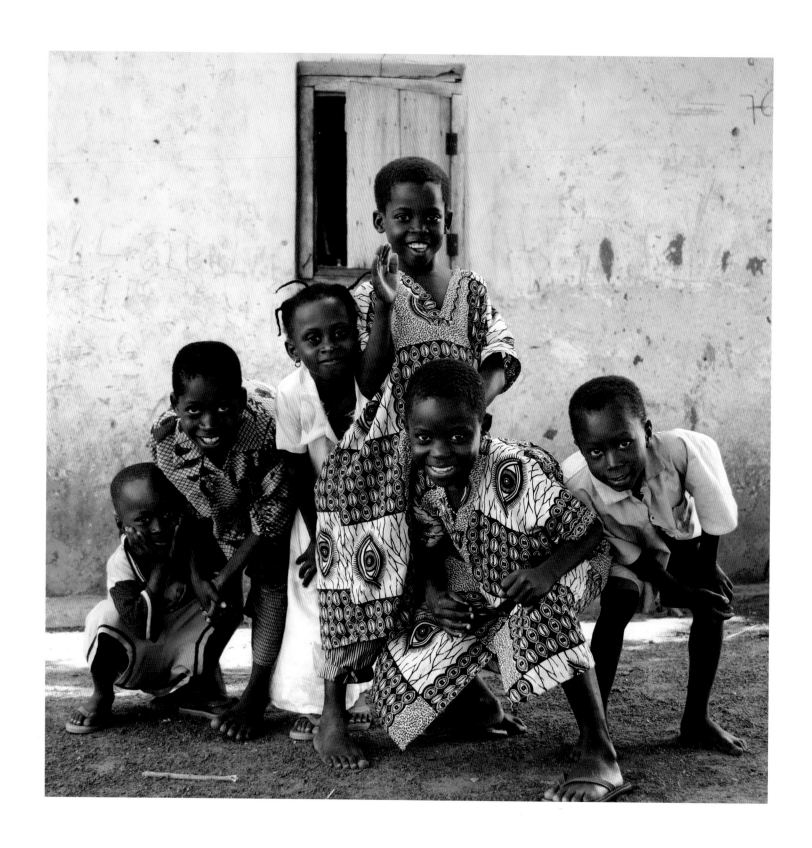

Having fun. Salaga, 2006, Tim Gaudreau.

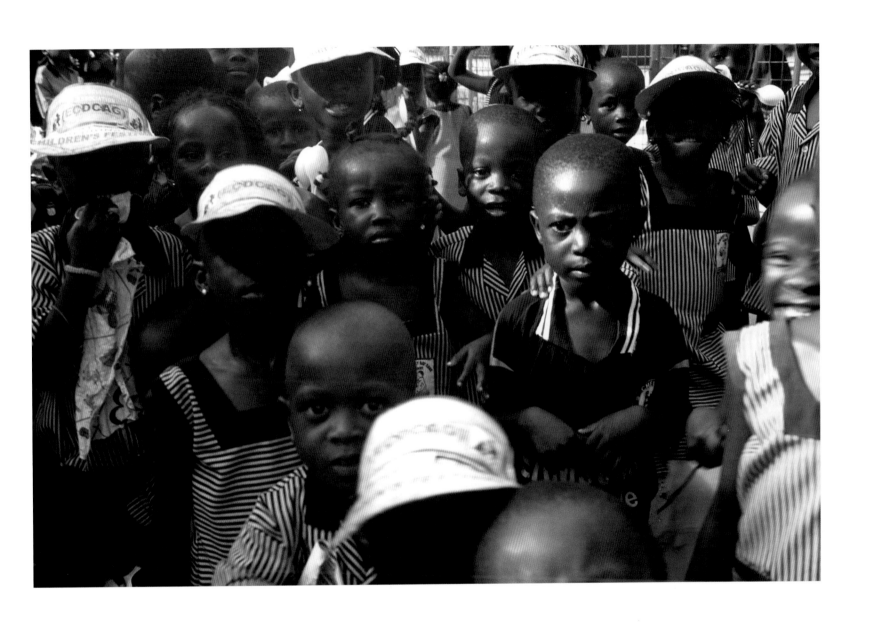

School children. Kumasi, 2006, Charter Weeks.

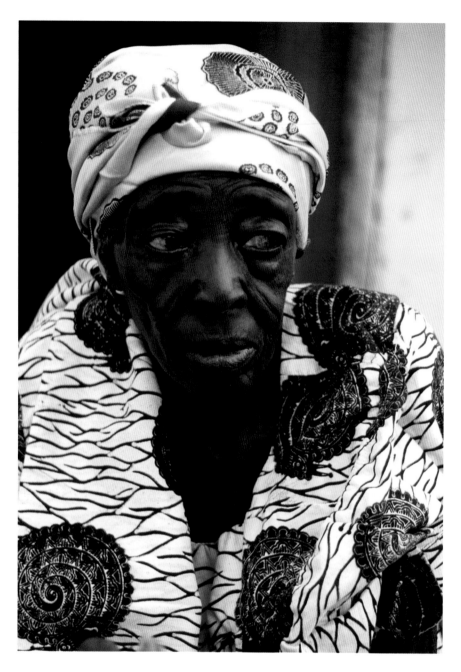

Woman. Pokuase, 2006, Charter Weeks.

A PASSING THOUGHT
Amu Djoleto

What you do expect me to sing, I will not,
What you do not expect me to croak, I will;
A bird sings what it likes without request.
I am getting old and have to look back:
It is a short time, it is a long time,
The idea is funny: it is my own time.
Some people have sometimes made me angry,
Some men have surely tried to make me sad,
Most men have quite often made me happy,
I have borne it all and I am grateful.

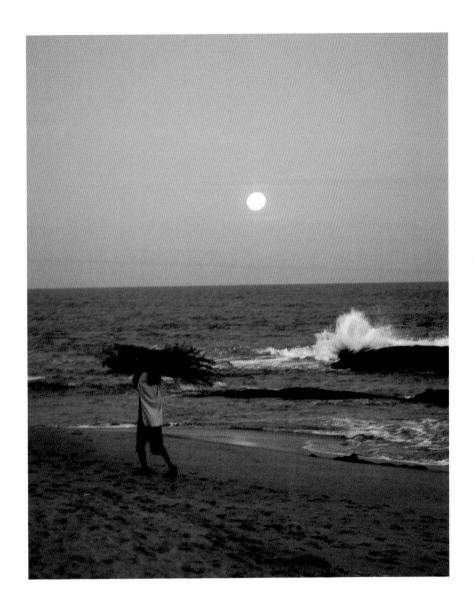

SUNBIRD
Kofi Anyidoho

They say the orphan may not die without
 A taste of harvest joys
Today your praise-name laughs like westwinds
 Among our cottonfields
I found you in that walnut grove
 Playing games with Moonchildren

Full moon, Gulf of Guinea, Coconut Grove Resort. Elmina, 2006,
Nancy Grace Horton.

133

Barbara Bickford began her photographic career in the early nineties when she took the photography certificate program at the New Hampshire Institute of Art. She immediately realized her deep affinity for photography, and after her first color class she never looked back. After finishing at NHIA she continued her studies at the Maine Photographic Workshop and the Harvard Extension in Cambridge. Over the years Bickford's goal was to refine her response to images that captivate her. She wants to show slices of life—show them as they unfold, often upbeat, irreverent, and surreal. While traveling and teaching for several years in Southeast Asia, she collected photographs for numerous exhibitions on Vietnam, Cambodia, and Burma.

Tim Gaudreau is a native New Hampshire artist who is passionate about the natural world and the preservation of the environment. Through his artwork, Tim advocates for environmental responsibility, the recognition of wonder and beauty in our world and generates dialogue about social issues. He has received awards from the New Hampshire State Council on the Arts and the National Endowment for the Arts. Several commissions from the city of Portsmouth have given Tim the opportunity to create public art projects that have stimulated collaboration and community interaction. He has photographed in India, Laos, and Brazil. For more information about Tim's work, check out www.wake-up.ws.

Nancy Grace Horton uses graphic bold compositions to convey a sense of curiosity in a subject, leaving the viewer with a mysterious familiarity. Over the course of fifteen years she has traveled and studied photography and art from her home base of Portsmouth, New Hampshire. Her photography continues to be published in numerous publications and she is presently working on a photo book project illustrating Portsmouth. Her work has appeared in *The Boston Globe*, *Yankee* magazine, and *Rolling Stone*. She has a personal interest in live entertainment documentation and has photographed over two hundred world class performances. Her workshop, Learning to See, brings senior citizens and teens together, using photography as a tool to learn, experiment, and collaborate together. More of her work can be seen at www.hortonphoto.com.

Peter E. Randall has been involved with photography since graduating from the University of New Hampshire. He has been a reporter, photographer, and editor of weekly newspapers, and for seven years edited *New Hampshire Profiles* magazine. Organized in 1976, Peter E. Randall Publisher LLC has produced more than 400 titles for individuals, organizations, municipalities, and businesses. Since 1974, he has authored fourteen books ranging from collections of photographs and travel guides, to local history. He has made personal photography trips to Zambia, Togo, Zimbabwe, Senegal, Ghana, Spain, Japan, and Guatemala. His most recent book is *New Hampshire Then and Now*, a collection of eighty historical photographs matched with his contemporary images. www.petererandall.com. www.ghanavisit.org. www.perpublisher.com.

Gary Samson is an accomplished fine arts photographer and educator. His work is included in the permanent collections of many art galleries and museums as well as private collections. During twenty-nine years at UNH, Gary carried out photography and filmmaking assignments in Peru, Ireland, Labrador, Belize, Guatemala, and the White House. His best known films, *A World Within A World: The Amoskeag Manufacturing Company* and *Milltown*, are sensitive portrayals of Manchester's textile mills and the people who labored in them. After producing a film on the life of internationally acclaimed portrait photographer Lotte Jacobi, Gary spent six years with Ms. Jacobi cataloging her archive of 47,000 negatives that were donated to the University of New Hampshire in 1981. In 2001 he was appointed Chair of the Photography Department at the New Hampshire Institute of Art in Manchester, New Hampshire.

Charter Weeks has been taking pictures since the 1960s in his travels across America and throughout the world. His work has appeared in photography annuals, national magazines, literary journals, and commercial publications, as well as in museums and galleries throughout the country. He is a partner, with poet Marie Harris, in a business-to-business communications firm. Examples of both his creative and commercial work can be seen at www.charterweeks.com and www.isinglassmarketing.com.